Drawings in Midwestern Collections

Drawings in Midwestern Collections

VOLUME I

Early Works

A Corpus Compiled by the Midwest Art History Society

Edited by Burton L. Dunbar and
Edward J. Olszewski

University of Missouri Press
Columbia and London

Copyright © 1996 by
The Curators of the University of Missouri
University of Missouri Press, Columbia, Missouri 65201
Printed and bound in the United States of America

5 4 3 2 1 00 99 98 97 96

Library of Congress Cataloging-in-Publication Data

Drawings in Midwestern collections : a corpus / compiled by the
 Midwest Art History Society ; edited by Burton L. Dunbar and
 Edward J. Olszewski.
 p. cm.
 Includes bibliographical references and index.
 Contents: v. 1. Early works.
 ISBN 0–8262–1062–7 (alk. paper)
 1. Drawing—Collectors and collecting—Middle West—Catalogs.
I. Dunbar, Burton L. (Burton Lewis), 1942- . II. Olszewski,
Edward J., 1937- . III. Midwest Art History Society.
NC37.D7 1996
741.9'074'77—dc20 96-13559
 CIP

⊗™ This paper meets the requirements of the
American National Standard for Permanence of Paper
for Printed Library Materials, Z39.48, 1984.

Designer: Stephanie Foley
Printer and binder: Thomson-Shore, Inc.
Typeface: Bembo

Contents

Works Included

Italian Artists

French, German, and Netherlandish Artists

Comparative Illustrations

Contributors to the Catalog

R.R.C. Robert Randolf Coleman, University of Notre Dame

B.L.D. Burton L. Dunbar, University of Missouri–Kansas City

W.S.G. Walter S. Gibson, Case Western Reserve University

L.M.G. Laura M. Giles, Art Institute of Chicago

J.C.H. Jane C. Hutchison, University of Wisconsin–Madison

R.M. Robert Munman, University of Illinois at Chicago

E.J.O. Edward J. Olszewski, Case Western Reserve University

A.R. Ann Roberts, University of Iowa

E.R. Eliot Rowlands, Nelson-Atkins Museum of Art

A.G.S. Alison G. Stewart, University of Nebraska–Lincoln

M.S.W. Mark S. Weil, Washington University

C.C.W. Carolyn C. Wilson, Houston Museum of Fine Arts

Preface

The Midwest Art History Society has from its inception held scholarly publication as a long-term objective of the organization. We are fortunate to have in our region works of art in museums and private collections that are distinctive in nature and enriching to the spirit. Both museums and collectors have often been willing to share their possessions for the benefit of our members and our students, and they deserve to have their works become better known. With this objective before us, we have explored the possibilities for contributing to the field to which we as individuals and as a society of art historians belong.

Paintings are the chief works of art that most of the museums in the Midwest collect first and publish. We have thus turned our attention to a field that, although collected, has been insufficiently published: the master drawing. The Midwest is rich in such works that are both preparatory and independent studies. Although the largest museums have published their drawings *in extenso* or published many in catalogs of exhibitions of paintings and other objects, there are still many other drawings that have not received the acknowledgment they deserve.

A corpus of drawings in the collections of the United States does not exist. We are immodest enough to hope that this volume of drawings from the earliest years, which we now have the temerity to present to the public at large, will be well received and will act as both catalyst and model for art historians in other parts of our nation.

It should immediately be said that the work of presenting these drawings here is the result of a labor of love for our profession. The director of the project, Burton L. Dunbar of the University of Missouri–Kansas City, who has borne the brunt of the organization, and the scholar-teachers who have written the entries have done so at cost to themselves and to their personal lives. Edward J. Olszewski of Case Western Reserve University deserves special mention for his efforts in researching a full third of the drawings published in this volume and for his willingness to co-edit the manuscript. Scholarship such as we find here always demands time and effort, the former a commodity of which busy academics never have enough; the contributors to this work have spent a large amount of academic coin in preparing the entries presented here.

This work is a pilot, an exploration of the vast quantities of artists' drawings that enrich our region. The volumes to follow will benefit from the experience gained in creating this start to what will become a gift to our profession from the Midwest Art History Society.

This volume begins at the beginning— drawings through the year 1500. Few in number, precious in value, they hint at the riches to come in future volumes.

Charles D. Cuttler
University of Iowa, Emeritus

Acknowledgments

The thirty entries are written by the twelve scholars listed on p. xiii as Contributors to the Catalog. Charles D. Cuttler, University of Iowa; Burton L. Dunbar; Molly Faries, Indiana University; and Edward J. Olszewski formed the publication committee for the Midwest Art History Society that defined the scope of the project, helped in assigning entries, and worked in creating the format of the entries.

The members of the publication committee and the authors are indebted to the following persons who contributed in many ways to the preparation of this manuscript: Alice Franklin, Catherine Nation, Geraldine E. Fowle, Kari Eaton, Deborah Campbell, Amy Scott, Dena Woodall, and Carol Crowley at the University of Missouri–Kansas City. Susan Slagle compiled the index. At Case Western Reserve University, Henrietta Silberger and Karen Wagner Marsh. At the Cleveland Museum of Art, Evan H. Turner, former director, Michael J. Miller, former assistant curator of prints and drawings; Anne S. Babcock and Sabine Kretzschmar, curatorial assistants; Ann Abid, head of the Ingalls Library; Georgina G. Toth, associate librarian for reference; Alfred L. Habenstein, circulation manager; Eleanor L. Schiefele, photograph librarian; and Stacie A. Murry, cataloger.

Suzanne Folds McCullagh, curator of earlier prints and drawings at the Chicago Art Institute, was especially patient in working with the society in helping to define the project. Marc Wilson, director, and Roger Ward, curator of European art, at the Nelson-Atkins Museum of Art opened their collections to the society and made available unpublished technical discoveries on the drawings in their museum. At the Allen Memorial Art Museum, Oberlin College, the society's appreciation is extended to Larry Feinberg, chief curator; Joan-Elisabeth Reid, registrar; and Scott Parsons, intern-assistant to the registrar. Paul W. Richelson, chief curator, Grand Rapids Art Museum, graciously made available information on the drawing in his collection. Finally, the co-editors of this volume are greatly indebted to Jane Lago, managing editor of the University of Missouri Press, for her patience and cooperative understanding through all stages of the publication process.

Financial assistance for the publication of this book was made possible by a grant from Mrs. Barbara James McGreevy, Mission Hills, Kansas, in memory of her husband, the late Mr. Milton McGreevy. With his wife, Mr. McGreevy was a lifelong collector of Old Master drawings and benefactor of the arts.

Drawings in Midwestern Collections

Introduction

In 1989, the members of the Midwest Art History Society adopted the long-term project of publishing an ongoing scholarly inventory of drawings in midwestern collections as a way of translating the society's interest in publications into tangible form. The end result of this effort will be a number of volumes published occasionally over the years that will provide the international scholarly community with a single source for basic information and photographs of drawings in collections within the central states. Thus, the corpus is intended to be the society's collective legacy to scholarship.

In adopting this project, the members of the society owe instant acknowledgment to the important long-term inventories adopted by other professional societies in the United States. The International Center of Medieval Art project to catalog Romanesque sculpture in North America and the *Census of Fifteenth-Century Prints* published by the Print Council of America are two important models. Like them, the Midwest Art History Society's corpus is designed to make selected artworks in American collections more accessible for study within the greater scholarly community.

A great deal of basic work remains to be done in the study of drawings in midwestern collections. Many drawings are unpublished, and fundamental art historical questions about the meaning, authorship, and dating of scores of others are still unsettled. Thus, this project will provide a rich opportunity for an ongoing dialogue among scholars about published pieces and the opportunity for new contributions involving previously undiscovered drawings. Each of the entries in the corpus series is written by a scholar who has immediate access to the artwork itself and who is a specialist in the art historical period of the work under study. The format for each entry is designed to make basic information about each work easily accessible, with data on current opinions by other authors in a chronological arrangement. Each drawing is accompanied by a photograph and by the author's comments on its art historical significance and problems surrounding it.

The corpus is geographically limited by the admittedly nebulous concept of what exactly constitutes the Midwest. While membership in the society is open to all scholars, the regional home of most of its members and supporting institutions includes the twenty-two central states that lie between the Rocky Mountains and the Ohio River, reaching from the Gulf on the south to the Canadian border on the north. The corpus reflects this workable, if not argumentative, definition of the Midwest.

The thirty drawings that are cataloged in this first volume fall mainly within the fifteenth century, although several take us up to, and others beyond, the first years of the sixteenth century. In particular, the drawing in Cleveland by Bernardo Parentino (No. 15) and most of the Northern European sheets (Nos. 21–26, 28) probably date after 1500. The style of all of them fits so closely within the spirit of the fifteenth century that they were included in this volume of earlier works.

Several of the entries present changes in attributions. Among the Italian works in the Cleveland Museum of Art, the Altichiero School *Crucifixion* (No. 3) is attributed here to Bernardino Butinone and dated about a century later than previously published. The Circle of Stefano da Zevio's *Madonna and Child* (No. 1) is now assigned to Giovanni Badile; the *Horse and Rider* previously cited as School of Carpaccio (No. 2) is linked instead to the Circle of Jacopo Bellini; and Mantegna's *St. Christopher* (No. 12) is attributed to an early follower. On the other hand, two sheets listed as "School of"—the Benozzo Gozzoli sheet of studies (No. 5) and the Parri Spinelli *Navicella* (No. 20)—are returned to the masters to whom they were once attributed. Another drawing is placed in the Circle of Ghirlandaio: a funeral scene is given to the master himself (No. 4) instead of to Fra Filippo Lippi. *A Head of a Man* previously associated with Granacci (No. 8) is returned to its earlier attribution to Filippino Lippi.

Of the other drawings, one is a recent acquisition (No. 13), another carries a secondary study newly discovered on the verso (No. 11), and a third, from the School of Martin Schongauer in Grand Rapids (No. 29), has not been discussed in detail in any previous publication.

The small number of drawings in the group is consistent with the relative sparsity of fifteenth-century drawings in the holdings of American museums nationwide, certainly in comparison to the numbers of sixteenth- and seventeenth-century sheets. A full one-third of the drawings in this first volume of the corpus are located in the Cleveland Museum of Art, all the result of gifts from private donors between 1924 and 1968. With the five drawings in Cleveland from the ancient collection of the Moscardo family (Nos. 1, 3, 12, 15, 22), we are reminded of the continuing importance of that collection for the preservation of Renaissance drawings.

This volume on early Renaissance drawings complements a barrage of new information on the subject within the last decade. Some mention of the major trends in the literature on fifteenth-century drawings from about 1983 on will help place the volume in context. The crescendo of attention devoted to early drawings may be in part explained by the excitement generated by our ability to learn more about them technically. New discoveries made possible by infrared reflectography or studies of sinopia appear in publications by J. van Asperen de Boer (1984), Maryan W. Ainsworth and Molly Faries (1986), Maryan Ainsworth (1989, 1992), Roger van Schoute and Dominique Hollanders-Favart (1983), Roger van Schoute (1991), Dirk de Vos (1986), and Joann Woods-Marsden (1985–1986, 1987), among others. Closely related to the technical studies of drawings are theories on fifteenth-century workshop practices and methods of producing paintings based on drawings, presented in publications by Jean Cadogan (1983, 1984), Francis Ames-Lewis (1987), and Catheline Périer-d'Ieteren (1987).

Happily, there is a growing trend among major museums with significant holdings of drawings in the United States and in Europe to undertake catalogs of their collections. These publications include critical catalogs on holdings in the Getty Museum (Goldner, 1988 and 1992), the Detroit Institute of Arts (Logan, 1988), the Metropolitan Museum in New York (Forlani Tempesti, 1991), the Pierpont Morgan Library in New York (Stample, 1991), the Wallraf-Richartz-Museum in Cologne (Robels, 1983), the Prentenkabinet in Leyden (*Oude tekeningen van het Prentenkabinet der Rijksuniversiteit te Leiden. Dessins anciens du Cabinet des Dessins de*

l'Université de Leyde, 1985), the Uffizi in Florence (Angelini, 1986; Petrioli Tofani, 1991), and the Landesmuseum in Hannover (*Die italienischen und französischen Handzeichnungen im Kupferstichkabinett der Landesgalerie,* 1987). Other important publications on fifteenth-century drawings include major exhibition catalogs, monographs, and studies on single works. The exhibit on the Housebook Master in Amsterdam (*'sLevens Felheid: de Meester van het Amsterdamse Kabinet of de Hausbuch Meester, ca. 1470–1500,* 1985) and the Uffizi assembly of selected drawings during the era of Lorenzo de' Medici (Petrioli Tofani, 1992) are two notable examples of the visual power of images on paper.

Our understanding and aesthetic appreciation of fifteenth-century drawings have been aided as well through studies about major artists who figure prominently in the history of the medium, especially in Italy. Publications by Jurg Meyer zur Cappellen (1985), Colin Eisler (1989), Bernhard Degenhart (with Annegrit Schmitt, 1990) and Patricia Fortini (1992) document the art of Gentile and Jacopo Bellini. Ronald W. Lightbown (1986) and Jane Martineau (1992)

contribute to our knowledge of Andrea Mantegna. Studies during the last decade of single fifteenth-century works or drawings in related series focus predominately on Italian artists. A rich variety of such studies has reshaped our understanding of early Renaissance drawings by Ghirlandaio (Garzelli, 1985), Ercole de' Roberti (Manca, 1987), Cosimo Rosselli (Griswold, 1987), Luca Signorelli (Kanter, 1992), and Mantegna (Even, 1992; Bruder, 1992). Studies on drawings north of the Alps include articles on the St. Lucy Master (Roberts, 1984) and Conrad Witz (Röttgen, 1987). Finally, as we learn more about the provenance of drawings, we are becoming more cognizant of the importance of major patrons in providing the circumstances that allowed the survival of drawings in the first place (Brugerolles, 1984; Stock and Scrase, 1985; Marqués, 1985; Talley, 1990).

This volume is intended to contribute to the enthusiasm for drawings of the early Renaissance, just as the project itself is a product of the fascination its authors have for the objects themselves.

Italian Artists

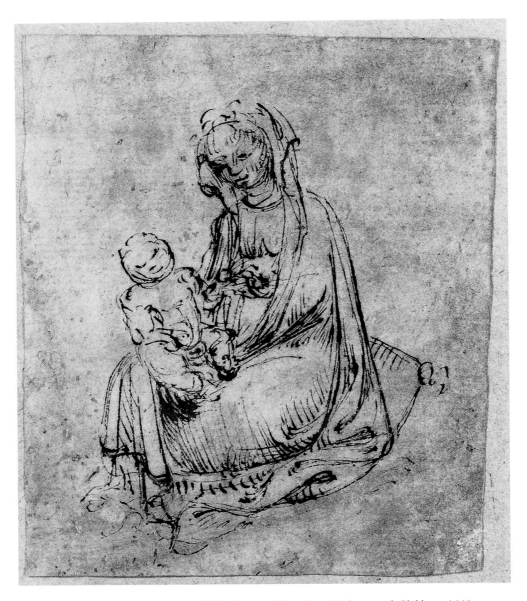

1. Giovanni Badile (active ca. 1409–1447), here attributed to, *Madonna and Child,* ca. 1440, Cleveland Museum of Art, purchase, Delia E. Holden Fund, 56.42. (Museum attribution: Anonymous, Italian, Veronese, ca. 1440–1450.) Reproduced larger than actual size.

1

Giovanni Badile (active ca. 1409–1447), here attributed to (formerly Anonymous, Italian, Veronese, ca. 1440–1450), *Madonna and Child,* ca. 1440, 107 x 91 mm (4 3/16 x 3 9/16 in.), pen and brown ink on tinted-pink laid paper, Cleveland Museum of Art, purchase, Delia E. Holden Fund, 56.42.

BIOGRAPHICAL NOTE: Giovanni Badile, from a Veronese family of several generations of artists, was active in the first half of the fifteenth century. He was a contemporary of Stefano da Zevio, also a native of Verona with an important workshop at mid-century, and active as a painter of frescoes and altar panels.

TECHNICAL CONDITION: Diagonal crease across the top; slight stains and abrasions along the left margin; uneven borders.

INSCRIPTIONS: None.

COLLECTORS' MARKS: None.

WATERMARKS: None observed.

PROVENANCE: Moscardo, Verona (Lugt supp. 2990c, 1171b); Marquis of Calceolari (under Lugt supp. 2990a); Francis Matthiesen, London.

EXHIBITIONS:
Cleveland Museum of Art, December 15, 1986–March 1, 1987, *Italian Drawings from the Permanent Collection* (as School of Verona).

BIBLIOGRAPHY:
Lugt supp. 422, no. 2990 b–h.
Bulletin of the Cleveland Museum of Art, 1958, 71 ill. (as Altichiero Altichieri).
Francis, 1958c, 201–2 ill. (as Anonymous, Italian, Veronese, 1440–1450).
"Acquisti di Musei Americani," 1959, 58 ill. (as circle of Stefano da Zevio).
"Gothic Art 1360–1440," 1963, 191, fig. 85; 213, no. 85 (as Verona, early fifteenth century).
Handbook of the Cleveland Museum of Art, 1966, 1969, 60 ill. (as Italy, Verona, 1440–1450).

COMMENTS:
This drawing is a compositional study for a Madonna of Humility type in which the Virgin humbles herself by sitting on the ground. The imagery seems to have originated in the circle of Simone Martini in Avignon in the 1340s[1] but continued to be popular in Italy into the fifteenth century. The depiction of the Virgin other than enthroned appeared during the so-called Babylonian Captivity from 1309 to 1376, when the Pope resided in Avignon instead of Rome, and reflected the wish for the papal throne to be returned to Rome.[2] The Madonna of Humility also appeared in a funerary context and was found most often on altars in convent churches.[3]

Several works of this type were painted by Stefano da Zevio in the 1440s, such as his *Madonna in a Rose Garden* in Worcester. In Stefano's *Madonna* in the Lanckoronski collection in Vienna, a pillow is evident at the right, the mother and infant are in an arrangement similar to that in the Cleveland sketch, and

1. Meiss, 1951, 132–56.
2. Kempers, 1987, 151.
3. Van Os, 1990, 76, 85.

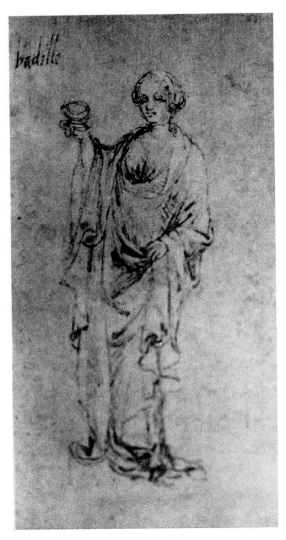

Fig. 1-A. Giovanni Badile, *Female Saint,* drawing, present location unknown (formerly, London, Sotheby's, October 21, 1963, no. 67).

is apt.[4] This subject was so popular in Verona in the 1440s that it seems reasonable to associate this drawing with Stefano's school.[5] Furthermore, the sheet has a provenance that places it in Verona in a sixteenth-century collection.[6]

Bernhard Degenhart and Annegrit Schmitt have identified a little-known family of artists active in Verona for eight generations from the fourteenth century into the sixteenth, the dynasty beginning with Antonio I Badile, who died before 1409.[7] They have characterized a corpus of fifteen drawings associated with Giovanni Badile, who was active in Verona ca. 1409–1447. These drawings match the Cleveland *Madonna and Child* in many

4. For reproductions of drawings attributed to Stefano da Verona, see van Marle, 1923–1938, 7:280–82 (figs. 182–84), 285 (fig. 186), 291 (fig. 191), 293 (fig. 192), and Shaw, 1983, 1:195–98, nos. 193–94, 3:pls. 218, 220–21.

5. Van Marle, 1929.

6. Curator's file, letter of June 28, 1957, from F. Matthiesen, Matthiesen Gallery, London, provides this information and adds that the album in which this sheet was mounted was taken apart in 1954, with other drawings entering the collections of the Albertina and of Frits Lugt. The inscription on the old blue paper cover identifying the collection was illegible except for the partial date "MCCCCC..." In a letter of January 9, 1956, Lugt gave the catalog title as *Note overo memorie del museo del Conte Lodovico Moscardo nobile Veronese* (Verona, 1672; *editio princeps,* 1656) and the description for the group of drawings in the collection as a general one: "In oltre vi sono più di 2000 fogli in libri trà Dissegni & Carte stampate de maggiori Pittori virtuosi del mondo."

Similar information on this album and the Moscardo provenance can be found in *Catalogue of Important Old Master Drawings,* 1963, 27, no. 64. See also *Old Master Drawings,* 1963, no. 62. For other drawings from the Moscardo album, see Nos. 3, 12, 14, 15, and 22 in this catalog. See also Francis, 1958b, 195, and, on the provenance, Shaw, 1:195–97, no. 4, 214, no. 1.

7. For biographical information on this family of artists, see Thieme and Becker, 1901–1956, 2:334–35; van Marle, 1923–1938, 7:312–28; and Shaw, 1:214.

the left hands of both touch. Such general similarities have led to the placement of the Cleveland drawing in the circle of Stefano da Zevio. Yet so few documented drawings exist for this artist that an attribution on stylistic grounds is difficult; those sheets associated with him do not compare well stylistically with the Cleveland *Madonna and Child,* but the context of Verona and Stefano's workshop

details of style. For example, a *Kiss of Judas* in Munich shares the ragged outlining, squashed oval heads, slitty eyes, and slashed mouths found in the Cleveland sketch.[8]

Like the Cleveland sheet, many of these are pen drawings, and some have the same provenance. *Presentation of Mary in the Temple* is in brown ink and associated with the Moscardo collection in Verona.[9] Here, too, the little figures' stylized faces, their abbreviated features resulting from studio conventions, and the crabbed hand dependent on a shorthand of lines to circumscribe forms relate the Cleveland drawing to this sheet and to the set associated with Stefano da Zevio's follower, Giovanni Badile. A *Female Saint* (Fig. 1-A) has comparable stylistic features, is an ink drawing on pink-tinted paper, and also has a Moscardo provenance.[10]

The same stylistic features appear in two paintings associated with Badile, a *Madonna* in Perugia and a *Polyptych* in Verona; especially similar are the oval head and flat face with dotted features in the Christ child of the latter's central panel.[11] This would date the drawing to about 1440, when Stefano was most active in Verona.

James Byam Shaw has identified a page of four drawings of a Virgin and Child seated on the ground and inscribed in north Italian dialect, "d M. o Zoane badille primo pictor."[12] Although not necessarily the artist's signature, it represents another bit of circumstantial evidence for grouping the drawings with Giovanni Badile. They can also be linked to the Cleveland *Madonna and Child* in terms of style and subject. On the basis of these observations, a reattribution of the Cleveland drawing to Giovanni Badile seems reasonable.

E. J. O.

8. Reproduced in Degenhart and Schmitt, 1966, 58–59, no. 26, Staatliche Graphische Sammlung, inv. 1963.261.

9. Degenhart and Schmitt, 1967, 50, no. 3.

10. This sheet is described in *Catalogue of Important Old Master Drawings,* 1963, 28, no. 67; for information on Badile and the Moscardo provenance see 27, no. 64, and 28, no. 67.

11. Reproductions of these works are in van Marle, 1923–1938, 7:324, fig. 217, and 322, fig. 215, respectively.

12. Shaw, 1:215, n. 7, nos. 213, 214.

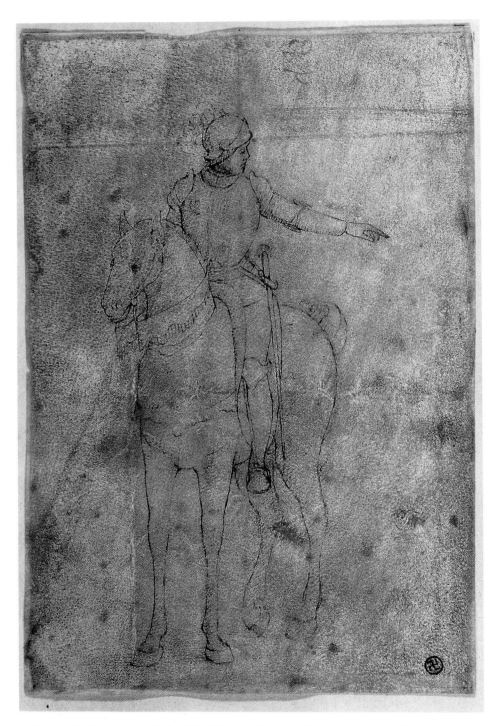

2. Jacopo Bellini (active 1423–1470), Circle of, here attributed to, *Armored Figure on Horseback,* ca. 1450, Cleveland Museum of Art, Dudley P. Allen Fund, 38.391. (Museum attribution: School of Vittore Carpaccio, Anonymous, Late XV Century School, Venetian.) Reproduced larger than actual size.

2

Jacopo Bellini (active 1423–1470), Circle
of, here attributed to (formerly Vittore
Carpaccio [ca. 1460–1526]), School of, late
fifteenth century), *Armored Figure on Horseback,*
ca. 1450, 145 x 95 mm (5 11/16 x 3 3/4 in.),
pen and brown ink on parchment, Cleveland
Museum of Art, Dudley P. Allen Fund, 38.391.

BIOGRAPHICAL NOTE: Jacopo Bellini was
first recorded as working in Florence with
the popular panel painter Gentile da
Fabriano. He was the father of the prominent
Venetian artists Gentile and Giovanni Bellini
and the father-in-law of the Paduan master
Andrea Mantegna. The few surviving paint-
ings attributed to Jacopo are small, conven-
tional Madonnas. He is better known for his
albums of drawings, now preserved in the
Louvre and the British Museum.[1] The faded
metalpoint drawings on parchment in the
Louvre album were later reinforced in ink by
Gentile, who inherited them. They contain
an extraordinary range of subjects with
experiments in foreshortening and explo-
rations of perspective.

TECHNICAL CONDITION: Horizontal crease
along the top; diagonal stain from the lower
left corner almost to the top center; some
abrasion; uneven borders.

INSCRIPTIONS: None.

COLLECTORS' MARKS: Lower right corner
(Lugt supp. 2917).

WATERMARKS: None observed.

PROVENANCE: Charles Molinier, Toulouse
(Lugt supp. 2917); Dr. Siegfried Bernfeld.

1. Golubew, 1908–1912; Eisler, 1989.

EXHIBITIONS:
Cleveland Museum of Art, December 15,
 1986–March 1, 1987, *Italian Drawings from
 the Permanent Collection* (as Anonymous
 North Italian).

BIBLIOGRAPHY: None.

COMMENTS:

This sheet once belonged to the late-nine-
teenth-century collector Charles Molinier
(1845–1910), who taught history of art at the
university in Toulouse. His brother, Emile, was
a curator at the Louvre. The American Indian
religious symbol of a swastika in a circle iden-
tifies the sheet with Molinier's collection.[2]

A horse and rider face the viewer's left in
three-quarter pose as the rider turns his head
in the opposite direction, pointing down with
his left arm and hand extended. He wears a
helmet with a raised visor and faint plume at
the top. A sword rests in its scabbard aligned
vertically on the knight's left hip.

The drawing has been variously described
as north Italian, Milanese, School of
Carpaccio, central Italian, and by Perugino.[3]
The style is not close to Perugino, although
the clear silhouette and simple pose may
explain this association. Its placement in north
Italy and, more to the point, Venice seems
more reasonable. The fifteenth-century north

2. Lugt supp. 2917. The medieval subject and the
use of parchment explain the popularity of this sheet
for a late-nineteenth-century collector, given the
interest at that time in the Pre-Raphaelites and in the
arts and crafts movements with their emphasis on old
materials such as vellum.

3. Curator's file, Cleveland Museum of Art.

Fig. 2-A. Jacopo Bellini, *Hermit Preaching,* drawing, Paris, Musée du Louvre, Département des Arts Graphiques.

Italian interest in animal studies is indicated in such naturalistic touches as the horse's relaxed hind hoof.

The drawing is here ascribed to the circle of Jacopo Bellini, whose manner of drafts-manship it matches more closely than that of Carpaccio. Carpaccio's drawing style is too fussy for this figure, often consisting of tiny, bunched strokes describing small forms or, in the case of single figure studies, a more fin-

ished style with a stronger interest in surface description. The unbroken outline of the Cleveland horse and rider and their curious proportions relate them to figures in Jacopo Bellini's album of drawings in the Louvre; like the Louvre drawings, the Cleveland study is also on parchment.[4] It can be dated to

4. Golubew, 1908–1912, 2:3 (unpaginated).

approximately the same time as the Louvre album, ca. 1450.

The horse in the Cleveland study is foreshortened and has thin, columnar legs with bulbous hooves and a small head set on a thick neck. The legs seem rubbery and the stance insecure: in these details the animal has a twin in Jacopo's Louvre drawing of *The Quick and the Dead*.[5] The rider in the Louvre composition holds a hunting falcon on his left wrist but also turns to his left. Another page in the Louvre album of a *Hermit Preaching* (Fig. 2-A) depicts a horse and rider posed frontally along the left border. The Cleveland study could have been used for a composition of St. Martin sharing his cloak with a beggar,

as depicted by Jacopo on a page in the British Museum album.[6]

The figures in Jacopo's albums seem more full-bodied than those in the Cleveland sheet, their morphology a bit more robust. Their parallel hatching for interior modeling, lacking in the Cleveland figures, may explain the difference in part, but the resulting timidity of definition in the Cleveland horse and rider relative to comparable figures in the Louvre album drawings leads to a more cautious attribution to the circle of Jacopo Bellini, possibly even the hand of the youthful Gentile.

E. J. O

5. Reproduced in ibid., 2:pl. B.

6. Reproduced in ibid., 1:pl. 44.

14

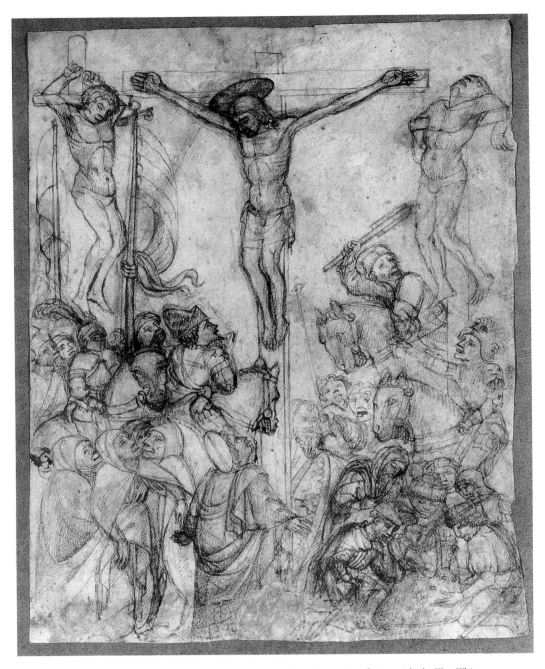

3. Bernardino Jacopi Butinone (1454–1507), here attributed to, *Crucifixion with the Two Thieves,* ca. 1485, Cleveland Museum of Art, purchase, Delia E. Holden Fund, L. E. Holden Fund, and John L. Severance Fund, 56.43. (Museum attribution: Altichiero Altichieri.)

3

Bernardino Jacopi Butinone (1454–1507), here attributed to (formerly Altichiero Altichieri [ca. 1330–1395]), *Crucifixion with the Two Thieves,* ca. 1485, 244 x 195 mm (9 5/8 x 7 11/16 in.), pen and brown ink over black chalk, Cleveland Museum of Art, purchase, Delia E. Holden Fund, L. E. Holden Fund, and John L. Severance Fund, 56.43.

BIOGRAPHICAL NOTE: Bernardino Butinone was born in Treviglio; he was active as a painter in Milan.[1]

TECHNICAL CONDITION: Stains along the bottom border and at the top center edge; ink blot along the left border; tiny hole at Christ's left hip; right edge cropped unevenly; repair at center of bottom border; diagonal crease and stain at upper left.

INSCRIPTIONS: None.

COLLECTORS' MARKS: None.

WATERMARKS: None observed.

PROVENANCE: Antonio II Badile, Verona (d. 1507); Moscardo, Verona (Lugt supp. 2990b–h, 1171b); Marquis of Calceolari (under Lugt supp. 2990a); Francis Matthiesen, London.

EXHIBITIONS:

Newark Museum, March 17–May 22, 1960, *Old Master Drawings,* no. 2 (as Altichiero Altichieri).

Baltimore, Walters Art Gallery, October 23– December 30, 1962, *The International Style,* no. 1 (as Circle of Altichiero).

1. W. von Seidlitz, "Butinone," in Thieme and Becker, 1901–1956, 5:300–302; Crowe and Cavalcaselle, 1912b, 2:349–54.

Cleveland Museum of Art, December 15, 1986–March 1, 1987, *Italian Drawings from the Permanent Collection* (as Altichiero).

BIBLIOGRAPHY:

(Attributed to Altichiero Altichieri, unless otherwise stated)

Bulletin of the Cleveland Museum of Art, 1958, 62 ill.

Francis, 1958d, 193 ill., 195–98 (as close to Altichiero Altichieri).

"Acquisti di Musei Americani," 1959, 58 ill. (attributed to Altichiero?).

Old Master Drawings, 1960, 12, no. 2 ill.

The International Style, 1962, 1, no. 1, pl. 37 (as Circle of Altichiero).

Moskowitz, ed., 1962, 1:no. 6 ill. (as Altichiero Altichieri?).

"Gothic Art 1360–1440," 1963, 182, fig. 84, 213, no. 84 (as close to Altichiero Altichieri).

Kruft, 1966, 186, n. 13.

Selected Works from the Cleveland Museum of Art, 1966, no. 114 ill.

Handbook of the Cleveland Museum of Art, 1966, 1969, 58 ill.

J. Scholz, 1967, 293.

M. W. Evans, 1969, 40, pl. 121.

Handbook of the Cleveland Museum of Art, 1991, 63.

COMMENTS:

This drawing was previously associated with the circle of Altichiero Altichieri (ca. 1330–1395), a native of Verona who had been active on fresco projects for chapels in Padua. The attribution is complicated by the paucity of comparative materials, but it is suggested here that the drawing may be a hundred years

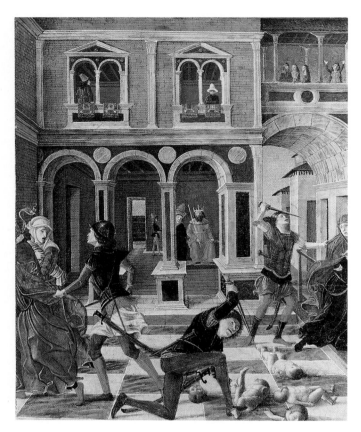

Fig. 3-A. Bernadine Butinone, *The Massacre of the Innocents,* tempera on panel, Detroit, Institute of Arts, Founders Society Purchase, Eleanor Clay Ford Fund, 64.81.

later and by the Lombard artist Bernardino Butinone (1454–1507).[2]

The artist's figure style in the Cleveland drawing is one of expressive faces with sharp features in large heads on stout bodies. There is variety in the treatment of horses, in the armored soldiers who are half medieval and half Roman in their costume, and in the intense concentration of the gambling soldiers in the lower right compared to the numbed grief of Christ's followers at the lower left. Clearly, the draftsman demonstrates a sound command of narrative. He also follows tradi-

tional iconography for the Crucifixion and a widely popular format.

The sheet has a compositional tightness, clarity, and sense of order more reminiscent of Italian art of the late fifteenth century than of the unfolding, boxlike spatial explorations found in Altichiero's frescoes. Too, Altichiero's figures as observed in his frescoes are consistently more Giottoesque in style than are those in the Cleveland drawing.

A number of paintings by Butinone display figures with large faces, with oversize, neckless heads on stocky bodies, and with flat, foreshortened, uplifted faces, such as his *Circumcision* in the Accademia Carrara in Bergamo.[3]

2. M. W. Evans (1969, 40) has suggested a northern source for this sheet: "The vigorous dramatic style of the drawing is close to northern art. It was probably done by a Tyrolean artist working in Padua."

3. Reproduced in Vergani, 1985, fig 6.

A *Crucifixion* panel in the Museum in Brno depicts a staring horse in a frontal view similar to the horse at the left of the Cleveland drawing, and there are likewise similarities in the gestures; fluttering pennants; the long, extended arms of Christ; and the slim, bikini loincloths of the thieves. Space in Butinone's *Crucifixion* panels is less congested than in the drawing, but that from his St. Martin polyptych of ca. 1485 in the Collegiata di San Martino in Treviglio was influenced by Mantegna's *Crucifixion* from the San Zeno altarpiece.[4] The drapery folds of the central figure at the foot of the cross in the Cleveland page are similar to those in a figure of the Magdalene in *Christ and the Magdalene* in the Chiesa della Maddalena at Camuzzago di Oruago. Butinone shares elements of style with Vincenzo Foppa and with his associate Bernardo Zenale.[5]

Drawings by Butinone are as rare as those by Altichiero, but the eccentricities of his style can be followed through his paintings, where one finds faces flattened in foreshortening, chiseled features, and disjointed necks, among other characteristics.[6] Butinone's use of

pointed nose, lips, and chin in profile faces can be seen on the mounted figure to the left of Christ in the Cleveland sheet as well as on the soldier left of center in the Detroit Institute of Arts panel painting of *The Massacre of the Innocents* (Fig. 3-A). Also, the formal motif of a raised arm bent at the elbow in concert with a head tilted back appears in the soldier at the right of the Detroit panel and in his counterpart of the cavalryman about to break the legs of the bad thief at the right of the Cleveland drawing.

The provenance of the sheet can be traced to an octavo album that was one of a set of volumes assembled in the sixteenth century, as indicated by a partially obliterated date on the cover, "MCCCCC..."[7]

E. J. O

4. Berenson, 1968, 3:109, pl. 1353.

5. Cook, 1903–1904; von Seidlitz, 1903, 31–36, 398.

6. For these elements, see the illustrations in Vergani, 1985, 33, fig. 6, and 37, fig. 9. A. Venturi

(1915, pt. 4, 864, 866) has characterized his paintings. Compare also Vincenzo Foppa's *Crucifixion* in A. Venturi, 1915, fig. 551. Venturi also illustrates two details of a *Crucifixion* drawing attributed to Ercole da Ferrara that match a number of features in the Cleveland sheet (1915, pt. 3, 679–80, figs. 505–6). A painting of a *Crucifixion* in the Berenson file is not identified by location, and a photograph in the Curator's file, labeled only "Altichiero," lacks the pair of thieves and has elongated figures, but both contain compositional similarities and details that correspond to the Cleveland *Crucifixion*.

7. For a discussion of the drawing's provenance, see No. 1, n. 6, above.

4. Domenico Bigardi del Ghirlandaio (1449–1494), here attributed to, *Study for the Death of St. Francis,* ca. 1483, Cleveland Museum of Art, purchase, John L. Severance Fund, 47.70. (Museum attribution: Fra Filippo Lippi, *The Funeral of St. Stephen.*)

4

Domenico Bigardi del Ghirlandaio (1449–1494), here attributed to, *Study for the Death of St. Francis,* ca. 1483 (formerly Fra Filippo Lippi [1406–1469], *The Funeral of St. Stephen,* third quarter of fifteenth century), 251 x 194 mm (9 7/8 x 7 5/8 in.), pen and brown ink with traces of black chalk, Cleveland Museum of Art, purchase, John L. Severance Fund, 47.70.

BIOGRAPHICAL NOTE: Ghirlandaio gave continuity to Florentine art, influenced in his early years by Filippo Lippi and serving in his maturity as the first teacher of Michelangelo. In 1477, he went to Rome with his brother, Davide, and a few years later he painted the fresco in the Sistine Chapel of the *Calling of Sts. Peter and Andrew.* In Florence, he painted the important fresco cycles of the *Life of St. Francis* in Santa Trinità for the Florentine banker Francesco Sassetti in 1483–1486, and episodes from the lives of the Virgin and of St. John the Baptist in Santa Maria Novella in 1485–1490. Ghirlandaio was a competent fresco painter and brilliant colorist. His paintings are characterized by accomplished architecture and exploration of space, as well as monumental forms, narrative directness, a strong still-life interest, and a high degree of descriptive naturalism. Recent studies of Ghirlandaio's drawings have shed much light on his working methods as a fresco painter.[1]

1. Cadogan, 1987; Cadogan, 1984; Cadogan, 1983; Ames-Lewis, 1981a; Cadogan, 1978, 212–16; Welliver, 1969.

TECHNICAL CONDITION: Two diagonal creases, upper left to center and lower right to center; two perforations, upper right corner; laid down on heavy paper.

INSCRIPTIONS: On verso in ink, "Pordonone fece."

COLLECTORS' MARKS: None.

WATERMARKS: None observed.

PROVENANCE: Giorgio Vasari, Florence and Rome; L. Rosenthal, Munich; Dr. F. A. Drey, Munich; Norman Colville, London; Paul Oswald, Locarno; Carl O. Schniewind, Zurich and Chicago; Dr. August Maria Klipstein, Bern; Richard H. Zinser, Long Island, New York.

EXHIBITIONS:

New York, Columbia University (M. Knoedler and Company), October 13–November 7, 1959, *Great Master Drawings of Seven Centuries,* no. 3.

Columbus Gallery of Fine Arts, October 27–November 27, 1961, *Renaissance Art* (published as *The Renaissance Image of Man and the World*).

Cleveland Museum of Art, July 13–September 19, 1971, *Florence and the Arts: Five Centuries of Patronage,* no. 51.

Cleveland Museum of Art, December 15, 1986–March 1, 1987, *Italian Drawings from the Permanent Collection* (as Filippino Lippi, *Study for the Funeral of St. Stephen in the Duomo at Prato*).

Cleveland Museum of Art, May 10–July 24, 1988, *Treasures on Paper* (as Domenico Ghirlandaio or his workshop, *The Funeral of St. Stephen in the Duomo at Prato*).

BIBLIOGRAPHY:

Francis, 1948, 15, ill. cover (as Domenico Ghirlandaio?).

Popham and Pouncey, 1950, 90, no. 149 (as Fra Filippo Lippi).

College Art Journal, 1951, frontispiece (as Ghirlandaio).

J. White, 1957, 186, pl. 47a (as Filippo Lippi).

"Drawings of Seven Centuries at Knoedler's, New York," 1959, 351, pl. 53 (as Fra Filippo Lippi).

M. T. G[laser], 1959, 5–6, no. 3, pl. 4 (as Fra Filippo Lippi).

"Disegni di grandi maestri di sei secoli alla Galleria Knoedler," 1959, 282 ill. (as Filippo Lippi).

Colnaghi's, 1760–1960, 1960, pl. 55 ill. (as Fra Filippo Lippi).

Pantheon, 1960, 54 ill., no. 1 (as Fra Filippo Lippi).

Berenson, 1961, 2:275–76, no. 1387 E-2 (as pupil of Filippo Lippi).

The Renaissance Image of Man and the World, 1961, no. 73, 21 ill. (as Filippo Lippi).

Pouncey, 1964, 286–87, pl. 35 (as Filippo Lippi).

Handbook of the Cleveland Museum of Art, 1966, 79 (as Fra Filippo Lippi).

Selected Works from the Cleveland Museum of Art, 1966, no. 117 ill. (as Fra Filippo Lippi).

Degenhart and Schmitt, 1968, 2:438, no 357, 4:pl. 301 (as Filippo Lippi).

Collobi, 1971, 18 ill. (as Filippo Lippi?).

Pillsbury, 1971, no. 51 ill. (ascribed to Fra Filippo).

Collobi, 1974, 1:60 (as Fra Filippo Lippi).

Borsook, 1975, 23–24, fig. 31 (as Filippo Lippi).

Marchini, 1975, 223, no. 185 ill. (as Filippo Lippi).

Handbook of the Cleveland Museum of Art, 1978, 90 ill. (as Fra Filippo Lippi).

Meder, 1978, 1:31, 426; 2:pl. 16 (as Fra Filippo Lippi).

Cadogan, 1978, 212–16 (Fra Filippo Lippi).

Borsook, 1980, 104, fig. 15 (as Filippo Lippi).

Cadogan, 1980, 17, 25–26, no. 13 (as Fra Filippo Lippi).

Ruda, 1982, 152–54, 164, nos. 33, 35, fig. 81 (as Ghirlandaio).

Miller, 1990, 158, fig. 15, 173–74, no. 33 (as Domenico Ghirlandaio).

Handbook of the Cleveland Museum of Art, 1991, 63 (as after Filippo Lippi, Workshop of Domenico Ghirlandaio).

COMMENTS:

Henry S. Francis reported that early owners of this drawing associated it with Ghirlandaio and called attention to its stylistic similarities with other sheets by the artist.[2] Francis's essay marked the beginning of a prolonged debate in the scholarly literature on the drawing's attribution. Two years later Arthur Popham and Philip Pouncey assigned the study to Fra Filippo Lippi on the basis of an association that they made with Lippi's fresco painting in Prato of the *Funeral of St. Stephen* of 1456 (Fig. 4-A).[3] The Cleveland drawing subsequently became identified in the literature with Lippi until 1961, when Bernard Berenson questioned this attribution. He did not reassign the drawing directly to Ghirlandaio but suggested it to be by a follower of Lippi.[4] Philip Pouncey once more stated the case for Lippi in his review of the catalog in which Berenson questioned Lippi's involvement.[5]

In 1968, Bernhard Degenhart and Annegrit Schmitt pointed out correctly that the Cleveland composition differs from the Prato fresco in many ways and concluded

2. Francis, 1948, 16.
3. Popham and Pouncey, 1950, 90, no. 149.
4. Berenson, 1961, 2:275–76, no. 1387 E-2.
5. Pouncey, 1964.

Fig. 4-A. Fra Filippo Lippi, *The Funeral of St. Stephen,* ca. 1456, fresco, Prato, Duomo.

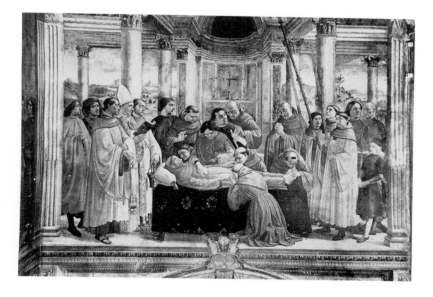

Fig. 4-B. Domenico Ghirlandaio, *Death of St. Francis,* ca. 1485, fresco, Florence, Santa Trinità, Sassetti Chapel.

that this was evidence that the drawing was one of Lippi's early studies for the fresco rather than a copy taken from it.[6] In her doctoral dissertation on Ghirlandaio's drawings, Jean Cadogan dismissed the sketch as

from the hand of Ghirlandaio and restated the Lippi connection.[7] More recently Jeffrey Ruda, in a dissertation on Filippo Lippi, argued persuasively that the sheet was not by Lippi but was clearly in the manner of

6. Degenhart and Schmitt, 1968, 2:438.

7. Cadogan, 1978, 212–16.

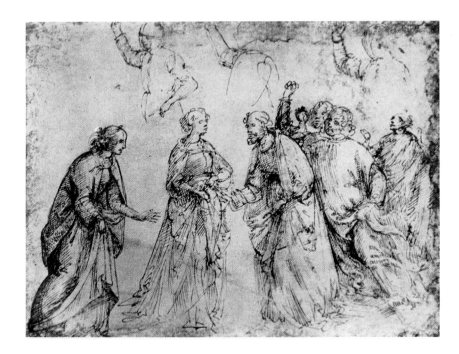

Fig. 4-C. Domenico Ghirlandaio, *The Marriage of the Virgin,* drawing, Florence, Uffizi.

Ghirlandaio.[8] Ruda saw it as identical in style to several drawings by Ghirlandaio, some of which Francis had previously recognized. He noted only a very general resemblance between the composition of the Cleveland drawing and that of Lippi's Prato fresco, although he also observed that the drawing depended on Lippi's works for some of its figures. Thus, Ruda confirmed the observation of Degenhart and Schmitt that the drawing's composition was little like that of the Prato fresco but concluded, instead, that it was not to be associated with Lippi.

In Lippi's *Funeral of St. Stephen* no priest appears at the altar as in the Cleveland drawing, the church nave has a coffered ceiling rather than groin vaulting, and women are seated at the corners of the bier where none

appears in the drawing. The number and arrangement of the figures are not the same in the fresco and the drawing.

In 1483–1486, Ghirlandaio painted his masterful fresco series for the Sassetti Chapel in Santa Trinità, Florence, depicting the *Death of St. Francis* (Fig. 4-B). It is suggested here that the Cleveland drawing was an early study for the left half of this composition, something at which Francis had hinted.[9] Although some of the same objections can be raised in comparing the drawing with Ghirlandaio's *Death of St. Francis* fresco as in comparing it with Lippi's Prato fresco—groin vaulting in the drawing is replaced by the classical orders in the fresco, and there are no figures at the altar—in the drawing as in the Ghirlandaio fresco an acolyte holding a censer and a cleric holding a book are prominent, and the deceased is given a tonsure. Also, it has been shown that Ghirlandaio frequently completed

8. Ruda, 1982, 152–54, 164, nos. 33, 35. The sheet has been published more recently (Miller, 1990) as *The Funeral of St. Stephen after Fra Filippo Lippi,* by Ghirlandaio, but without discussion.

9. Francis, 1948, 17.

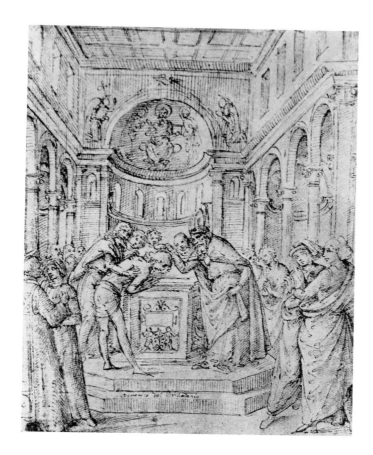

Fig. 4-D. Domenico Ghirlandaio, *Confirmation of Franciscan Rule,* drawing, Berlin-Dahlem, Kupferstichkabinett, 4519.

his compositions in the process of painting his frescoes, filling in figures as he worked.[10]

The best argument for attributing the drawing to Ghirlandaio lies, however, in its stylistic affinities with other sheets by the artist. The single shared characteristic in these works is the broadly spaced parallel hatching, especially as used in details of architecture. Too, the looser hatching in modeling drapery—especially the tendency to use parallel lines for shading drapery folds—with the occasional passages of fluttering garments and expressive gestures further identifies these sheets as by Ghirlandaio's hand.[11] There are

also the conventions of circles for eyes and ink slashes for mouth and nose. These elements appear in two drawings for which the attribution to Ghirlandaio, as Ruda has pointed out, has never been questioned: his Uffizi study for *The Marriage of the Virgin* in Santa Maria Novella (Fig. 4-C) and his study for the Santa Trinità *Confirmation of Franciscan Rule* (Fig. 4-D). Similar comparisons can be

10. Welliver, 1969.

11. The fluttering drapery is a late-fifteenth-century detail inspired by the poetry of Ovid that fur-

ther argues against an attribution to Filippo Lippi. Even the most animated of Lippi's figures, such as Salome in the Prato fresco of *The Feast of Herod,* appear relatively tame when details such as rippling garment folds are compared. For a discussion of the emergence of interest in movement and animation in the visual arts in the 1470s and 1480s as evidenced in the paintings of Botticelli, see Gombrich, 1970, 57–66.

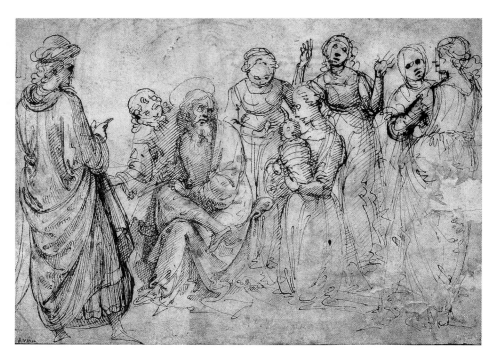

Fig. 4-E. Domenico Ghirlandaio, *Naming of St. John the Baptist,* drawing, London, British Museum, 1895-9-15-452.

made with other drawings by Ghirlandaio, many of which Francis and Ruda have already noted: for example, the British Museum's sheet of *Naming of St. John the Baptist* (Fig. 4-E).[12] Consequently, the Cleveland drawing can be associated with the Sassetti Chapel project and dated to ca. 1483.

Both Francis and Ruda have referred to figures in the drawing as borrowings from Lippi's Prato frescoes, so that the association of the sheet with Lippi is not to be abandoned entirely, but Lippi's art served Ghirlandaio only as a frame of reference. The physical placement of Lippi's Prato fresco above eye level on the chapel's left wall gives a strong perspective rush to the architecture at the left of the funeral scene, lending greater prominence to the group of figures there.[13] Given Lippi's illusionistic trick, it is easy to see how the composition impressed Ghirlandaio, but in the end he found it less useful because the Sassetti Chapel funeral scene was placed on the right wall.[14]

In addition, it may be shortsighted to credit Lippi as Ghirlandaio's only influence. The ghosts of individual compositional elements from the art of Masaccio, specifically his *Sagra* fresco in the Carmine, can be seen in the Cleveland sheet. The fresco was destroyed at

12. Note the following pen drawings: *Visitation,* Uffizi (291 E); *Saint Appearing to a Congregation,* Gabinetto Nazionale delle Stampe, Rome (FC 130495r); British Museum, *Birth of the Virgin* (1866-7-14-9) and *Naming of St. John* (1895-9-15-452), Francis, 1948; Ruda, 1982, 184.

13. Compare photographs of the *Funeral of St. Stephen* in Borsook, 1975, 19:21, fig. 26, and 23, fig. 30. The adjoining fresco scene of the *Lapidation of St. Stephen* also crowds the group at the right.

14. There is also Ghirlandaio's habit of designing his large fresco compositions as two uncoordinated parts (Gilbert, 1969, 268).

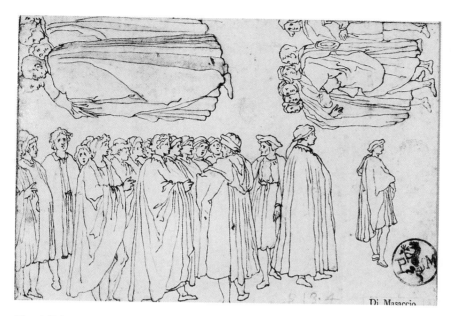

Fig. 4-F. Anonymous sixteenth-century artist, copy after Masaccio's *Sagra* fresco (now lost), Folkestone, Museum, Grace Hill.

the end of the sixteenth century, but it survives in the form of a copy (Fig. 4-F).[15] E. Borsook and J. Offerhaus have noted Ghirlandaio's borrowings from this work of 1423, and comparisons can also be drawn between individuals in Masaccio's lost *Sagra* composition and Lippi's monolithic forms.[16]

The figure with the slightly raised right hand at the far left of Ghirlandaio's drawing has its counterpart at the far left of Masaccio's composition. Continuing from left to right, note Ghirlandaio's acolyte with a censer in the foreground and the similarly placed figure

in Masaccio's grouping. Finally, the central figure engulfed in drapery and holding a book was taken from another of Masaccio's monumental forms right of center.[17]

Ghirlandaio has filled in the fresco composition with more figures than are found in the Cleveland drawing, but it has been shown that this was typical of his approach to fresco painting.[18] He usually worked out full compositions in red chalk (sinopia) drawings on the *arriccio,* or underlayer of plaster, adding figures as space allowed and his subject required, but using a compositional study on paper as a point of departure.

E. J. O.

15. The Cleveland drawing was not associated with Ghirlandaio's fresco or Masaccio's *Sagra* composition in Borsook's Sassetti Chapel study. Borsook (1975) discussed the sheet, but she did not relate Lippi's fresco to Masaccio's *Sagra* composition.

16. For example, the man at the far left of Lippi's *Funeral of St. Stephen* is a mirror image of the central figure in the copy of Masaccio's lost work. They share the characteristic turn of the head against the raised shoulder.

17. Chiarini (1962) noted that a group of figures in the Sassetti Chapel fresco of *St. Francis Resuscitating the Spini Child* is identical to the cluster of figures in the upper right corner of the *Sagra* sheet.

18. Cadogan, 1987.

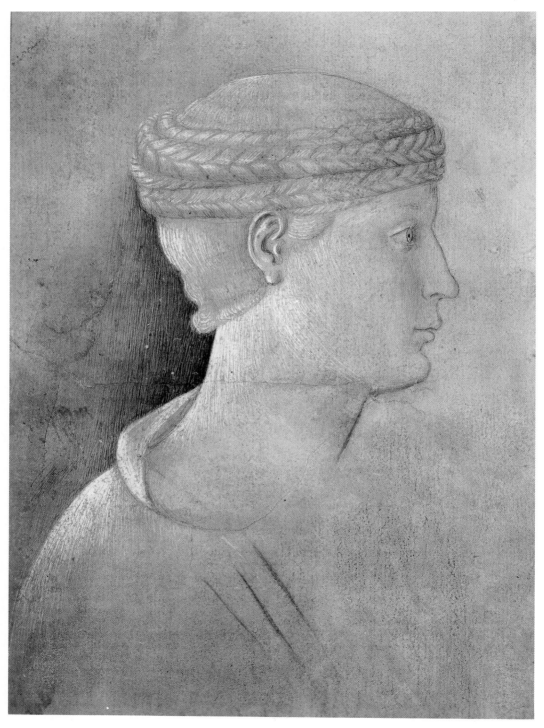

5 recto. Benozzo Gozzoli (Benozzo di Lese di Sandro, 1421–1497), here attributed to, *Page from a Sketchbook: Bust of a Woman,* ca. 1458, Cleveland Museum of Art, purchase, J. H. Wade Fund, 37.24. (Museum attribution: Circle of Benozzo Gozzoli.) Reproduced actual size.

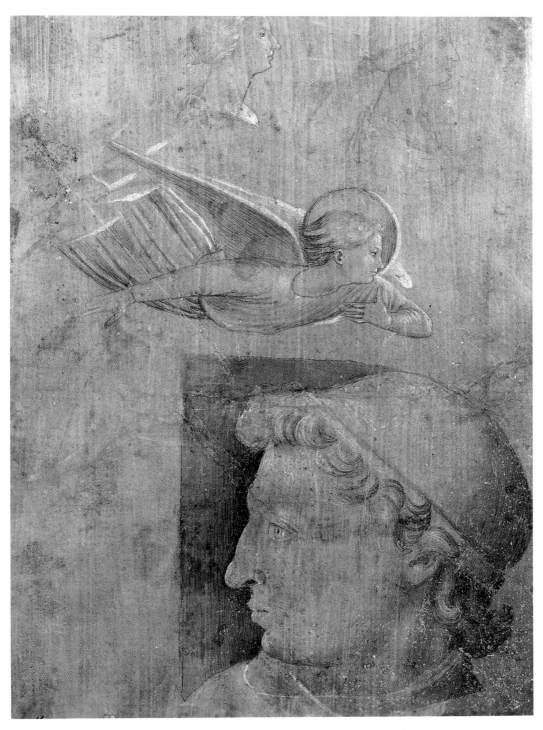

5 verso. Benozzo Gozzoli (Benozzo di Lese di Sandro, 1421–1497), here attributed to, *Head of a Man, Two Studies of a Woman's Profile, and a Study of an Angel,* ca. 1458, Cleveland Museum of Art, purchase, J. H. Wade Fund, 37.24. (Museum attribution: Circle of Benozzo Gozzoli.) Reproduced actual size.

5

Benozzo Gozzoli (Benozzo di Lese di Sandro, 1421–1497), here attributed to (formerly Circle of), *Page from a Sketchbook: Bust of a Woman* (recto) and *Head of a Man, Two Studies of a Woman's Profile, and a Study of an Angel* (verso), ca. 1458, 194 x 143 mm (7 5/8 x 5 5/8 in.), metalpoint heightened with white gouache on prepared rose paper, Cleveland Museum of Art, purchase, J. H. Wade Fund, 37.24.

BIOGRAPHICAL NOTE: A native of Florence, Gozzoli is recorded as helping Lorenzo Ghiberti with the latter's second set of bronze doors for the Florentine Baptistry ca. 1444–1447. He assisted Fra Angelico with his Vatican frescoes for Pope Nicholas V and accompanied the artist to Orvieto at the end of the decade. Gozzoli worked independently in Umbria after midcentury. His masterpiece was the Medici Chapel fresco project for Piero de' Medici. In the 1460s his work took him to San Gimignano, then to the Campo Santo in Pisa, where he was active until 1485.

TECHNICAL CONDITION: Horizontal crease across the center of recto from left border to middle right; slightly worn and faded.

INSCRIPTIONS: In brown ink at lower left corner of verso, "48."

COLLECTORS' MARKS: Collector's stamp "K E H" at lower left corner of verso (Lugt 860–61).

WATERMARKS: None observed.

PROVENANCE: Jacopo Durazzo, Genoa; Karl Ewald Hasse (Lugt 860); Thomas Agnew and Sons, London, 1937.

EXHIBITIONS:

Stuttgart, Staatsgalerie, 1872, *Katalog der kost-baren und altberümten Kupferstich-Sammlung des Marchese Jacopo Durazzo in Genoa,* no. 3914 (as Buffalmacco).

Leipzig, C. G. Boerner, May 9–10, 1930, *Handzeichnungen des XV bis XVIII Jahrhunderts.*

Cleveland Museum of Art, June 26–October 4, 1936, *The 20th Anniversary Exhibition,* no. 129.

London, Thomas Agnew and Sons, 1937.

Detroit Institute of Arts, April 5–May 8, 1960, *Master Drawings of the Italian Renaissance,* no. 3.

Cleveland Museum of Art, July 13–September 19, 1971, *Florence and the Arts: Five Centuries of Patronage,* no. 52a, b.

Bloomington, Indiana University Art Museum, October 6–December 18, 1983, *Italian Portrait Drawings, 1400–1800, from North American Collections,* no. 1.

Cleveland Museum of Art, December 15, 1986–March 1, 1987, *Italian Drawings from the Permanent Collection* (as School of Benozzo Gozzoli).

Cleveland Museum of Art, May 10–July 24, 1988, *Treasures on Paper* (as School of Benozzo Gozzoli).

Cleveland Museum of Art, June 7–September 8, 1991, *Object Lessons: Cleveland Creates an Art Museum* (as School of Benozzo Gozzoli).

Cleveland Museum of Art, November 5, 1991–January 12, 1992, *Artists' Working Books* (as School of Benozzo Gozzoli).

BIBLIOGRAPHY:

Katalog der kostbaren und altberümten Kupferstich-Sammlung des Marchese Jacopo

Durazzo in Genoa, 1872, 357, no. 3914 (as B. Buffalmacco).

Boerner, 1930, 32, no. 167, ill. frontispiece (recto) (as Gozzoli).

Francis, 1936, 56–57, no. 129 (as Benozzo Gozzoli).

Francis, 1937a, 123–25 (as Circle of Gozzoli).

Francis, 1937b, 12, 21 (as School of Benozzo Gozzoli).

Wunderlich, 1937, 318–21 (as Circle of Gozzoli).

Rubinstein, 1938, 62 (as Florentine School, fifteenth century).

Berenson, 1938, 2:54, nos. 558B, C (as School of Gozzoli).

Master Drawings of the Italian Renaissance, 1960, 11, no. 3, verso ill. 26, fig. 3 (as Circle of Benozzo Gozzoli).

Berenson, 1961, 2:98–99, no. 547b (as School of Gozzoli).

Handbook of the Cleveland Museum of Art, 1966, 78 ill. (verso) (as Circle of Benozzo Gozzoli).

Selected Works from the Cleveland Museum of Art, 1966, no. 115 ill. (as Circle of Benozzo Gozzoli).

Agnew's: 1817–1967, 1967, 216 ill. (as Benozzo Gozzoli).

Degenhart and Schmitt, 1968, 2:484–85, no. 451; 4:331c, d (as Gozzoli workshop).

Kleine Museumsreise durch Amerika, 1969, 50, 51 ill. verso (as workshop of Benozzo Gozzoli).

Pillsbury, 1971, no. 52 ill. (Circle of Benozzo Gozzoli).

Handbook of the Cleveland Museum of Art, 1978, 90 ill. (verso) (Circle of Gozzoli).

Gealt, 1983, 14–16, no. 1; 15, 17 ill. (as Shop of Benozzo Gozzoli).

Handbook of the Cleveland Museum of Art, 1991, 67 (verso) (as workshop of Benozzo Gozzoli).

COMMENTS:

The recto of this page depicts a finely drawn female head in right profile. Although provided with a caplike triple ring of braids, the face has an androgynous quality as if a shop assistant served as the model; it has also been somewhat idealized. Added to the middle tone of the paper are white highlights in thin, linear strokes on the top and back of the head and at the neck, collar, and shoulder.

The verso contains a male head in left profile more convincing in its naturalism than the recto figure. An angel in flight and a pair of nearly identical female heads are drawn in right profile along the top border. The heads are portraitlike in the treatment of the bridge of the nose and of the weak chin with its incipient second chin and match the profile of the angel in flight. The male head, angel, and one female head are highlighted in identical fine touches of white. In ink at the lower left corner is written "48."

This sheet appears to be associated with an artist's sketchbook of at least eighty-five pages from which thirty-nine survive.[1] Bernhard Degenhart and Annegrit Schmitt have found evidence that the original book was bound as a sketchbook before the drawings were made rather than consisting of loose sheets later assembled by a collector. One folio, numbered 35, is a violet-tinted page that shows on the verso a green strip not covered by the tint because presumably protected by the binding; the following page (36 recto) has a green strip along the border where overlap occurred as the preceding page was being prepared.[2]

1. The Rotterdam shopbook has been studied by Salmi, 1930; Popham, 1930; Scheller, 1963, no. 30; and Degenhart and Schmitt, 1968, 2:478–90. For an idea of the Rotterdam shopbook's place in the tradition of the model book, see Jenni, 1987.

2. Degenhart and Schmitt, 1968, 2:464–65, no. 408, 4:pl. 317e–f. For 36 recto in Stockholm, see 2:483, no. 444. An infrared reflectography study of this sheet might be informative, as some metalpoint drawings on prepared paper have been shown to cover black chalk drawings of slightly varied compositions. See Pagden, 1987, 99–100.

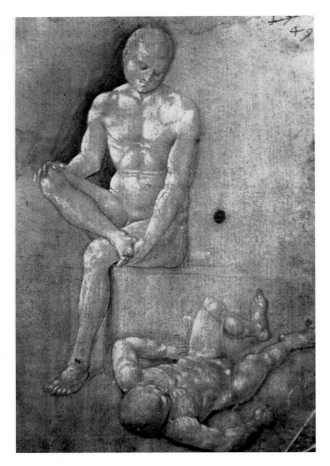

Fig. 5-A. Workshop of Benozzo Gozzoli, *Sheet with Seated and Reclining Figures,* drawing, Rotterdam, Boymans–van Beuningen Museum, I 561, fols. 9B–10.

Twenty of the sheets are now in Rotterdam. Written on one of the Rotterdam folios is "60," and "carte 85" is inscribed in an identical hand on what functions as the volume's title page. Nineteen other similar drawings are known, of which nine are numbered.[3] The ten unnumbered pages may have been cropped or were never part of the sketchbook.[4]

The bound folios had been paginated at different times in the lower left and upper right corners of the same page, the numbers now aiding in the identification of sheets in various collections and allowing for a partial reconstruction of the artist's sketchbook.[5] The sheets were already being disassembled in the sixteenth century, as Giorgio Vasari had three drawings in his collection with similar page markings.[6]

The pagination at the bottom is consistently two numbers higher than that at the upper right. This would suggest that the original sketchbook was cut down over the years as pages were removed for sale and that those remaining were numbered anew. The older pagination, therefore, would be that at the lower left. A *Sheet with Seated and Reclining Figures* in Rotterdam (Fig. 5-A) has "49" in the upper right corner, above which is "57" (or "51") crossed out, implying that two or more sheets had been removed and the remainder renumbered. Similarly, another Rotterdam sheet has a "56" crossed out above a "44" at the top right and "46" at the lower left, implying that ten sheets had been removed before renumbering at the bottom left.[7]

3. Degenhart and Schmitt (1968, 2:478 and passim) report locations for all the sheets.

4. One, a folio in Rome, is of the same size as the Rotterdam sheets (2:466, no. 410).

5. Popham (1930) has identified the pagination of the sheets in the Rotterdam shopbook with the rectos. This system is inverted in the labeling of the Cleveland drawing, where the numbered side is considered the verso, although a previous collector had apparently considered it to be the recto, because he placed his mark on that side. Curiously, twenty years later Popham (Popham and Pouncey, 1950, 52, no. 87, and 54, no. 91) called the numbered side of a Gozzoli drawing in the British Museum the verso, yet referred to a Gozzoli school sheet as numbered on the recto.

6. See also Degenhart and Schmitt, 1968, 2:478.

7. A good reproduction appears in Ames-Lewis,

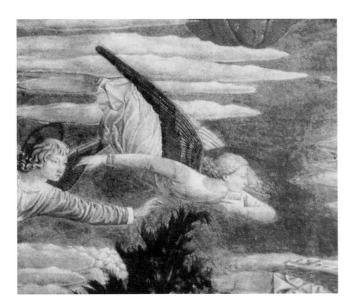

Fig. 5-B. Benozzo Gozzoli, detail of *Angel* from the *Angel Choir,* fresco, Florence, Medici-Riccardi Palace, Chapel.

As collated by Arthur Popham, the Rotterdam pages lack a number 48, and that numbered 49 is on tinted paper,[8] a striking coincidence suggesting that the Cleveland drawing, numbered 48, was once part of the original sketchbook. Also, the Cleveland folio's 48 matches the numbers on the other sheets in script and color of ink.

The Cleveland drawing's lack of a second number at the upper right suggests the sheet may have been cropped at some time, an observation reinforced by its smaller dimensions relative to the other numbered drawings, namely 19.4 x 14.3 cm against the usual 22.9 x 16 cm, and by the missing tops of the female heads. All of the pages must have been cropped at least partly when removed from the bound book, as there is no evidence of binding on any sheet. Consequently, it is not possible physically to distinguish recto from verso in terms of a sheet's original placement in the sketchbook. Neither is there any evidence that one side was used for finished drawings and the other for practice exercises.

Popham associated figures in the shopbook with Gozzoli fresco projects between 1447 and 1474, whereas Degenhart and Schmitt identified a watermark on some folios that places them in the period 1452–1469.[9] If the drawings related to these projects followed the numbering of the pages in chronological sequence, this would argue that the book was used by Gozzoli to compose studies for his projects rather than as a collection of later studio copies, but the surviving data suggest otherwise. The Cleveland drawing, numbered 48, is associated with Gozzoli's fresco project of 1455–1458, that in Rotterdam numbered 51 is related to his work of 1474 in the Camposanto in Pisa,[10] whereas a drawing in London, numbered 56, is connected with his San Francesco project of 1450–1452 in Montefalco.[11]

9. Popham, 1930, 57; Degenhart and Schmitt, 1968, 2:479. Because this watermark (Briquet, 1923, 6654–55) was used in Rome, Perugia, and Pisa, Gozzoli could have assembled his sketchbook after he had joined Fra Angelico in Rome in 1447 or on his journey into Umbria (Montefalco) in 1450. The location of the watermark in Tuscany would not rule out the possibility that Gozzoli began his sketchbook while in Ghiberti's workshop, ca. 1445, given the broad range of watermark dates.

10. Degenhart and Schmidt, 1968, 2:485, no. 452.

11. Ibid., 2:465–66, no. 409, and 4:pl. 318a–b. A

1981b, 81, fig. 56. The drawing has recently been published by Luijten and Meij, 1990, 149–50, no. 54. See also Popham, 1930, 54, fol. 11, and Degenhart and Schmitt, 1968, 2:484, no. 449.

8. Popham, 1930, 54, fol. 10.

Fig. 5-C. Benozzo Gozzoli, detail of *Angel* from the *Assumption of the Virgin,* fresco, Castelfranco.

The two profiles of a woman at the top verso of the Cleveland drawing used for the angel in flight correspond with a female profile on another page of the Rotterdam sketchbook, suggesting the same hand.[12] The profiles of the faces match others in various works by Gozzoli. The finely drawn silhouette of a young woman on the recto with her distinctive hairstyle is close to other figures in frescoes, a panel painting, and a drawing by Gozzoli.

The verso's flying angel has a counterpart in Gozzoli's *Angel Choir* fresco in the Medici Chapel of Michelozzo's palace in Florence (Fig. 5-B), but the halo of the angel in the drawing, unlike that in Gozzoli's fresco, is not foreshortened. Degenhart and Schmitt have pointed out that the drawn figure has static, tubular drapery folds and a planar halo, unlike the fresco figure, which has fluttering garments and a foreshortened halo. They have concluded that because the Cleveland angel does not match its counterpart in the fresco, the drawn figure must be a copy.[13] Clearly, the draftsman was more concerned with describing the angel's drapery at the risk of ignoring its appearance in flight, although the fluted garment folds do curve to follow the downward plunge of the angel. The flat halo denies

second page in Venice (2:489, no. 468), also related to the Pisa project, unfortunately lacks pagination. Another folio in Berlin can be associated with the Chapel of Pope Nicholas V of 1448–1450, but it too is unpaginated (2:488, no. 464), as is the sheet in Stockholm connected with Gozzoli's San Francesco project in Montefalco (2:489, no. 467).

12. Reproduced in ibid., 2:482–83, no. 442, and 4:pl. 392b. See also, 2:484–85, no. 451.

13. Ibid., 485, no. 451.

three-dimensional space. Yet the painted angel is an anomaly in failing to conform with the other fresco figures, which are consistent in their rigidly fluted drapery and planar halos.

The angels on the ground in Gozzoli's fresco face the viewer, and their drapery falls in tangible folds. More likely, the Cleveland drawing represents Gozzoli's study for the angel in the fresco, which was then painted by a younger, more forward-looking studio hand whose enhanced sense of naturalism caused him to foreshorten the halo and energize the draperies. This is probably the same assistant who painted the angel in the Castelfranco *Assumption of the Virgin* (Fig. 5-C) who holds the hem of the Virgin's garment at her right foot; that angel also has a foreshortened halo and draperies that are askew rather than tubular.

Only a single foreshortened halo appears in the Rotterdam sketchbook or in other drawings by Gozzoli. In his Brera panel of *St. Dominic Reviving a Child Killed by a Horse,* Gozzoli depicts St. Dominic with a flat halo and columnar drapery, something he derived from Fra Angelico. The concave disc of the Cleveland angel's halo is like that on Gozzoli's figure of St. John the Evangelist in a drawing in Paris.[14] Similarly, in his San Francesco project of 1450–1452 at Montefalco, Gozzoli shows no hint of interest in foreshortening halos. Even as late as Castelfiorentino, in 1484–1490, he rarely foreshortens halos, with the exception of Gabriel and Mary, who face each other in the prominently displayed *Annunciation.* St. Dominic also has features similar to those of St. John the Evangelist in the previously mentioned drawing in Paris.

Johannes Meder first identified the Cleveland page with Benozzo Gozzoli in 1907 after it had been associated with

Buonamico Buffalmacco.[15] In 1930, Arthur Popham interpreted the Rotterdam shopbook as by one draftsman, as did Kenneth Clark, but Mario Salmi observed different hands,[16] an opinion that Bernard Berenson shared some years after.[17] Popham later agreed that it was curious for an artist to so copy and repeat himself.[18] Degenhart and Schmitt have commented on noticeable individual nuances throughout the pages, which suggest the involvement of different hands, but have also acknowledged the impossibility of identifying the hands.[19]

Adelheid Gealt has observed that apprentices in the Renaissance workshop copied as part of their early training. She contends that all parts of the Cleveland sheet, except the man's head on the verso, which she believes was drawn from life, are copies of Gozzoli's works.[20] Gealt evaluates the verso head of a man as the best drawing on the Cleveland sheet and holds the page to be "among the finest of the entire shop book." She dates the sketchbook after 1474, the date of Gozzoli's Pisa cycle, because she interprets the pages related to the fresco as copies from it and not studies for it. In the case of the Cleveland page, Gealt also sees it as a copy after the Medici Chapel fresco. Because she accepts

14. Ibid., 2:468–69, no. 415, 4:pl. 320a.

15. Boerner, 1930, no. 167.

16. Popham, 1930; Clark, 1930; Salmi, 1930.

17. Berenson, 1938, 2:54.

18. Popham first modified his view in a private communication: Curator's file, Cleveland Museum of Art, letter of August 26, 1937, from A. S. Popham to Henry S. Francis; "M. Salmi . . . holds that the drawings in the Sketch Book are by different hands. It is certainly curious that an artist should copy and repeat himself as in the case in the 'Sketch Book' and of which the small head in your drawing is an example." Popham and Pouncey (1950, 52, no. 87) note with reference to Gozzoli sheets in the British Museum collection that several hands can be detected.

19. Degenhart and Schmitt, 1968, 2:478.

20. Gealt, 1983, 14–16.

Popham's early observation that all the draw-ings are by the same hand, she concludes that they were drawn at the same time and, there-fore, had to be made from drawings rather than from the widely scattered frescoes with which they are associated.[21] But as we have seen, this view has been contradicted inde-pendently by Salmi, by Berenson, and by Degenhart and Schmitt, and later even modi-fied by Popham himself.[22]

Lack of uniformity of quality in a corpus of drawings is often the mark of a second-line draftsman, such as Lorenzo di Credi, Filippino Lippi, or Gozzoli. The lack of even-ness is a consistent mark for such artists. The quality of the drawings on the Cleveland sheet falls within the range of Gozzoli's draftsmanship and is generally high, from which it can be concluded that the page is an exclusive Gozzoli autograph.[23] The number of metalpoint drawings in American collec-tions from this period is small, adding to the sheet's rarity.[24]

E. J. O.

21. Scheller (1963) observes that a pair of oxen had been copied from a Pisanello drawing in the Louvre (184, 210, n. 5), but he also notes that the drawing of a camel was executed from the fresco because the creature's legs are a conflation of those of two camels in the painting (207, f. 14v). No one has suggested that Gozzoli may have assembled the sketchbook during his years in Ghiberti's workshop only to make reference to it through the ensuing decades as he took on various fresco projects. This would explain why the drawings cannot be related to Gozzoli's fresco projects in a chronological sequence.

22. Gealt, 1983, 16.

23. See Scheller, 1963, 211, n. 8; Popham and Pouncey (1950, 53, no. 89) accept Berenson's claim that the British Museum drawing of *Two Young Men* (1895-9-15-444) is by Gozzoli.

24. Mongan, 1987, 151.

Filippino Lippi

The artistic education of Filippino Lippi (1457–1504) began in the workshop of his father, Filippo Lippi.[1] After the elder Lippi died in 1469, Filippino entered Botticelli's studio, where he remained for ten years. He completed Masaccio's fresco paintings in the Brancacci Chapel in 1484 and then was in Rome for the Carafa Chapel commission in Santa Maria sopra Minerva. On his return to Florence in 1487, he embarked on his splendid frescoes in the Strozzi chapel of Santa Maria Novella.

Filippino's palette of pure, saturated colors reflected Florentine taste in the last two decades of the fifteenth century. The influence of his visit to Rome is evident in decorative details of his late works, such as urns, masks, lamps, and fanciful tendrils, reflecting recent discoveries in the Golden House of Nero.[2] Filippino's *Vision of St. Bernard* (Fig. 10-A) of ca. 1486 in the Church of the Badia summarizes late Tuscan characteristics and is one of his masterworks.

The large number of drawings attributed to Filippino Lippi attests to his prolific output. Many of the drawings associated with his name, however, have been given to him without clear agreement in the literature. Perhaps more so than any other late-fifteenth-century Florentine artist, Lippi has become something of a convenient label to attach to drawings of high quality but uncertain authorship from the late Tuscan Quattrocento. The six drawings in midwestern collections attributed to Lippi in this catalog (Nos. 6–11) represent a variety of compositions, techniques, stylistic handlings, and degrees of finish. The fundamental differences in how form and volume are constructed in these six sheets can be explained in part by their different sizes, techniques, and the purposes for which they may have been intended. Lurking among the artists of the six is the real artistic personality of Lippi the draftsman. The problem is to separate him from his followers and imitators.

Innis Shoemaker has cataloged almost 130 drawings associated with Lippi.[3] Her study is the single most important contribution in clarifying his corpus of designs. Of the six drawings included here, Shoemaker was aware of all but two (Nos. 9 and 10). Of the four she cataloged, she accepted only two as autograph (Nos. 6 and 8). The three authors who have cataloged the works mentioned by Shoemaker have kept her attributions, with the exception of the Cleveland *St. Jerome in His Study* (No. 7), which is listed here as an original by Lippi rather than as by Sangallo, as Shoemaker argued.

1. The most recent study of Filippino Lippi's paintings is Berti and Baldini, 1991. Ruda, 1982, also touches on attributions to Filippino Lippi and Domenico Ghirlandaio.

2. For Lippi's influence on later art in Italy, see Peters-Schildgen, 1989. For Lippi's involvement in the Brancacci Chapel, see Shulman, 1991; Ladis, 1993, 67–89.

3. Shoemaker, 1975.

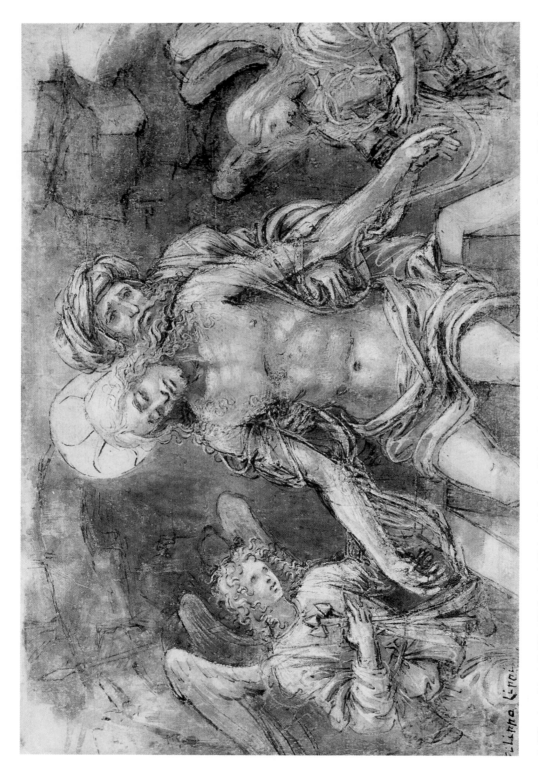

6. Filippino Lippi (1457–1504), *Dead Christ with Joseph of Arimathea and Angels*, ca. 1491, Oberlin College, Dudley Peter Allen Memorial Art Museum, R. T. Miller Jr. Fund, 54.64.

6

Filippino Lippi (1457–1504), *Dead Christ with Joseph of Arimathea and Angels,* ca. 1491 (formerly *Lamentation of Christ at the Tomb,* ca. 1490–1495), 180 x 263 mm (7 1/16 x 10 5/16 in.), pen and brown wash heightened with white on laid paper and pricked for transfer, Oberlin College, Dudley Peter Allen Memorial Art Museum, R. T. Miller Jr. Fund, 54.64.

TECHNICAL CONDITION: Slight horizontal crease at upper right; slight curved crease on right edge of sarcophagus.

INSCRIPTIONS: In a later hand at lower left corner in dark brown ink, "Filippo Lippi."

COLLECTORS' MARKS: None.

WATERMARKS: None observed.

PROVENANCE: Earl of Pembroke, Wilton House; Henry Oppenheimer, London; C. R. Rudolf, London; Mrs. R. Langton Douglas, London.

EXHIBITIONS:

(Unquestioned as Filippino Lippi)

London, Burlington Fine Arts Club, 1917, no. 82.

London, P. and D. Colnaghi, May 12–June 27, 1953, *Exhibition of Old Master Drawings,* no. 15.

Ann Arbor, Museum of Art, University of Michigan, March 11–April 1, 1956, *Drawings and Watercolors from the Oberlin Collection.*

New York, Columbia University (M. Knoedler and Company), October 13– November 7, 1959, *Great Master Drawings of Seven Centuries,* no. 10.

Detroit Institute of Arts, April 5–May 8, 1960,

Master Drawings of the Italian Renaissance, no. 4.

Kenwood, England, London County Council, Iveagh Bequest, May 30–September 30, 1962, *An American University Collection,* no. 43.

Poughkeepsie, N.Y., Vassar College Art Gallery, May 2–June 9, 1968, *The Italian Renaissance,* no. 15.

BIBLIOGRAPHY:

(Unquestioned as Filippino Lippi)

Strong, 1900, pt. 2, pl. 18.

Thieme and Becker, 1901–1956, 32:270, "Lippi, Filippino: Zeichnungen" (*Pietà* by Filippino Lippi, L 462).

"In the Auction Rooms: The Oppenheimer Collections, The Drawings," 1917, 244, pl. (B).

Scharf, 1935, 120, no. 184, pl. 44, fig. 62.

"In the Auction Rooms: The Oppenheimer Collections," 1936, 180.

Berenson, 1938, 2:151, no. 1349A.

Neilson, 1938, 121, n. 57.

Scharf, 1950, 54, no. 61, pl. 61.

Davis, 1953, 992.

Art Quarterly, 1955, 195 ill.

Gamba, 1958, 125, pl. 21.

Allen Memorial Art Museum Bulletin, 1959a, 88–89, no. 61.

Allen Memorial Art Museum Bulletin, 1959b, 203 ill.

van Schaack, 1959, 13–14, no. 10, pl. VII.

Stechow, 1964, 289–302, fig. 7.

Spencer, 1966a, 23–34, fig. 1.

The Italian Renaissance, 1968, 7, no. 15.

Shoemaker, 1975, 318–23, no. 90, fig. 90.

Fig. 6-A. Filippino Lippi, *Ecce Homo with Four Angels,* drawing, Florence, Uffizi.

Stechow, 1976, 48, no. 228, fig. 102.
Bongiorno, 1976, 91–92, fig. 3.
van der Marck, 1984, 174–75, fig. 28.
Berti and Baldini, 1991, 90, no. 69.

COMMENTS:

This is a well-established drawing. Although inscribed "Filippo Lippi" by a previous owner, it has long been accepted as an autograph Filippino Lippi. Bernard Berenson has related the sheet to other drawings by Filippino, and it has been included in monographs on the artist by Alfred Scharf, Katharine Neilson, Fiametta Gamba, and L. Berti and U. Baldini. It is similar in style to a black chalk drawing in the Uffizi, an *Ecce Homo with Four Angels* (Fig. 6-A).[1] Like the Cleveland *St. Jerome,* this sheet has been perforated along the contours of the figures for transfer, probably to the small painting of like dimensions and almost identical composition in the National Gallery of Art in Washington, D.C., with which the Uffizi

drawing has been associated (Fig. 6-B).[2] The painting's small size would suggest a predella for an altarpiece that has been lost or was never completed.

The combination of pen and wash with white highlights is infrequent among Filippino's drawings, but those examples that are known appear to be from throughout his career.[3] One of the artist's most exquisite studies, the Oberlin work is also rare in his corpus as a preparatory drawing. Based on careful stylistic analysis, John Spencer has assigned a date of 1485–1486 to the sheet, whereas Innis Shoemaker has argued for a date of 1490–1495.[4] The nervous quality of line as in the hair of the angel at the left, facial types like those in the Caraffa Chapel in Santa Maria sopra Minerva in Rome and the Strozzi Chapel in Santa Maria Novella in Florence, and a sense of exhaustion in the

1. Shoemaker (1975, 431–33, no. 130) dated this drawing to ca. 1495–1504.

2. Spencer, 1966a, 25, fig. 2; for a color reproduction, see Berti and Baldini, 1991, 216;
3. Spencer, 1966a, 27.
4. Ibid.; Shoemaker, 1975, 320–22.

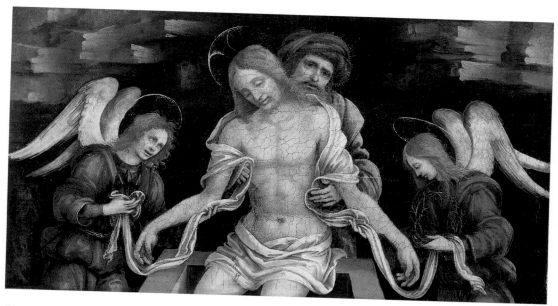

Fig. 6-B. Filippino Lippi, *Dead Christ with Joseph of Arimathea and Angels,* panel, Washington, D.C., National Gallery of Art.

faces with their comparable morphology suggest a date of ca. 1491.[5]

There are several drawings and paintings of this subject by Filippino Lippi, although the subject was more common in the north at the time, as in the paintings of Giovanni Bellini and Cosimo Tura. The figures are placed in a crypt. The dead Christ would appear to be displayed in the form of an *Andachtsbild* or devotional demonstration piece, although the emphasis is less on Christ's wounds than on the instruments of his Passion. The iconic character of the composition is underscored by Filippino's symmetrical disposition of the flanking angels and the frontal depiction of Christ with his cruciform halo. The angel at the left holds three nails. Eric van Schaack has suggested that Filippino had originally given him a lance, which is still

visible in the upper left.[6] His opposite number holds a crown of thorns. Each supports one of Christ's arms, and both have an extra wing, showing that the artist experimented with foreshortening of the figures and their placement in space. In the Washington painting, Filippino has replaced the foremost wing of each angel with a foreshortened halo.

Each of the four evangelists recounts how the rich man, Joseph of Arimathea, approached Pilate for permission to prepare Christ's body for burial.[7] Matthew, Mark, and Luke state that Joseph provided the shroud for Christ, and Matthew identifies the tomb as Joseph's. The evangelists variously mention the tomb as new, unused, and hewn out of rock. In the *Meditations* of the Pseudo-Bonaventure, Joseph is described as removing the nail from Christ's right hand,[8] the side on

5. See Berti and Baldini, 1991, 244, 249, 252, 257, 260, for color reproductions of these facial types.
6. Van Schaack, 1959, 14.

7. The Gospel accounts are Mark 15:42–46, Matthew 27:57–60, Luke 23:50–55, and John 19:38–42.
8. Stechow, 1964, 290.

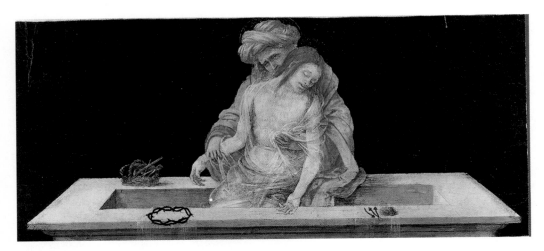

Fig. 6-C. Filippino Lippi, *Lament at the Tomb,* panel, London, National Gallery.

which the angel with nails is placed. The Oberlin drawing would seem to depict the "rich man" Joseph as an elegantly turbaned figure who supports Christ on his own sarcophagus before a "rock-hewn tomb," flanked by angels holding both Joseph's shroud as it dangles from Christ's arms and the nails and crown of thorns that Joseph would have removed in taking Christ's body from the cross to prepare it for burial. Although John mentions that Nicodemus brought a hundredweight of myrrh and aloes to anoint the body, it is Joseph of Arimathea who became the patron saint of embalmers and grave diggers.[9]

The identity of the figure holding Christ, which seems straightforward in the gospels, is complicated by the apocryphal accounts of Christ's death. The *Painters' Guide of Mt. Athos* reported Nicodemus as supporting the head of Christ as he and Joseph of Arimathea carried the body to the tomb.[10] Wolfgang Stechow has identified the turbaned figure as Nicodemus, although he also

observed that Joseph of Arimathea was frequently depicted as wearing a turban in paintings of the Deposition.[11]

Stechow referred to the popularity of the Acta Pilati or apocryphal Gospel of Nicodemus.[12] The Greek original of this text was known in a fifteenth-century Italian version,[13] but this may have been more popular in the sixteenth century;[14] in any case, it is as rich in information on Joseph of Arimathea as on Nicodemus.[15] For example, it tells of Christ appearing to Joseph after the Resurrection. In a Greek version of the gospel from a later date, Nicodemus is too frightened to accompany Joseph to approach Pilate

9. Réau, 1955–1958, 3:pt. 2, 760–61.
10. Stechow, 1964, 302.

11. Ibid., 297, n. 34.
12. Stechow (ibid., 289–90, 298, no. 40, and 299–300) refers to its popularity in the context of his discussion of Michelangelo's *Pietà* of ca. 1547. For more on Nicodemus, see Kristof, 1989; Shrimplin-Evangelidis, 1989.
13. Guasti, ed., 1862.
14. Stechow (1964, 289–90) interprets Ascanio Condivi's and Giorgio Vasari's descriptions of Michelangelo's Florentine *Pietà,* which include Nicodemus as "the traditional identification," but these accounts were published more than sixty years after Filippino's drawing.
15. Ibid.

for Christ's body, and Joseph proceeds alone.

A figure supporting Christ appears in several works by Filippino. Stechow has concluded that the Christ bearer is to be identified as Nicodemus on the basis of a basket included in Filippino's *Lament at the Tomb* in the National Gallery, London (Fig. 6-C). This basket is clearly displayed on the rim of the sarcophagus in allusion to the basket of Nicodemus mentioned in *Painters' Guide of Mt. Athos*. It contains the nails that Nicodemus has removed from Christ's left hand and feet and the instruments that he used to do so. No basket, however, appears in the Oberlin drawing or in the Washington, D.C., painting related to it. That the addition of a basket with tools and nails was necessary in the London painting to identify the Christ bearer with Nicodemus would suggest that the Oberlin counterpart is instead Joseph of Arimathea, who did not require such a specific attribute. Finally, van Schaack's observation that the angel with the nails was originally given a lance to hold would suggest that Lippi was indifferent to the association of the figure with Nicodemus.[16]

E. J. O.

16. Filippino's London painting may have served as a model for Botticelli's predella panel of the *Pietà* in his *San Barnaba Altarpiece* of ca. 1487 in the Uffizi. Filippino's figure of Christ in the Oberlin sheet is almost identical in pose to Botticelli's. Although nails are placed on the edge of the sarcophagus in which Christ sits, no other figure appears in Botticelli's predella. See Lightbown, 1989, 191, pl. 63, for a reproduction of Botticelli's predella.

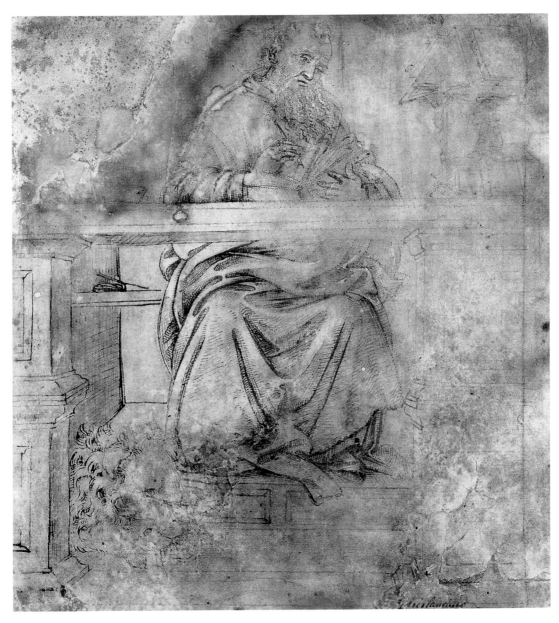

7. Filippino Lippi (1457–1504), *St. Jerome in His Study,* ca. 1490, Cleveland Museum of Art, gift of Leonard C. Hanna Jr., 24.532.

7

Filippino Lippi (1457-1504), *St. Jerome in His Study,* ca. 1490, 241 x 209 mm (9 1/2 x 8 1/4 in.), pen and brown ink, brush and brown wash heightened with white, Cleveland Museum of Art, gift of Leonard C. Hanna Jr., 24.532.

TECHNICAL CONDITION: Soiled; all corners missing; numerous holes and tears; pricked for transfer.

INSCRIPTIONS: In a later hand at lower right in pen and brown ink: "Ghirlandaio."

COLLECTORS' MARKS: None.

WATERMARKS: None observed.

PROVENANCE: Richard Johnson (Lugt 2216); Richard Johnson Walker (under Lugt 2216); Fitz Roy Carrington.

EXHIBITIONS:

Cleveland Museum of Art, 1924, *An Exhibition of Drawings.*

Cleveland Museum of Art, July 13–September 19, 1977, *Florence and the Arts: Five Centuries of Patronage,* no. 54.

Cleveland Museum of Art, March 6–April 22, 1979, *The Draftsman's Eye,* no. 17.

Cleveland Museum of Art, February 19–March 23, 1980, *Idea to Image: Preparatory Studies from the Renaissance to Impressionism.*

Cleveland Museum of Art, December 15, 1986–March 1, 1987, *Italian Drawings from the Permanent Collection.*

BIBLIOGRAPHY:

Sizer, 1924, 141 (as anonymous).

Berenson, 1938, 2:142, no. 1277F; 3:fig. 221 (as Filippino Lippi).

Hind, 1938–1948, 1:208, under D. IV. 6 (as probably by Filippino Lippi).

Suida, 1951, 54, no. 15 (as Filippino Lippi).

Degenhart, 1955, 215, 218, n. 307, fig. 269 (as Giuliano da Sangallo).

Shapley, 1961, no. 13 (as Filippino Lippi).

Berenson, 1961, 2:250, no. 1277; 3:fig. 221 (as Filippino Lippi).

Shapley, 1966–1973, 1:137 (as Filippino Lippi).

Pillsbury, 1971, no. 54 ill. (as Filippino Lippi).

Levenson, Oberhuber, and Sheehan, 1973, 236, 248, n. 1, no. 93, 250, fig. 10-2 (as Filippino Lippi).

Shoemaker, 1975, 449–50, no. R29, fig. 214 (as Giuliano da Sangallo).

Olszewski, 1977, fig. 60 (as Filippino Lippi).

Johnson, 1980, 48–57, fig. 57 (as Filippino Lippi).

Olszewski, 1981, 43–44, no. 17 (as Filippino Lippi).

Landau and Parshall, 1994, 116–17, 387, nos. 44, 45.

COMMENTS:

Fillipino's Cleveland design is unusual for the pinholes tracing the saint's silhouette, the desktop, and the lion's head. This suggests its use as a preparatory drawing for a finished work in another medium. Two related works exist: a panel painting in the El Paso Museum of Art (Fig. 7-A) and an engraving once attributed to Giovanni Antonio da Brescia (Fig. 7-B).[1] Because the painting is

1. Shapley, 1966–1973, 1:137, no. K 1727, fig. 375. Landau and Parshall (1994, 116–17, 387, nos. 44–45) argue against the attribution to Giovanni Antonio da Brescia made by Levenson, Oberhuber, and Sheehan, 1973. They do not identify an artist for the engraving.

Fig. 7-A. Filippino Lippi, *St. Jerome in His Study,* tempera on panel, El Paso, Texas, Museum of Art.

larger and simpler, the drawing's relationship to it is less direct than is its relationship to the engraving, in which St. Jerome is of identical size. The composition of the engraving is not the reverse of that in the drawing as is normal with a compositional sketch and a copper plate. This suggests the Cleveland drawing was probably placed against a second sheet, with both perforated simultaneously.[2] Next, the blank pinpricked second sheet was placed facedown on the plate, that is, with the drawn design now in reverse, and pounced with a bag of charcoal. This procedure had two purposes; it preserved the original drawing from charcoal stains, and it transferred the outline of St. Jerome in reverse. After the full composition was incised into the plate, the plate inked, and paper applied, the engraved design was transferred to a fresh sheet of paper once more in reverse, thereby making it match the original drawing.[3]

2. This *spolvero* technique is described by Armenini in his treatise on painting of 1586 (Olszewski, 1977, 174).

3. Because the Cleveland drawing is mounted on heavy paper, it cannot be examined for charcoal stains on the verso. No such stains are evident on the recto.

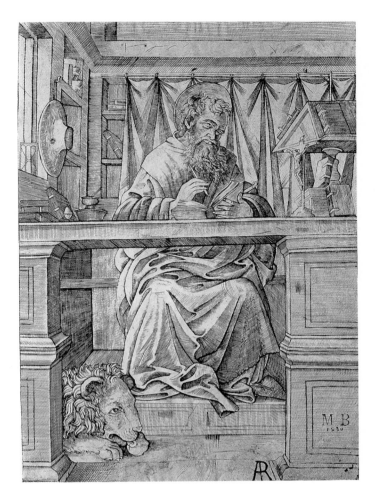

Fig. 7-B. Giovanni Antonio da Brescia(?), *St. Jerome in His Study,* engraving, Washington, D.C., National Gallery of Art, Rosenwald Collection, 1943.3.1344.

Bernard Berenson has noted similarities in physiognomy between St. Jerome and figures of Abraham and of a heretic in Filippino's Carafa Chapel project in Santa Maria sopra Minerva.[4] These similarities in morphology would date the sheet to ca. 1485 and would also rule out earlier attributions to Giuliano da Sangallo.

The Cleveland drawing can be related to the late-fifteenth-century Florentine interest in images of saints in their studios, the recent introduction of printing to Italy contributing to the librarylike setting. Ghirlandaio's *St. Jerome* and Botticelli's *St. Augustine* in the Ognissanti are but two examples. Jay Levenson has echoed A. M. Hind's suggestion that the *St. Augustine* fresco was Filippino's

4. Berenson, 1938, 2:142, no. 1277 F. The panel is dated to the 1490s. See Shapley, 1966–1973, 1:137, no. K 1727. Degenhart (1955, 218) and Shoemaker (1975, 449–50) attribute the sheet to Giuliano da Sangallo. In addition to Berenson, Hind (1938–1948, 1:208, under D. IV. 6) and Levenson, Oberhuber, and

Sheehan (1973, under no. 93) suggest an attribution to Filippino Lippi. The following inscriptions appear on the verso of the mount: in brown ink, "Domenico Ghirlandaio Fiorentino"; in pencil, "R. Johnson-1877, A 273" (in different modern hands).

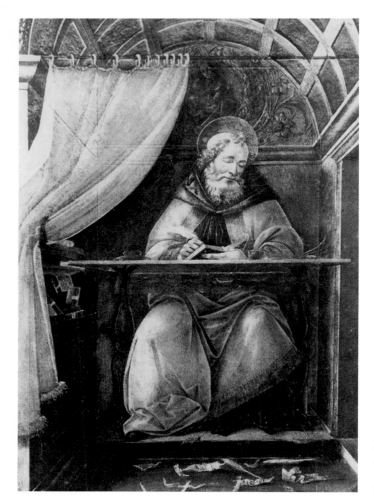

Fig. 7-C. Sandro Botticelli, *St. Augustine Writing in His Cell,* ca. 1490–1494, tempera on panel, Florence, Uffizi.

model, but Botticelli's Uffizi panel of *St. Augustine Writing in His Cell* (Fig. 7-C) of ca. 1490–1494 may, in turn, have been inspired by Filippino's composition.[5]

St. Jerome may be seen here writing his Latin translation of the Bible, an activity of his late years. The lion is not fully visible in the drawing, but in the anonymous engraving he seems to be licking either his paw, from which St. Jerome had removed a painful thorn, or the bloody rock with which the saint is frequently shown striking his chest in penitence.[6]

E. J. O.

5. Levenson, Oberhuber, and Sheehan, 1973, no. 93; Hind, 1910, 208, no. 6.

6. Recent studies of the popularity of St. Jerome imagery include Meiss, 1976, 189–202; Ridderbos, 1984; Rice, 1985; and Pilliod, 1988.

8

Filippino Lippi (1457–1504), *Head of a Young Man,* ca. 1495, 119 x 92 mm (4 15/16 x 3 5/8 in.), pen and brown ink heightened with white on tan paper, Cleveland Museum of Art, purchase, Dudley P. Allen Fund, 68.19.

TECHNICAL CONDITION: Dark brown stain at upper right corner; slight horizontal crease just below center at right border; small hole in left chin; brown ink stain just to the right of and above center covered with white highlighting.

INSCRIPTIONS: None.

COLLECTORS' MARKS: None.

WATERMARKS: None observed.

PROVENANCE: C. R. Rudolf, London (Lugt supp. 2811b); De Beer Fine Art Ltd., London.

EXHIBITIONS:
Cleveland Museum of Art, January 29–March 9, 1969, *Year in Review for 1968,* no. 86.
Cleveland Museum of Art, July 13–September 19, 1971, *Florence and the Arts: Five Centuries of Patronage.*
Cleveland Museum of Art, December 15, 1986–March 1, 1987, *Italian Drawings from the Permanent Collection* (as Filippino Lippi[?]).

BIBLIOGRAPHY:
"Drawing," 1968, 434, no. 4 (as Filippino Lippi).
"The Year in Review, 1968," 1969, 4 ill., 47, no. 86 (as Filippino Lippi).
Pillsbury, 1971, no. 56 (ascribed to Francesco Granacci).
Shoemaker, 1975, 440, no. R13, fig. 194 (as workshop of Filippino Lippi).

COMMENTS:

This head study has never been associated with a known painting; its date and attribution rely on stylistic analysis. On the basis of the drawing technique used in this sheet—thin, linear, white highlights on pen underdrawing—it can be seen as similar to various drawings by Raffaellino del Garbo, Davide Ghirlandaio, Francesco Granacci, Piero di Cosimo, and Filippino Lippi.

The original assignment of this sheet to Filippino appears acceptable for several reasons. Several head studies survive among his drawings, but more important, the Cleveland drawing shares stylistic characteristics with many sheets attributed to him. Most striking are the sets of slashing parallel strokes in different directions used for both shading and highlights, a quality found in a number of drawings by Filippino.[1] The forceful narrow chin dimpled at the center and the concave eye sockets in *Head of a Young Man* resemble Filippino's drawing of *St. Francis* in the Louvre.[2] For comparative purposes, a sharply chamfered chin appears in the partially cropped face of an angel in Filippino's *Madonna and Child with Two Angels* in the Louvre.[3] Also noteworthy is the face of a fig-

1. For example, compare the Louvre drawing, *Profile,* inv. 2690 (Berenson, 1938, 2:152, no. 1359B), with the *Young Man Seated,* verso, Musée Bonnat, Bayonne, inv. 1246, and the *Draped Man Seated,* recto, Musée Bonnat, Bayonne, inv. 1245 (Berenson, 1938, 2:139, no. 1266A).
2. Paris, Louvre, inv. 2689.
3. Reproduced in Berti and Baldini, 1991, 17.

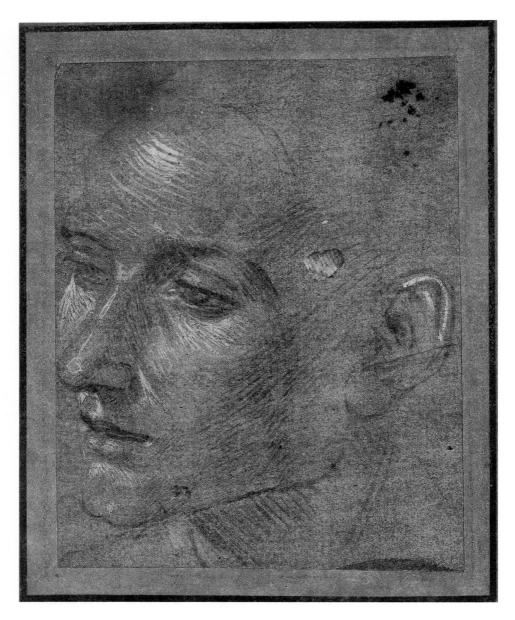

8. Filippino Lippi (1457–1504), *Head of a Young Man,* ca. 1495, Cleveland Museum of Art, purchase, Dudley P. Allen Fund, 68.19. Reproduced larger than actual size.

ure at the far right looking at the viewer in the *Dispute with Simon Magnus* from Filippino's fresco in the Brancacci Chapel.[4] This face, while not that in the sheet under discussion, has a comparable strong nose and chiseled chin. The head in *Head of a Young Man,* however, is presented from a different vantage point than the Brancacci Chapel face. It is seen from a higher viewpoint with the nose overlapping the cheekbone and a full view of the ear, which is obscured in the faces of many of Filippino's paintings. In this regard, however, note the face of St. Dominic in Lippi's *Madonna and Child with Sts. Jerome and Dominic* in London, which shows a bald

head, higher vantage point, full ear, and the nose overlapping the cheekbone in a three-quarter view of the face from its proper left.[5] Finally, the emphasis in the Cleveland study on the figure's chin and cheekbone and on facial muscle tone adds a characteristic note of vigor to the head.[6]

E. J. O.

4. Reproduced in ibid., 101, and detail 99.

5. Reproduced in ibid., 177.

6. Compare, for example, *Tondo: Head of a Man* in the Uffizi, no. 1151 E (Berenson, 1938, 2:146, no. 1313); *Head of a Man Looking Down* in the Louvre, recto, inv. 2665 (Berenson, 1938, 2:152, no. 1359A); and *Head of a Young Man* in the Berlin Kupferstichkabinett, no. 5174 (Berenson, 1938, 2:140, no. 1271B).

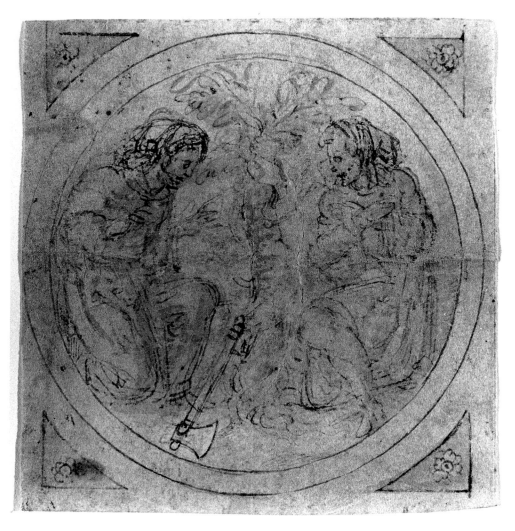

9. Filippino Lippi (1457–1504), *Two Figures Kneeling by a Tree,* ca. 1490, University of Notre Dame, Snite Museum of Art, gift of John D. Reilly, 92.38.18. Reproduced larger than actual size.

9

Filippino Lippi (1457–1504), *Two Figures Kneeling by a Tree,* ca. 1490, 85 x 81 mm (3 5/16 x 3 3/16 in.), pen and brown ink, gray and light brown washes over black chalk on off-white paper, University of Notre Dame, Snite Museum of Art, gift of John D. Reilly, 92.38.18.

TECHNICAL CONDITION: Fair; slightly abraded and cracked.

COLLECTORS' MARKS: Verso, lower left corner: a red stamp with "WB" atop a circle enclosing a cross or "T" (Professor Walter Burgi, Switzerland, not in Lugt).[1]

WATERMARKS: None.

PROVENANCE: John Minor Wisdom Jr., New Orleans.

EXHIBITIONS:

New York, Piero Corsini, November 5–23, 1985, *Mia N. Weiner Presents an Exhibition of Old Master Drawings* (as Filippino Lippi).

University of Notre Dame, Snite Museum of Art, 1987, *Master Drawings: The Wisdom-Reilly Collection,* no. 15 (as Filippino Lippi).

BIBLIOGRAPHY:

Mia N. Weiner Presents an Exhibition of Old Master Drawings, 1985, no pagination, no illustration number (as Filippino Lippi).

Spiro and Coleman, 1987, 13, 24, no. 15, fig. 15 (as Filippino Lippi about 1490).

COMMENTS:

The purpose of this little drawing by Filippino is unknown, but its design and sub-

ject suggest it may have been intended as a religious allegorical decoration. Two draped figures kneeling beside a tree are framed within an ornamental tondo consisting of two concentric circles. Four triangles with rosettes at their centers mark the corners of the sheet, and their inner edges echo the curve of the circular frame. The figures are posed in a devotional attitude, the hands of one figure crossed on his (?) chest. An ax leans against the tree between the two figures. This implement may foreshadow the felling of the tree or evoke the theme of classical sacrifices.[2]

1. The same collector's mark may be found on a drawing by Pirro Ligorio in the Ian Woodner collection. See *Old Master Drawings from the Woodner Collection,* 1991, lot 78.

2. The ax is an emblem of Sts. Joseph and Matthew. It is also an attribute of St. John the Baptist, who in a sermon at the River Jordan called for repentance: "O generation of vipers, who hath warned you to flee from the wrath to come? Bring forth, therefore fruits meet for repentance: And think not to say within yourselves, We have Abraham to our father: for I say unto you, that God is able of these stones to raise up children unto Abraham. And now also the axe is laid into the root of the trees: therefore every tree which bringeth not forth good fruit is hewn down, and cast into the fire" (Matthew 3:7–10). An almost identical passage is found in Luke 3:7–10, which Ruda (1993, 227) cites in his discussion of Fra Filippo's Palazzo Medici *Adoration* (Gemäldegalerie, Berlin). In this painting, Fra Filippo signed his name on an ax in a tree stump in front of the Baptist.

In the drawing, the tree against which the ax is placed cannot be identified with certainty, but it may also refer to Christ's Passion. According to legend, all trees, upon hearing that Christ was to be crucified, refused to offer up their wood. If a tree was struck by an ax, its wood would splinter. Only the ilex or holly oak allowed itself to be used for the wood of the Cross. The holly oak sometimes appears in works where St. Jerome contemplates the Passion or the Baptist foretells it. See Ferguson, 1959, 16, and Strozzi, 1993.

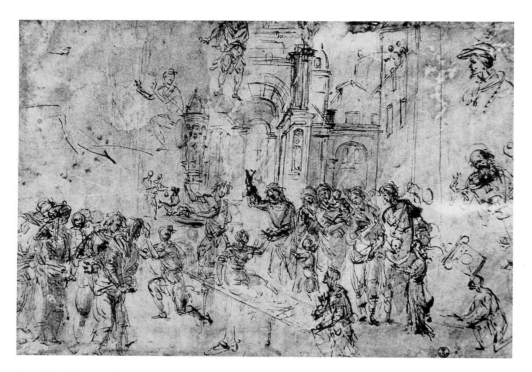

Fig. 9-A. Filippino Lippi, *St. John the Evangelist Resurrecting Drusiana and Other Sketches,* Florence, Uffizi.

Lippi frequently enlivened his compositions with historical, mythological, or allegorical motifs and used grotesques to adorn such architectural or sculptural components as cornices, architraves, pilasters, archivolts, panels, and plinths. His frescoes for the Strozzi Chapel in Santa Maria Novella, Florence (commissioned in 1487 and completed in 1502), reveal an abundance of classical Roman motifs that were influenced by his archaeological, antique-inspired frescoes painted in the Carafa Chapel in Santa Maria sopra Minerva, Rome.

As Innis H. Shoemaker has noted, the ancient sources for Filippino's *all'antica* designs are extremely difficult to trace, because the artist often manipulated classical motifs to suit a specific design.[3] Like

Pinturicchio before him and a number of contemporary artists working in Rome, Filippino was influenced by the antique grotesque decorations in the Domus Aurea, discovered as early as 1475, and incorporated elaborate and fanciful ornamental motifs into his religious works.[4]

That the Notre Dame drawing is related to such antique-inspired decorations may not seem clear, since its subject is not overtly classical. Yet the symmetrical placement of the figures on either side of the tree clearly recalls

3. Shoemaker, 1978.

4. Hall, in a 1992 NEH Summer Seminar at Temple University in Rome, suggested that the earliest known example of Roman Renaissance *grotteschi* inspired by the antique decorations in the Golden House of Nero may be seen on the pilasters of the Buffalini Chapel in Santa Maria in Aracoeli, painted by Pinturicchio around 1483–1485. For two important discussions regarding Pinturicchio's Roman fresco decorations see Schulz, 1962, and Parks, 1979.

Filippino's classically inspired grotesque designs for the Carafa and Strozzi Chapels. Two drawings in the Uffizi, *Two Centaurs Supporting an Urn* and *Two Tritons Supporting a Lamp,* reveal Filippino's interest in such symmetrically disposed ornamental designs, which, as Shoemaker has pointed out, appear in both chapels.[5]

Like the Uffizi drawings, the Notre Dame composition is defined by a circular "frame." The drawing is even more ornamental than the Uffizi examples, and it may offer clues to the original appearance of the Uffizi tondi, suggesting they may have been cut into the shape of roundels at a later date. On the Notre Dame sheet, Lippi has drawn concentric circles in ink around the image and has added triangles with rosettes in their centers at the corners. As Shoemaker has noted, circular frames and the general ornamental character of such drawings reveal Lippi's consistent interest in embellishing his designs.[6]

In addition to the iconographic and com-positional similarities with the Uffizi examples, the Notre Dame drawing resembles the pen-and-ink studies for the Strozzi Chapel frescoes. These studies, too, are characterized by rapidly sketched pen strokes to which light touches of wash were applied. A drawing of this type is the compositional study of *St. John the Evangelist Resurrecting Drusiana and Other Sketches* (Fig. 9-A), designed for the fresco of the same subject in the Strozzi Chapel.

Further comparisons can be made with regard to figural compositional study. For example the mantled heads of the women to the left and at right of center of the Uffizi sheet resemble the kneeling figure on the right of the Notre Dame drawing. In addition, the kneeling figure at the left in the Notre Dame drawing is similar to the figures in the left and right foreground in the Uffizi drawing in its posture (kneeling, with the body tilted forward) and the manner in which its garment is draped about the shoulders.

The Notre Dame drawing thus seems most comfortably to fit into a category of preparatory studies for the classicizing architectural ornamentation that embellishes Filippino's late Quattrocento fresco cycles, and it should be dated around 1490.

R. R. C.

5. Shoemaker, 1978, 39, and pls. 33a–b (Uffizi, nos. 1630 E and 1631 E, respectively). These drawings, along with others inspired by antique decoration, may be seen in Tofani, 1992, 255–59, cat. nos. 12.11 through 12.17; see especially nos. 12.11 and 12.12.

6. Shoemaker, 1978, 39.

10. Filippino Lippi (1457–1504), *Young Man, Half-Length, in a Tondo,* ca. 1485, University of Notre Dame, Snite Museum of Art, gift of John D. Reilly, 92.38.19. Reproduced larger than actual size.

10

Filippino Lippi (1457–1504), *Young Man, Half-Length, in a Tondo,* ca. 1485, diameter 72 mm (2 13/16 in.), laid down to a sheet 84 mm in diameter, silverpoint, brush, and white heightening on rose paper, University of Notre Dame, Snite Museum of Art, gift of John D. Reilly, 92.38.19.

TECHNICAL CONDITION: Good with no apparent abrasions; in the shape of a roundel since its ownership by August Grahl (1791–1868).

COLLECTORS' MARKS: Recto, right side, the stamp of August Grahl (Lugt 1199); verso, inscribed in pencil in a later hand, "D.^co Ghirlandajo"; lower left, "G"; lower center, in pencil, "25."

WATERMARKS: None.

PROVENANCE: August Grahl, Dresden;[1] Henry Oppenheimer, London;[2] Bellesi;[3] John Minor Wisdom Jr., New Orleans.

EXHIBITIONS:

London, Yvonne Tan Bunzl and Somerville and Simpson, 1978, *Old Master Drawings: Exhibition,* no. 40 (as Filippino Lippi).

1. *Catalogue of Drawings by the Old Masters Formed by the Late Professor August Grahl of Dresden,* 1885, 11, no. 136, as Domenico Ghirlandaio.
2. The drawing is listed in the Oppenheimer Collection as no. 631 by Scharf (1935, 128, no. 283) and was sold in London by Christie, Manson & Woods Ltd. (*Catalogue of the Famous Collection of Old Master Drawings Formed by the Late Henry Oppenheimer Esq.* [1936], 57, lot 113).
3. According to Shoemaker (1975, 206), a photograph in the Frick Art Reference Library cites this study as owned by Bellesi (no full name, date, or location given).

University of Notre Dame, Snite Museum of Art, 1987, *Master Drawings: The Wisdom-Reilly Collection,* no. 16 (as Filippino Lippi about 1485).

BIBLIOGRAPHY:

Scharf, 1935, 79 and 128, no. 283 (as Filippino Lippi about 1485–1490).

Berenson, 1938, 2:88, no. 850A (as David Ghirlandaio).

Shoemaker, 1975, 206, no. 44 (as Filippino Lippi, ca. 1485–1486).

Ragghianti and Dalle Regole, 1975, 141 (as Filippino Lippi, location unknown).

Old Master Drawings: Exhibition, 1978, no. 40, pl. 11 (as Filippino Lippi).

K. Roberts, 1978, 863 (as Ghirlandaio).

Spiro and Colemen, 1987, 13, 25, no. 16, fig. 16 (as Filippino Lippi ca. 1485).

COMMENTS:

In his monograph on Filippino Lippi, Alfred Scharf, in a short chapter on Filippino as a draftsman, identifies *Young Man, Half-Length, in a Tondo* without further comment as a study for Filippino's *Vision of St. Bernard* (Fig. 10-A), Church of the Badia, Florence, a work generally dated to ca. 1485–1490.[4] As noted by the inscription of uncertain date and origin on the verso, the drawing had also been attributed to Domenico Ghirlandaio

4. Scharf, 1935. Filippino received the commission in 1479 from Pietro di Francesco del Pugliese for his chapel in the Church of the Campora. Documentation for the Chapel's decorations continues until 1488, and scholars have postulated dates for the work spanning at least ten years. For a brief discussion of the painting's dating and commission see Shoemaker, 1975, 204, n. 2, and Geiger, 1986, 25 and n. 25.

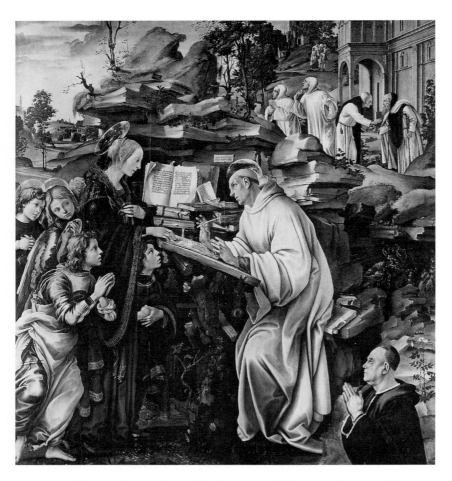

Fig. 10-A. Filippino Lippi, *Vision of St. Bernard,* ca. 1486, panel, Florence, Church of the Badia.

(1449–1494).[5] In 1938, Bernard Berenson included the work, also without comment, among the drawings ascribed to Domenico Ghirlandaio's brother and assistant, David (1452–1525), describing it as the bust of an

"apostle or prophet speaking, with right hand held out."[6] Although she was unaware of the drawing's location, Innis Shoemaker concurred with Scharf's attribution of the drawing but suggested it may have been a study for the figure of St. Bernard in Lippi's altarpiece *Virgin and Child with Sts. John the Baptist, Victor, Bernard, and Zenobius,* dated 1486. This altarpiece was executed for the Palazzo della Signoria and is now in the Uffizi. Shoemaker's convincing explication of

5. It is likely that the attribution to Domenico Ghirlandaio was made by August Grahl when the drawing was in his collection and that the inscription on the verso was made by Grahl himself. This hypothesis is supported by the ascription to Domenico Ghirlandaio in *Catalogue of Drawings by the Old Masters Formed by the Late Professor August Grahl of Dresden,* 1885.

6. Berenson, 1938, 2:88, no. 850A.

the similarities between the drawing and the altarpiece suggests the drawing can be dated to 1485–1486.[7]

A comparison of the sketch with a more complete drawing of St. Bernard in the Uffizi and with the figure of the saint in the Badia painting supports Scharf's identification. As noted by Shoemaker, the Notre Dame drawing is similar to the Uffizi drawing and the painting in the tilted position of the saint's head, his raised, gesturing right hand, and the patternings of drapery across his shoulders, chest, and arms.

Like the Uffizi drawing, the Notre Dame study is a metalpoint (here, silver) with brushed white heightening on a rose-pink preparation. Metalpoint drawings had been a practice since the trecento, and silverpoint drawings were used by numerous midcentury artists, among them Filippino's father, Fra Filippo, whose beautiful *Standing Female Saint*[8] is one such example. However,

Filippino's handling of the medium is more rapid and spontaneous than is that of his father. This kind of energetic rendering seems to ignore the methodical process that went into the making of drawings on prepared paper. As with many late Quattrocento Florentine artists with demands for increased productivity and a need for greater flexibility, Filippino seems to have outgrown such traditional drawing practices, while his interest in and appreciation of the three-toned drawing remained. Given what is known of the working procedures of many of Filippino's contemporaries, it seems likely that *Young Man, Half-Length* may be a fragment of a preparatory design for the more finished Uffizi sheet, and it probably represents a quick but carefully rendered sketch of one of Lippi's draped *garzone*. Thus, the drawing would be one of the earliest drawings for the painting. Given the relationship of the Notre Dame study to the Uffizi drawing and to the Badia Church panel itself, we can date the drawing around 1485 with some certainty.

R. R. C.

7. Shoemaker, 1975, 206.
8. British Museum, 1895-9-15-442.

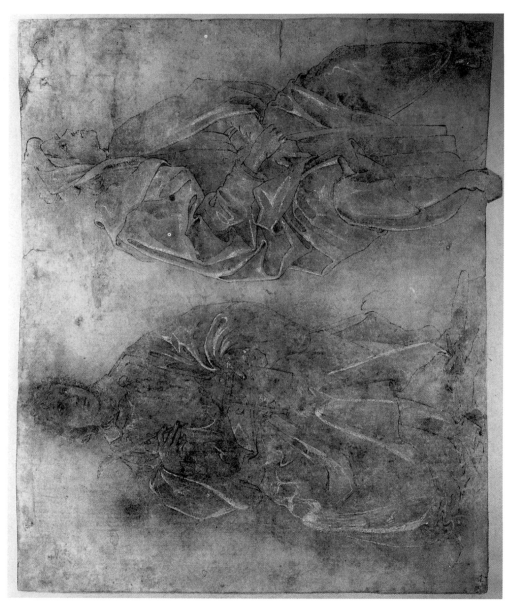

11 recto. Follower of Filippino Lippi (1457–1504), *Two Seated Men*, ca. 1480, Kansas City, Nelson–Atkins Museum of Art, 56–71.

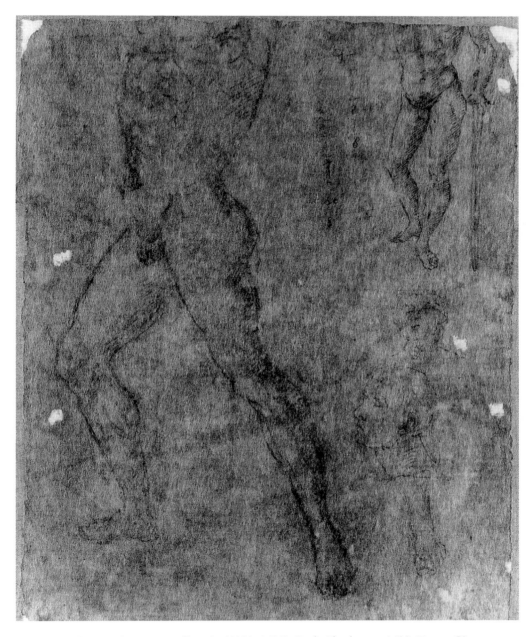

11 verso. Follower of Antonio Pollaiuolo (1429–1498), *Study Sketches,* ca. 1480, Kansas City, Nelson-Atkins Museum of Art, 56-71.

11

Follower of Filippino Lippi (Italian, 1457–1504), *Two Seated Men* (recto), and Follower of Antonio Pollaiuolo (Italian, 1429–1498), *Study Sketches* (verso), ca. 1480, 205 x 248 mm, irregular (8 1/8 x 9 3/4 in.); recto: pen and brown ink, brown wash heightened with white lead on dark buff paper, red pigment applied for transfer (?); verso: black chalk, warm-toned laid paper; Kansas City, Nelson-Atkins Museum of Art, 56-71.

TECHNICAL CONDITION: Edges severely trimmed; right edge cut away by at least 30 mm; proper right foot of the right figure on recto projects below the current bottom edge; modern gold border painted around the drawing to "square" the image area was removed in the course of 1987 conservation treatment (evident in the photo taken before restoration, Fig. 11-A); numerous abrasions, with some minor discoloration over the entire surface; recto has suffered water stains (the most obvious being at the lower right) and foxing; small hole losses were mended, as was a 3/4-inch-long tear located in the proper left calf of the figure at right; several other tears each 1/2 inch long, one on the top edge, one 5 1/2 inches from the left, and two on the lower edge.

Examination of the drawing under ultraviolet light reveals that about one-third of the white highlighting is composed of zinc white, a pigment that did not become widely available until about 1830; it is apparent that such retouching was applied to enhance the original heightening and not to create new areas of highlights. Red coloring is broadly applied over each figure. Rather than being red chalk as previously described, this material is probably the pigment *terra rosa*. This pigment lies over all other media and is driven deeply into the fibers of the paper. It is applied too broadly to be considered a drawing material, but it seems to have been used deliberately enough to discount accidental smudging from another sheet of drawings. Very likely it was used in a transfer process in which the image was first dusted with the red pigment. The outlines of the two figures were then transferred in reverse onto a new sheet by tracing these two figures from the verso of the Kansas City drawing with a stylus. Unfortunately, the evidence of such tracing cannot be ascertained since the drawing's verso is currently covered by a sheet of Japanese paper, applied when the drawings were treated in 1987. (The above notations are based on the examination report of March 5, 1992, prepared by Mark Stevenson, former assistant conservator of works of paper, to whose comments the author is much indebted.)

INSCRIPTIONS: The old mount contained a watercolor rendition of the Campbell coat of arms (Fig. 11-A). When the mount was removed in 1987, the section bearing this coat of arms was detached; in 1992, however, a new mount was reconstituted by Mark Stevenson incorporating the coat of arms.

COLLECTORS' MARKS: None.

WATERMARKS: Bird (peacock?); not in Briquet, 1923.

Fig. 11-A. Filippino Lippi, *Two Seated Men* (before restoration), ca. 1480, drawing, Kansas City, Nelson-Atkins Museum of Art, 56-71.

PROVENANCE: John Campbell, Duke of Argyll, by descent to Lord Frederick Campbell (1729–1816);[1] Fürst Liechtenstein; Richard H. Zinser, New York.

EXHIBITIONS:

Houston, Museum of Fine Arts, January 15– February 21, 1960, *The Lively Arts of the Renaissance,* no. 68 (as Filippino Lippi).

BIBLIOGRAPHY:

Art Quarterly, 1956, 422, 423 ill.

1. Information from vendor, Richard H. Zinser. It is not known whether the fourth duke (1693–1770) or the fifth (1723–1806)—both of whom were named John—is meant. That it did indeed belong to this family is confirmed by the coat of arms on the early mount. This form of ownership is mentioned by Revely (1820, 8). Frits Lugt (1921, 10), citing the above, states that he did not know of any such emblazoned mounts. Lugt further cites Revely, who notes that Lord Frederick Campbell owned a collection of drawings "which formed the reserved part of the late Duke of Argyle's."

Handbook of the Collections in the William Rockhill Nelson Gallery of Art and Mary Atkins Museum of Fine Arts, 1959, 64 ill.

Berenson, 1961, 2:261, no. 1341J-1.

Taggart and McKenna, eds., 1973, 1:177 ill.

Shoemaker, 1975, 458, no. R64; cited 147, no. 11.

COMMENTS:

The right figure on the drawing's recto is clearly a copy after Filippino's autograph sheet now in the Louvre (Fig. 11-B).[2] In both figures almost exactly the same schema of white highlighting appears. The other figure on the

2. Silverpoint with white highlights, on violet-tinted paper, 193 x 110 mm. This opinion was first voiced by Berenson (1961, 2:261) and later seconded by Shoemaker (1975, 458). Berenson noted that the retouchings were by a later hand. He did not rule out the possibility that in its original state the Kansas City recto was an autograph work by Filippino.

Fig. 11-B. Filippino Lippi, *Figure Study,* drawing, Paris, Musée du Louvre, Département des Arts Graphiques, RF 432, recto.

for example, *Hercules Killing the Hydra* in the Uffizi. The larger of the nude figures, however, was clearly copied after a bronze statuette of Marsyas (Fig. 11-C), attributed in the past to Pollaiuolo but in recent years more convincingly ascribed to that artist's studio.[3] Versions of this work were known to Florentine artists as early as the late 1440s—for instance, Uccello adopted it for a figure seen from the rear in the background of his *Flood* fresco in the Chiostro Verde, Florence. One is even recorded in the 1492 inventory of the collection of Lorenzo ("il Magnifico") de' Medici.[4] It was also copied by Umbrian artists such as Luca Signorelli and by the author of the so-called "Libretto Veneziano," now preserved in the Gallerie dell'Accademia, Venice.[5] Part of the bronze's great authority as a model was no doubt due to its derivation from an antique marble or limestone statue or statuette, which was known in the Renaissance but has long since disappeared. In fact, the only evidence of the antique work's existence at all is a drawing by an anonymous fifteenth-century Florentine artist in the Statens Museum for Kunst, Copenhagen.[6]

The smaller of the two heads depicted on the Kansas City drawing's verso may even be

recto side probably depicts either St. Lawrence or St. Stephen. The lack of pertinent attributes (such as a stone, a reference to Stephen's martyrdom) precludes any more precise identification. This figure does not relate to any known composition by Filippino.

The faded anatomical studies on the verso—discovered when the drawing was detached from its old backing in 1987—depict two male nudes, two male heads, a foot, and two columns of numbers. The active poses of the nudes suggest paintings and drawings by Antonio Pollaiuolo—that at left,

3. See Pope-Hennessey, 1970, 30–36, which catalogs the Frick statuette as "Style of Antonio Pollajuolo" and reproduces it on p. 31. The following discussion owes much to this catalog entry.

4. Rossi, 1893, 18–20; cited in Pope-Hennessey, 1970, 32, n. 10.

5. See Fusco, 1982. On p. 194, app. 2, she conveniently lists Renaissance paintings and drawings in which the *Marsyas* statuette figures as a compositional element. For a penetrating study of this sketchbook, see Pagden, 1982, 134–216, no. 83. Pen-and-ink studies after the *Marsyas* appear on fols. 9r (fig. 118 of Pagden), 14r (fig. 128), and 16r (fig. 132). Pagden considers the sketchbook to be the work of an Umbrian artist from the circle of the young Raphael, possibly identifiable with the latter's friend and colleague Domenico Alfani.

6. This is the supposition of Bober and

Fig. 11-C. Studio of Antonio Pollaiuolo, *Marsyas*, bronze, New York, The Frick Collection.

the head of the *Marsyas* statuette as seen from a frontal point of view. If so, it shows the mortal without the bandage usually worn by ancient Greek and Roman flute players. Interestingly, only one of the surviving bronze statuettes is without this bandage, known in antiquity as a *phorbeia*—the version in The Frick Collection, New York.[7]

The other male nude sketch does not appear to be based on any known sculptural model. The inclusion of a sword with this figure implies that its subject was probably that of the young David, a frequent theme in Florentine art of the fifteenth and sixteenth centuries.

Although the historic interest of the verso drawing is considerable, its qualities as a work of art are clearly secondary. Presumably its author was active in the studio, or at least the circle of, Pollaiuolo. He was certainly a different person from the artist of the drawing on the recto.

E. R.

Rubinstein, 1986, 73–74, fig. 30a. In the nineteenth century, even the *Marsyas* bronze statuette passed at times for an antique work of art.

7. See also Pope-Hennessy, 1970, 30; on the *phorbeia,* see Bober and Rubinstein, 1986, 73–74, for a *Marsyas* statuette in the Bargello, Florence, that sports the same mask.

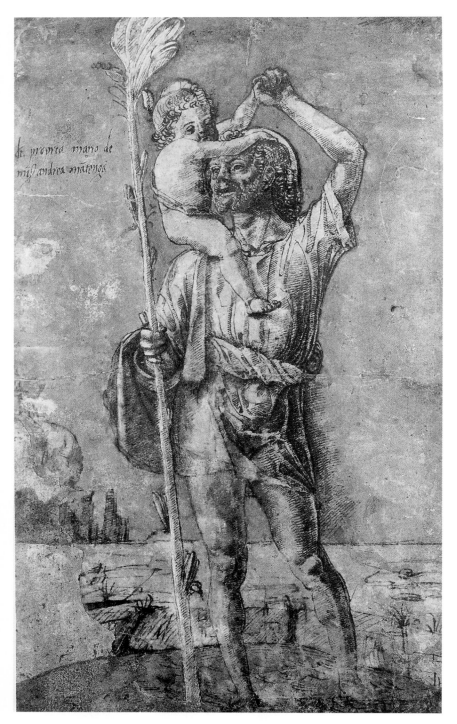

12. Follower of Andrea Mantegna (1431–1506), *St. Christopher,* ca. 1500, Cleveland Museum of Art, purchase, Dudley P. Allen Fund, 56.39. (Museum attribution: Andrea Mantegna.)

12

Follower of Andrea Mantegna (1431–1506) (formerly Andrea Mantegna), *St. Christopher,* ca. 1500, 286 x 175 mm (11 1/4 x 6 7/8 in.), pen and brown ink with colored washes and touches of white heightening, Cleveland Museum of Art, purchase, Dudley P. Allen Fund, 56.39.

BIOGRAPHICAL NOTE: Trained in Padua by the artist Francesco Squarcione, Andrea Mantegna was a precocious talent who had produced a signed altarpiece at the age of seventeen. His important early series of frescoes for the Church of the Eremitani, lost in the Second World War, depicted scenes from the lives of Sts. James and Christopher. By 1460, Mantegna had become court painter to Lodovico Gonzaga at Mantua, for whom he produced portraits, palace frescoes, and religious paintings. Mantegna was an avid antiquarian who moved in sophisticated humanist circles. He was also a gifted draftsman, an illuminator of manuscripts, and an influential engraver.[1]

TECHNICAL CONDITION: Horizontal fold at center; numerous creases; horizontal repair along lower right edge; large fragment added at lower left; abrasion at center along right edge; on paper backing.

INSCRIPTIONS: In a sixteenth-century hand in darker ink, "di propria mano de mi[a] andrea mātenga."

COLLECTORS' MARKS: None.

WATERMARKS: None observed.

1. See Lightbown, 1986; Meiss, 1957; Martineau, ed., 1992.

PROVENANCE: Conte Lodovico Moscardo, Verona (Lugt supp. 2990a–h, 1171b); Marquis de Calceolari (under Lugt supp. 2990a).

EXHIBITIONS:

Detroit Institute of Arts, April 5–May 8, 1960, *Master Drawings of the Italian Renaissance,* no. 14 (as Andrea Mantegna).

Cleveland Museum of Art, December 15, 1986–March 1, 1987, *Italian Drawings from the Permanent Collection* (as Andrea Mantegna).

BIBLIOGRAPHY:

Tietze-Conrat, 1924, 66–67.

Bulletin of the Cleveland Museum of Art, 1958, 67 ill. (as Andrea Mantegna).

"Mostre, musei, galerie: Museo di Cleveland," 1958, 2 ill. (as attributed to Mantegna).

Frankfurter, 1958, 31, fig. 20 (as Andrea Mantegna).

Master Drawings of the Italian Renaissance, 1960, 14, 29, no. 14 (as Andrea Mantegna).

Moskowitz, ed., 1962, 1:no. 78 ill. (as School of Mantegna).

Jaffé, 1963, 466 (as Mantegna).

Selected Works from the Cleveland Museum of Art, 1966, no. 124 ill. (as Andrea Mantegna).

Handbook of the Cleveland Museum of Art, 1966, 1969, 87 ill. (as Andrea Mantegna); 1978, 99 ill. (as Andrea Mantegna); 1991, 67 ill. (as Circle of Andrea Mantegna).

COMMENTS:

Although Mantegna had painted frescoes of St. Christopher subjects for the Church of the Eremitani in Padua at the start of his career, he depicted no figure of the saint in

Fig. 12-A. Andrea Mantegna, *Bacchanal with a Wine Press,* ca. 1475, engraving, Washington, D.C., National Gallery of Art, gift of W. G. Russell Alton, 1941.1.5.

this pose. The sheet appears to be an early-sixteenth-century pastiche and is not referred to in major monographs on Mantegna. The inscription in the upper left, "from my own hand, Andrea Mantegna," is in sixteenth-century penmanship and in darker ink than the pen drawing of St. Christopher. It does not match Mantegna's signature or spelling.[2]

Exhibited and published with an Andrea Mantegna attribution, the drawing has a dry, marmoreal style with the flavor of Mantegna's manner, but the placement of the Christ child on the saint's shoulders is heavy-handed, and the infant's face has little of the sureness of

Mantegna's draftsmanship or the appeal of his figures. Problems of foreshortening appear in St. Christopher's left arm, and his ankles have been awkwardly thinned. In a passage that further removes the drawing from Mantegna, the saint's oily curls appear to hang from his halo rather than the back of his head.

The pose of St. Christopher repeats that of a nude Bacchus in Mantegna's engraving of ca. 1475 of *Bacchanal with a Wine Press* (Fig. 12-A), and the pose of the Christ child is that of an adjacent figure being carried by a fellow carouser and of a reveler on the wine barrel in this conflation of elements from Mantegna's print. Although by a Mantegna follower, the drawing is early. The sheet was mounted in an octavo album, one of a set of volumes dated "MCCCCC...," indicating that

2. Mantegna's signature can be seen in a letter in the Archivio di Stato, Mantua, sent to the Marchioness Isabella d'Este Gonzaga in 1506; reproduced in Martindale and Garavaglia, 1967, 84.

the volumes had been assembled some time in the sixteenth century.[3]

E. Tietze-Conrat has discussed the importance of Mantegna's engravings for motifs in works by other artists, such as a St. Christopher woodcut by Pseudo-Dürer that retains the

pose of the Bacchus figure in the winepress engraving, although the infant Christ is not like that in the Cleveland drawing.[4]

E. J. O.

3. On the provenance for this sheet see No. 1, n. 6, above.

4. Tietze-Conrat, 1924.

13. Gian Francesco de' Maineri (active 1489–1506), *Sacrificial Scene,* 1489–1490, Art Institute of Chicago, Regenstein Collection, 1989.686.

13

Gian Francesco de' Maineri (active 1489–1506), *Sacrificial Scene,* 1489–1490, 418 x 300 mm (16 1/2 x 11 7/8 in.), pen and black ink with brush and gray and brown wash, heightened with lead white (partially discolored), on cream laid paper, edge mounted to cream wove card, Art Institute of Chicago, Regenstein Collection 1989.686.

BIOGRAPHICAL NOTE: Born in Parma between 1460 and 1470, Gian Francesco de' Maineri studied in the workshop of the celebrated Ferrarese painter Ercole de' Roberti (1451/56–1496), long known to scholars as the largely hypothetical Ercole Grandi.[1] Maineri succeeded his master as the leading artist at the court of the d'Este family in Ferrara. He is documented as having executed commissions for the reigning duke, Ercole I d'Este, between 1489 and 1505, the year of Ercole's death; he is also recorded as having worked in Mantua during this period. Primarily a painter of court portraits and religious works, many of which he repeated, Maineri was also a miniaturist, as is indicated by the signature on a letter he wrote in Mantua on June 23, 1506, to Isabella d'Este, which has been transcribed as "Johannes Franciscus de Mayneriis inminiator."[2] In this

letter the sick artist asked for financial help for himself and his family, complaining that while he had begun work on certain paintings, he could not finish them because he had no money for supplies. It is thought that perhaps Maineri died shortly afterward, possibly in Lombardy.

TECHNICAL CONDITION: Water damage visible as splotchy brown staining throughout; numerous small repairs throughout; central horizontal crease; along the bottom an added band of paper, also a later restoration, extends about 20 mm into the composition. The drawing has been heightened with lead white, which was probably applied at a later date over the original ink and wash and which has oxidized. The crisp black lines may have been reinforced in certain areas at a later date with black ink.

INSCRIPTIONS: On verso, at lower left, in graphite: "From Davenport/Bromley, [illegible]."

COLLECTORS' MARKS: None.

WATERMARKS: Carnation within circle (Briquet, 1923, no. 6702, Ferrara, 1489).

PROVENANCE: Bromley-Davenport; John Malcolm; The Hon. A. E. Gathorne-Hardy, Newbury, Berkshire; Geoffrey Gathorne-Hardy; The Hon. Robert Gathorne-Hardy; sale, Sotheby's, London, November 24, 1976, lot 6; British Rail Pension Fund.

EXHIBITIONS:

(Unless stated otherwise, the drawing is attributed to Ercole de' Roberti in all exhibition catalogs and other publications before 1971, when it was assigned to

1. For various reasons (explained concisely in Lippincott, 1991, 8 n. 2), the painter now called Ercole de' Roberti was thought to be two different individuals: an earlier painter called "Ercole di Antonio de' Roberti" and a later painter believed to be a Bolognese pupil of Lorenzo Costa called "Ercole di Giulio Cesare Grandi."

2. Zamboni, 1975, 12. For the best summary of Maineri's work and career, see ibid., 10–23, 39–61.

Maineri by Philip Pouncey in the Colnaghi exhibition of Gathorne-Hardy drawings)

London, Royal Academy of Arts, 1930, *Exhibition of Italian Art, 1200–1900,* no. 601.

Ferrara, Italy, Musei Civici, 1933, *Mostra della pittura ferrarese del Rinascimento,* no. 239.

London, P. & D. Colnaghi, 1971, *Loan Exhibition of Drawings by Old Masters from the Collection of Mr. Geoffrey Gathorne-Hardy,* no. 8.

New York, Frick Collection, April 23–July 7, 1991, and Chicago, Art Institute of Chicago, September 10–January 5, 1992, *From Pontormo to Seurat: Drawings Recently Acquired by the Art Institute of Chicago,* no. 1.

BIBLIOGRAPHY:

Descriptive Catalogue of the Drawings . . . in the Possession of the Hon. A. E. Gathorne-Hardy, 1902, no. 39.

Schönbrunner and Meder, 1896–1908, 9:no. 1046 ill.

Gardner, 1911, 224.

Gronau, 1921, 507.

A. Venturi, 1926, fig. 9 (as Bramantino).

Balniel and Clark, 1931, 239, no. 752.

Popham, 1931, 42, no. 150, pl. 129.

Longhi, 1934, 170 n. 89; reprinted in Longhi, 1956, 5:103, n. 89.

Saxl, 1938–1939, 352, pl. 61b.

Ortolani, 1941, 191.

Salmi, 1960, 45, pl. 51.

Ruhmer, 1962, 246, n. 4.

Ruhmer, 1963, col. 621.

Zamboni, 1975, 12, 56, no. 33, pl. 1.

Vaccaro, 1976, no. 1 ill.

Stoichita, 1978, 41, fig. 23, also 70.

Lippincott, 1991, 6–21, color pl. 2.

COMMENTS:

One of the finest surviving examples of Ferrarese Renaissance draftsmanship, this monumental sheet represents an ancient sacrifice occurring in a severely classical setting.

Two symmetrically placed priests tend to the fire on the altar, which is surmounted with a statuette of a nude female deity—perhaps Diana or Venus—who carries a spearlike arrow in her right hand. A third priest slits the throat of a small animal, while his attendant holds a bowl to catch the blood.

Because Maineri's painting style encompasses a variety of influences, his works were for the most part attributed to some of his better-known contemporaries until at least the end of the nineteenth century. Such is the case with this drawing, which was originally attributed to Ercole Grandi by A. E. Gathorne-Hardy, and accepted as such for many years by most scholars. Gathorne-Hardy suggested this drawing was by the same hand as the small inset scenes in the base of the Virgin's throne in the so-called *Pala Strozzi* in the National Gallery, London.[3] As Kristen Lippincott has recently noted, one of the scenes, *Massacre of the Innocents,* is reminiscent of *Sacrificial Scene* in the way the figures are set within a shallow stage and backed by a triumphal arch.[4] This altarpiece was thought to be by Ercole Grandi until 1937, when Philip Pouncey, following a suggestion previously made by Roberto Longhi, proposed that it was a collaborative work by two other Ferrarese artists: Gian Francesco de' Maineri, who was responsible for the underpainting of the principal figures, the architecture, and the aforementioned small inset scenes, and Lorenzo Costa (1460–1535), who completed and "improved" the painting.[5]

3. For illustrations of the *Pala Strozzi,* and of the base of the Virgin's throne in this altarpiece, see Lippincott, 1991, figs. 2 and 12; also Zamboni, 1975, pl. 9, color pl. IV.

4. Lippincott, 1991, 21, fig. 23. This detail is also reproduced in Zamboni, 1975, fig. 11c.

5. Pouncey, 1937. Longhi (1934, 121 ff.; 1956, 72–73) rejected the attribution of the *Pala Strozzi* to Ercole Grandi, proposing instead that the design and

Pouncey's attribution has been accepted by subsequent scholars, including Silla Zamboni, who considered the drawing to be Maineri's earliest known work and dated it to the late 1480s, when Maineri was strongly influenced by Ercole de' Roberti. Zamboni noted that several key elements in the drawing, such as the large central arch, the classical statuette, and the turbaned heads, derived from Roberti, as did the overall conception of the scene, which explicitly recalls the central portion of a lost *Melchizedek and Abraham*.[6] As Zamboni also pointed out, Maineri's work can be distinguished from that of Roberti by the strict symmetry of the composition and by the lack of any vigorous or incipient movement in the figures. This latter quality is vividly expressed in Roberti's drawings, such as his quick pen-and-ink sketch for *Betrayal of Christ* in the Uffizi[7] and the more elaborate study for the more static and symmetrical *Massacre of the Innocents* in the Louvre.[8] By comparison, the execution of *Sacrificial Scene* is more precise and detailed, and the modeling is harder, as in the only other known drawing attributed to Maineri, a pen-and-ink sketch of two women and a child that is in the British Museum.[9] These differences in draftsmanship reveal the different responses of the

two artists to Andrea Mantegna. Whereas Roberti emulates Mantegna's soft chiaroscuro effects, Maineri ignores these while being specifically drawn to the lapidary permanence of Mantegna's figures. Maria Grazia Vaccaro has noted that the sharpness of Maineri's handling in this sheet almost rivals that of a miniaturist, which indeed he was. The one extant miniature by the artist, a *Circumcision* in the Biblioteca Reale, Turin, which has been dated around 1490 by Zamboni, is similar to this *Sacrificial Scene* in its relieflike figures and symmetrical composition.[10] Executed in tempera on vellum, the Turin miniature was originally attributed to Mantegna, presumably on account of the classicizing interpretation of the biblical scene, wherein the relieflike figures are symmetrically organized in front of and within an elaborate triumphal arch.

Although its large size and high degree of finish suggest the drawing was intended as a gift or presentation piece, Kristen Lippincott has argued that it was a final preparatory drawing, or *modello,* for a painting or part of a painting. Lippincott has suggested that the enigmatic sacrificial scene may have served as a pagan or Old Testament "type," or symbolic counterpart, to a New Testament event, or "antitype." The drawing could thus have served as a refined study for one such illusionistic "type" inset, similar in appearance to the inset panels in the base of the Virgin's throne in the *Pala Strozzi*.

L. M. G.

the execution of two of the figures was by Lorenzo Costa and that the remainder was by a younger Ferrarese artist he identified as Pellegrino Munari.

6. *Melchizedek and Abraham* is recorded in a copy formerly in the Murray collection in Florence, reproduced in Salmi, 1960, pl. 26b.

7. Inv. 1448E, reproduced in Lippincott, 1991, fig. 9.

8. Reproduced in Ciammitti, 1985, 181.

9. Inv. 1895-9-15-486; see Popham and Pouncey, 1950, 1:53, no. 154, 2:pl. 142. Vaccaro, 1976.

10. See Zamboni, 1975, 59–60, no. 41, pl. 2.

14. Anonymous, North Italian School, *Bust of a Young Priest in Profile,* mid-fifteenth century, Art Institute of Chicago, Margaret Day Blake Collection, 1957.59.

14

Anonymous, North Italian School, *Bust of a Young Priest in Profile,* mid-fifteenth century, 241 x 174 mm (9 1/2 x 6 7/8 in.), silverpoint on prepared gray white ground on salmon-tinted paper, Art Institute of Chicago, Margaret Day Blake Collection, 1957.59.

TECHNICAL CONDITION: Mounted on a blue-green album sheet that is stained and foxed in several places; large, brown stain in the lower center of the sheet extending up to the figure's chin; smaller discolorations in upper right corner; a number of cracks, the most evident extending vertically from the bottom edge through the face to the upper border; a smaller, diagonal crack running vertically through the back of the figure's head and a smaller, irregular tear running in from the left border; numerous hairline cracks all over, particularly on the left edge, but for the most part not reaching the figure. The paper was once disengaged into at least two sections along the upper part of the main vertical crack, and these sections, as well as the large tear in the upper left corner, have been fixed to the support sheet. A small (ca. 5 x 4 mm) piece of the original paper is missing at the bottom of the large vertical crack.

INSCRIPTIONS: On the recto, upper center, in pen and brown ink, "joane [jeane?] badille prete" (Giovanni Badille priest). Above and to the right of "badille" is a mark, usually described as the number "2" (but see Comments below). (According to the museum's files, "10" was written on the upper right in pen and brown ink and "38" was written in graphite at the left side; these numbers are no longer visible.) On the verso at the left edge in graphite, "39" and "40."

COLLECTORS' MARKS: The inscription (see above), generally accepted as identifying works from the Moscardo Collection (see below) (Lugt supp. 2990b–g).

WATERMARKS: None.

PROVENANCE: Moscardo Collection, Verona;[1] Richard Zinser, New York.

EXHIBITIONS:

Chicago, Art Institute, January 22–March 3, 1958, *The Carl O. Schniewind Memorial Exhibition of Prints and Drawings,* no. 1 (as "Anonymous Flemish, 15th century [circle of Rogier van der Weyden]").

New York, Wildenstein and Co., October 17–November 30, 1963, *Master Drawings from the Art Institute of Chicago,* no. 1, pl. I (as "circle of Rogier van der Weyden").

Chicago, Art Institute, April 28–June 7, 1970, *A Quarter Century of Collecting: Drawings Given to the Art Institute of Chicago, 1944–1970, by Margaret Day Blake,* no. 2 (as *"Portrait of a Cleric,* Anonymous North Italian, 15th Century").

Washington, D.C., National Gallery of Art, 1974–1975, *Venetian Drawings from American Collections,* no. I (*"Portrait of a Young Man in Profile,* Michele Giambono? ca. 1450").

BIBLIOGRAPHY:

1. This suggestion originated with Richard Zinser, the seller of the drawing, but without documentation (letter to C. O. Schniewind, April 6, 1957). Zinser also suggested the drawing had been part of an album of drawings. (See n. 6 below and No. 1, n. 6, above.)

"Accessions of American and Canadian
Museums, April–June, 1957," 1957, 317,
319 ill., no. 2 ("Flemish," "Circle of Rogier
Van der Weyden, ca. 1455").

Art Institute of Chicago Quarterly, 1957 ("Circle
of Rogier van der Weyden, Flemish, about
1455").

*Catalogue of the Carl O. Schniewind Memorial
Exhibition of Prints and Drawings,* 1958, no. 1
(*Portrait of a Cleric,* "Anonymous Flemish,
15th century [circle of Rogier van der
Weyden]").

Master Drawings from the Art Institute of Chicago,
1963, no. 1, pl. I ("Circle of Rogier van
der Weyden").

Frankfurter, 1963, 29, 56 ("North Italian, 15th
century").

Sonkes, 1969, 252–54, 275, pl. 68, no. E21
("very probably Italian, even Veronese,
attributable quite hypothetically to
Giovanni II Badile").

Joachim, 1970, no. 2.

Pignatti, 1974, 5, no. I (*"Portrait of a Young
Man in Profile,* Michele Giambono? ca.
1450").

Joachim and McCullagh, 1979, 19, pl. 1
("Anonymous North Italian, mid-fifteenth
century").

Joachim, 1979, 11, no. 1A3, repr. on enclosed
microfiche, no. 1A3 ("Anonymous, mid-
fifteenth century, Northern Italy").

COMMENTS:

The drawing represents a half-length por-
trait of a young man, possibly a priest, facing
left in near profile. His hair is trimmed in a
"bowl-cut" style—cut straight around the
head with the neck and back of the head
shaved—commonly found in northern Italy
and northern Europe in the late fourteenth
and early fifteenth centuries. In the young
man's right hand, only sketchily indicated, is
an unidentified object, possibly a crozier or
the stem of a flower.[2] The subject is dressed in

a loosely fitting robe with a sleeve decorated
in what seem to be shirred, scalloped ribbons.

This carefully executed silverpoint drawing
presents problems of attribution, subject, and
date, problems made more complex by the
inscription on the sheet. The latter—"joane
[jeane?] badille prete" (Giovanni Badile
priest)—may be read as a signature of either
the artist or a past owner, a description of the
artist by a later hand, or, as is usually the case,
a later identification of the artist ("Giovanni
Badile") and a description of the subject
("Priest"). In addition, a small character is
inscribed slightly above "badille," generally
interpreted as "2."

In its first appearances in the literature the
drawing was associated with the work of
Rogier van der Weyden because of its general
resemblance to the fine-lined silverpoint
drawings by that painter or after his work.[3]
For the most part, however, the drawing has
been considered north Italian—more specifi-
cally Veronese—and dated toward the middle
of the Quattrocento. The work of Pisanello
(before 1395–1455/1456) has been pointed
out on several occasions as offering compar-
isons in both the appearance of the subject

2. Sonkes, 1969, 252.
3. The sheet was, in fact, bought by the Art
Institute with an attribution to Rogier. Sonkes (1969,
253) suggests "it is the expressive character of the
drawing and a certain affinity of modeling with that
of *Laurent Froidmont,* as he appears in the portrait in
the Musées Royaux des Beaux-Arts, in Brussels (no.
922), that makes one think of Rogier van der
Weyden." According to the archives of the Art
Institute's Department of Prints and Drawings, Erwin
Panofsky, in a letter of April 1, 1957 (to C. O.
Schniewind), though admitting the difficulty of judg-
ing a drawing known only from a photograph, indi-
cated that he did not recognize the sitter's face.
Further, he felt that it was "out of the question" that
Rogier could have produced the drawing, because of
its "somewhat haphazard graphic quality [and] such
palpable faults of design as the articulation of the
hand, the form of the skull, and the placement of the

(particularly because of the type of haircut) and, less often, the drawing's style.[4] It is the inscription, however, that has suggested an alternative attribution to a member of the Badile, the family of artists active in Verona from the late fourteenth century through much of the fifteenth. The most notable of these painters was Giovanni Badile (ca. 1379–before 1451; work documented 1409–1447), a follower of Stefano da Zevio (Stefano da Verona) whose career coincides with the period of the Chicago silverpoint. As it happens, however, a number of drawings have been reliably attributed to Giovanni Badile,[5] and the far looser and sketchy style of these works, rather in the manner of Stefano and early Pisanello, does not confirm the attribution of the Chicago drawing to him.

On the other hand, it is known that some of the Badile drawings that came from the Moscardo collection,[6] as is thought to be the case with the Chicago sheet, carry inscrip-

tions similar to that of the latter. These inscriptions have been attributed to one Antonio II Badile (d.1507), who collected drawings by, or thought by him to be by, members of his family and who, in an effort to classify these works, wrote an attribution on each. The handwriting on the Chicago piece does, in fact, closely correspond with the inscriptions apparently placed by Antonio on these works; one of them carries the inscription "di m(aestro) Joane primo Badille" and another, "Zuan primo Badile," which is to say, "Giovanni Badile, the first."[7] For this reason, it has been concluded by Micheline Sonkes that the son of this "Master Giovanni, the first, Badile"—Giovanni II Badile—might be the author of the Chicago sheet, a suggestion supported by the inscription on the latter that seems to contain a "2" in reference to the inscribed name.[8]

There are, however, several problems with the reasoning that leads to these conclusions. First, although Antonio Badile, in the annotations to his drawing collection, mentioned a "Giovanni II" as the author of several profile portraits, those works have not been identified and, thus, cannot supply the needed comparison to the Chicago work. Second, while the identification of a "2" on the Chicago drawing would seem to allude to the named "joane badille," the addition of "prete" mitigates the clarity of that reference; that is, why should the description of the subject, supposedly a priest ("prete"), be appended directly

right [sic] ear." Panofsky added that there was a "rather remarkable similarity, in faults as well as virtues" between the silverpoint and the work of an artist named by the author as "The Master of the Abegg Altarpiece" (1953, 1:298–302; 2:figs. 398–400, where, however, the artist is simply called a "Follower of" Rogier). Panofsky concludes that the "Italian character" of the drawing is "not so much a matter of style as a matter of physiognomy and costume."

4. According to Joachim and McCullagh (1979, 19), the Veronese origin was first suggested (verbally?) by Pouncey. On the style, see, for example, Sonkes, 1969, 253. The suggested attribution of Michele Giambono (Pignatti, 1974, 5) was not accepted by Joachim and McCullagh; see Guzzo, 1992, 216–18, for full bibliographic information.

5. *Catalogue of Important Old Master Drawings*, 1963, nos. 64, 66–68, 71–73, 75–85, 88, ill.

6. The prints, drawings, and other miscellanea collected by a sixteenth-century Veronese, Count Lodovico Moscardo, were dispersed in the early nineteenth century. No evidence conclusively places the Chicago silverpoint in the collection. For other drawings from the Moscardo collection, see Nos. 1, 3, 12, 22.

7. The suggestion that Antonio II was responsible for these inscriptions was made by Degenhart and Schmitt (1967, 50, nos. 3–4, pls. 2–3). The drawings (Munich, Staatliche Graphische Sammlung) represent *The Presentation in the Temple and the Marriage of the Virgin* and *The Kiss of Judas and a Head of a Boy and a Man Seen from the Back*.

8. According to Joachim and McCullagh (1979, 19), this was a (verbal?) suggestion by Bertha Wiles.

to the artist's name?[9] Finally, why would Antonio write "first" ("primo") in two other inscriptions but here adopt an arabic numeral? There is, moreover, an additional problem with the identification of the "2" in the inscription, for upon close examination the character can be seen to have been made in one smooth stroke, without the pen reversing direction at the figure's base, as is commonly the case. As a result, the detail has more the appearance of a decorative embellishment than a number, an impression that is strengthened by the presence of two small dots on each side of the downstroke.

It is thus evident that the value of the inscription on the Chicago drawing in establishing its authorship must be considerably tempered. If, for the sake of the argument, one accepts that the inscribed name was meant to be that of the painter Giovanni Badile II, and that "prete" was meant to identify the subject as a priest,[10] there is no assurance that Antonio Badile's inscription was anything more than a hopeful assumption. All of which is not to say that the ingenious solution to the problem of attribution offered by Sonkes is not correct. But her attribution—based as it is on the none-too-reliable significance of the drawing's inscription—requires that we accept it, with her own qualifying statement, as "quite hypothetical." Pending more conclusive evidence, caution suggests that the Chicago figure should simply be called (per Pignatti) "Anonymous Bust of a Young Man in Profile." Certainly, "Anonymous North Italian, ca. Mid–Fifteenth Century," seems the most prudent identification of the work's origins.

R. M.

9. No such double identification is found on the other drawings.

10. This is suggested, but not confirmed, by the style of haircut. This style of hair is, in fact, commonly found on secular as well as priestly subjects of the period. It is also worth noting that there is nothing about the figure's clothing that necessitates an identification as a priest; indeed, if anything, the clothing, more specifically the design of the sleeve, suggests a secular costume.

Bernardo Parentino

Bernardo Parentino (ca. 1437–1531), iden-
tified with Bernardo da Parenzo, was a
native of Istria who worked in Padua. A late
follower of Andrea Mantegna (which is
immediately evident from his archaeological
interests and dry line), he was active well into
the sixteenth century. He is best known for
his frescoes in Santa Guistina, Padua, which
he began in 1496. A signed easel painting by
Parentino, *The Redeemer between SS. Augustine
and Jerome,* is in the Galleria Estense, Modena.
A few other paintings have been attributed to
him on the basis of this signed work.[1]

The first of the two drawings in midwest-
ern collections given to Parentino, *Allegory of
Plenty and Peace,* in Cleveland, fits with the
artist's known works. The second drawing, in
the Art Institute in Chicago, relates to his
style in its general classicizing subject matter
and the relieflike treatment of the figures.
However, the handling of the pen suggests a
less close association with Parentino himself.

1. Wazbinski, 1963b; Salmazo, 1989. The latter

reproduces all the paintings and drawings that she
accepts as by Parentino. For earlier references to this
artist, see Thieme and Becker, 1901–1956, 26:231–32;
Crowe and Cavalcaselle, 1912, 11, 61, no. 1.

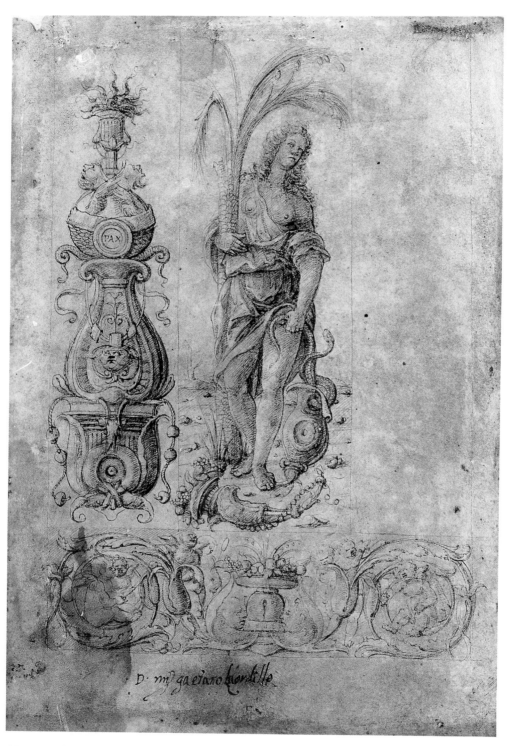

15. Bernardo Parentino da Parenzo (ca. 1437–1531), *Design for a Candelabrum: Allegory of Plenty and Peace,* ca. 1510, Cleveland Museum of Art, purchase, John L. Severance Fund, 56.41.

15

Bernardo Parentino da Parenzo (ca. 1437–1531), *Design for a Candelabrum: Allegory of Plenty and Peace,* ca. 1510, 254 x 171 mm (10 x 6 3/4 in.), pen and brown ink, Cleveland Museum of Art, purchase, John L. Severance Fund, 56.41.

TECHNICAL CONDITION: Soiled; large stain lower left; two repairs at upper left corner.

INSCRIPTIONS: At bottom in pen and dark brown ink in a later hand, "D. mi gaetano Laordillo"; in artist's hand on sphere of finial at top left, "PAX."

COLLECTORS' MARKS: Possibly Gaetano Laordillo.

WATERMARKS: None observed

PROVENANCE: Antonio II Badile, Verona; Moscardo (Lugt supp. 2990c); Calceolari (under Lugt supp. 2990a); Francis Matthiesen, London.

EXHIBITIONS:
Detroit Institute of Arts, November 17, 1958–January 6, 1959, *Decorative Arts of the Italian Renaissance, 1400–1600,* no. 6 (as Bernardo Parentino).
Cleveland Museum of Art, March 6–April 22, 1979, *The Draftsman's Eye,* no. 116 (as Parentino).
Cleveland Museum of Art, November 2, 1982–March 20, 1983, *Master Goldsmiths of the Renaissance: Their Models and Designs* (as Parentino).
Cleveland Museum of Art, December 15, 1986–March 1, 1987, *Italian Drawings from the Permanent Collection* (as Bernardo Parentino).
Cleveland Museum of Art, August 7–October 28, 1990, *Design and Decoration: Ornament Prints* (as Bernardo Parentino).

BIBLIOGRAPHY:
Bulletin of the Cleveland Museum of Art, 1958, 66 ill. (as School of Andrea Mantegna).
Francis, 1958b, 194 ill., 199–200 (as Parentino).
"Accessions of American and Canadian Museums, April–June 1958," 1958, 336 ill. (as Bernardo Parentino).
"Acquisti di Musei Americani," 1959, 58 ill. (as attributed to Bernardo Parentino).
Grigaut, 1959, 25, no. 6 (as Bernardo Parentino).
Wazbinski, 1963a, 24, fig. 21 (as Parentino).
Olszewski, 1981, 142, no. 116 (as Parentino).
Shaw, 1983, 1:221, n. 4.

COMMENTS:

The tight pen technique, gritty texture, plainness of features, and antiquarian interests in this sheet relate it to other drawings associated with Parentino (Fig. 15-A).[1] The independent nature of the three designs on the page suggests this sheet may have been part of a shopbook, with the drawings to be used for various purposes. Although the page is divided into one horizontal and three vertical strips of about equal width, not all of the sketches were necessarily meant to be used as decorative borders for manuscript pages. The bottom design could have served that function but is also appropriate for a cassone relief, whereas that along the left border has a modeled quality appropriate for a finial,

1. Wazbinski, 1963b, 24.

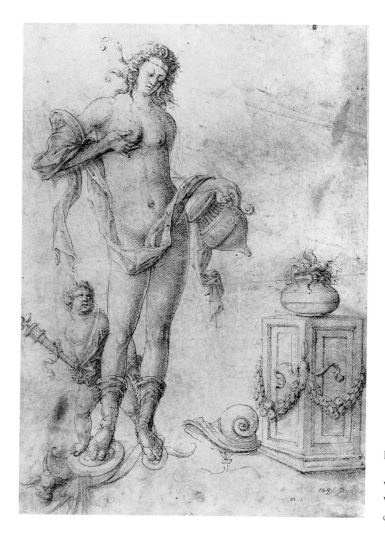

Fig. 15-A. Bernardo Parentino, *Venus and Amor,* drawing, London, Victoria and Albert Museum. Victoria and Albert Museum, by courtesy of the Board of Trustees.

candlestick, or bishop's staff. The inscription "PAX" on the latter's sphere could be appropriate for either religious or secular usage. The central figure is placed in an illusionistic setting more suitable for a painting. She appears to be a personification of Abundance, her date palm, cornucopia, serpents, and bared breasts indicative of prosperity, health, and fertility.

No precise date can be determined for these sketches. Although they seem to be from the fifteenth century in treatment of outline and surface, the emphasis on volume might suggest the new interests of the next generation and a date closer to 1510.

E. J. O

16

Attributed to the Circle of Bernardo Parentino, *Triumph of Cybele,* late 15th century?, 182 x 291 mm (7 3/16 x 11 7/16 in.), pen and brown ink on tan-laid paper, laid down on buff-laid paper, Art Institute of Chicago, Leonora Hall Gurley Memorial Collection, 1922.48.

TECHNICAL CONDITION: Trimmed unevenly on all four sides; upper corners rounded; lower corners cut at an angle; an overall sense of abrasion, with numerous holes, some of which have been filled and redrawn, small tears, and stains; obvious redrawing on the belly and left forepaw of the lion, on the neck of the female figure walking behind the triumphal cart, and on a spot directly in front of her right knee; two vertical creases divide the sheet into thirds and suggest it was once folded in three.

INSCRIPTIONS: In block letters on the flag at the upper edge, presumably by the artist, "CIBELE"; in script to the right of the flag, "Cibele." The tops of both inscriptions were cut when the sheet was trimmed. The verso of the sheet is filled with inscriptions and marks, including the attribution to Andrea Mantegna formed in block letters in ink at the lower left; the same attribution in small script in graphite in the center left; childlike, unreadable graphite marks at various locations; "J. D. Murray" in graphite at the left center; an illegible inscription in graphite at the lower left; and "22A8" also at the lower left in lavender ink.

COLLECTORS' MARKS: The mark of William F. E. Gurley appears below the lions pulling the triumphal cart and on the verso as well. The verso also includes the stamp of the Leonora Hall Gurley Memorial Collection (Lugt supp. 1230b), and in the lower right a stamp in lavender ink that reads "Frederick R. Aikman collection Sold Mch 14, 1913 by Puttick & Simpson."

WATERMARKS: None.

PROVENANCE: J. D. Murray; Frederick R. Aikman; William F. E. Gurley.

EXHIBITIONS: None.

BIBLIOGRAPHY: None.

COMMENTS:

The drawing has been attributed to Andrea Mantegna (1431–1506), Francesco Squarcione (1397–1468), and Marco Zoppo (1433–1478), as well as Bernardo Parentino. It is related to the work of Mantegna and the school of Mantua by the proportions of the figures and the drawing technique. The drawing is not by the same hand as other drawings emulating ancient Roman reliefs that have been attributed to Parentino.[1] These are elegant and more precisely drawn than *Triumph of Cybele.*

Cybele was the great mother goddess of ancient Anatolia, where she was considered the mother of all living things, including gods and men. She was known in Greece by the fifth century B.C. and was associated with

1. The drawings have been published by Shaw, 1934–1935, and Wazbinski, 1963b, 21–26, who also refers to other drawings by the same hand. I would like to thank Susan J. Ross, research assistant in the Department of Prints and Drawings of the Chicago Art Institute, for her assistance in preparing this entry.

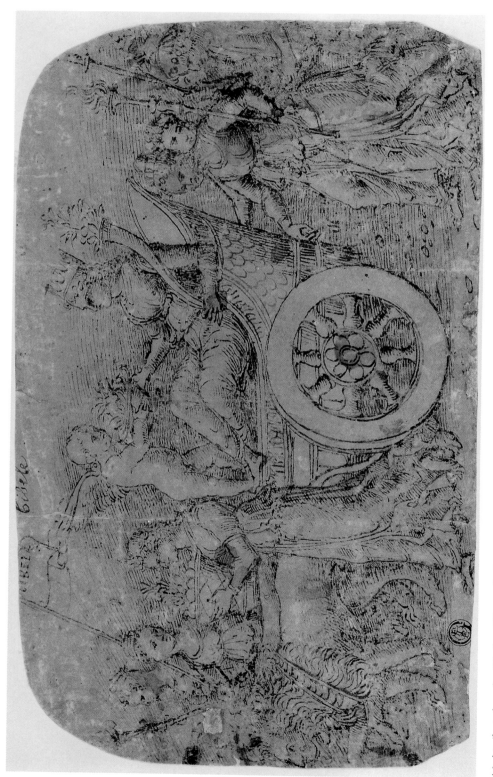

16. Attributed to the Circle of Bernardo Parentino, *Triumph of Cybele*, late fifteenth century?, Art Institute of Chicago, Leonora Hall Gurley Memorial Collection, 1922.48.

Demeter. Throughout antiquity Cybele's attributes are the mural crown, which she wears in the Chicago drawing, tympana or cymbals, the sacred tree, and lions. In Roman and medieval representations she often is depicted riding in a triumphal cart pulled by lions.[2] The drums and/or cymbals represent the ecstatic nature of her cult, and the lions, the wildness of nature. The sacred tree, which Cybele holds in her left hand in the Chicago drawing, probably represents fecundity. The companions of Cybele who walk beside her cart seem to be unique to the drawing, as are the bowls of fruit and the amoretto standing in front of Cybele on her cart. The addition

of these figures suggests that the author of the drawing combined elements from a number of sources. The figure of Cybelle riding in a chariot pulled by lions is reminiscent of a relief in the Villa Albani. The relief was known in the late Quattrocento. The amoretto may have been taken from a statue or statuette of *Fortuna,* whose attributes in Roman times included the mural crown, a cornucopia (shaped like the container of the sacred tree in the drawing), and an amoretto.[3]

M. S. W.

2. Sources for Cybele's attributes include Cartari, 1647 (reprint 1963), 110–17; F. R.W., "Cybelle," *The Oxford Classical Dictionary,* 1961, 246–47; Steinbrucker and von Erffa, 1954; and Seznec, 1953, 167–69.

3. The relief in the Albani collection and statuettes of *Fortuna* are discussed by Mandowsky and Mitchell, 1963, 67, cat. no. 27, and 79, cat. no. 51. I am grateful to Edward Olszewski for calling the Albani relief to my attention.

Pietro Perugino

Pietro Perugino (1445/50–1523) was born in Città della Pieve near Perugia. He was in Florence by 1472, as recorded by his enrollment in the painters' confraternity. Perugino was one of the major figures involved in the fresco commission for the walls of the Sistine Chapel in 1481–1482. His earlier projects in the Vatican (1478–1479) have not survived.

As the master of a popular workshop, Perugino received numerous commissions for frescoes and altar panels. His signed and dated altarpiece of 1493 for San Domenico in Fiesole, *Virgin and Child Enthroned with St. John the Baptist and St. Sebastian* (Fig. 17-A), now in the Uffizi, was painted a year before his *Portrait of Francesco del Opere,* also in the Uffizi. He received commissions in the following decade from the Doge in Venice, Isabella d'Este, and the Sienese banking family of the Chigi.

Among Perugino's best works are his frescoes in Cestello (1493–1496), the murals for the Cambio in Perugia (1496–1500), and his allegory for Isabella d'Este's studio, the *Battle between Love and Chastity* (1503–1505), now in the Louvre.

Perugino studies have advanced in recent years with the publication of Pietro Scarpellini's monograph and Sylvia Ferino Pagden's essays on the artist's working methods.[1] The two drawings by the artist cataloged here are remarkably similar in their subjects, their carefully modeled forms on prepared paper, and even their sizes. Acquired within twenty-five years of one another, the works clearly offer evidence of Perugino's calculated accuracy of line and his propensity for highly plastic renditions of human figures in an economy of poses.

1. Scarpellini, 1984; Pagden, 1987; Pagden, 1979.

17

Perugino (Pietro di Cristoforo Vannucci, 1445/50–1523), *St. Sebastian,* ca. 1493, 256 x 146 mm (10 1/16 x 5 3/4 in.), metalpoint, brush and brown wash heightened with white on prepared pink paper, Cleveland Museum of Art, purchase, Dudley P. Allen Fund, 58.411.

TECHNICAL CONDITION: Paper rubbed, but hints of white highlighting remain; vertical tear in upper left corner; vertical crease along top right edge; tiny wormholes scattered throughout; horizontal abrasion at lower left.

INSCRIPTIONS: None.

COLLECTORS' MARKS: Lower left, von Fries (Lugt 2903).

WATERMARKS: None observed.

PROVENANCE: Count Moriz von Fries, Vienna, ca. 1820; Prince of Liechtenstein; Herbert N. Bier, London.

EXHIBITIONS:
Cleveland Museum of Art, December 2–20, 1959, *The Year in Review for 1959* (as Pietro Perugino).
Cleveland Museum of Art, July 13–September 19, 1971, *Florence and the Arts: Five Centuries of Patronage* (as Pietro Perugino).
Cleveland Museum of Art, February 19–March 23, 1980, *Idea to Image: Preparatory Studies from the Renaissance to Impressionism* (as Pietro Perugino).
Cleveland Museum of Art, June 14–September 18, 1983, *National Schools of Style* (as Perugino).
Cleveland Museum of Art, December 15, 1986–March 1, 1987, *Italian Drawings from the Permanent Collection* (as Perugino).
Cleveland Museum of Art, November 19, 1991–January 12, 1992, *The Recovery of a Renaissance Painting: A Madonna by Pintoricchio.*

BIBLIOGRAPHY:
Van Marle, 1923–1938, 14:396, 538 (as Perugino).
Art Quarterly, 1959, 396 ill. (as Pietro Perugino).
"The Year in Review, 1959," 1959, 231, ill. 212 (as Pietro Perugino).
Moskowitz, ed., 1962, 1:no. 241 ill. (as Perugino).
Richards, 1962, 170–72 (as Pietro Perugino).
Selected Works from the Cleveland Museum of Art, 1966, no. 123 ill. (as Pietro Perugino).
Handbook of the Cleveland Museum of Art, 1966, 1969, 83 (as Pietro Perugino).
Aymar, 1970, 56 (as Perugino).
Pillsbury, 1971, no. 53 (as Pietro Perugino).
Handbook of the Cleveland Museum of Art, 1978, 95 ill. (as Pietro Perugino).
Borowitz, 1978, 58 (as Perugino).
Johnson, 1980, 33–35, fig. 28 (as Pietro Perugino).
Handbook of the Cleveland Museum of Art, 1991, 67 ill. (as Perugino).

COMMENTS:
Fewer than eighty drawings survive from Perugino's long career. They include no drapery studies, architectural designs, or landscape sketches. Many are attempts to fix pose or movement in individual figures. Metalpoint was often used for this purpose in the fifteenth century as well as for cos-

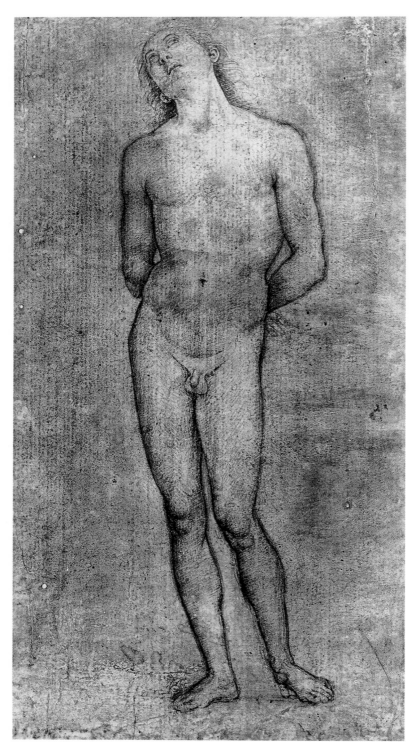

17. Perugino (Pietro di Cristoforo Vannucci, 1445/50–1523), *St. Sebastian,* ca. 1493, Cleveland Museum of Art, purchase, Dudley P. Allen Fund, 58.411.

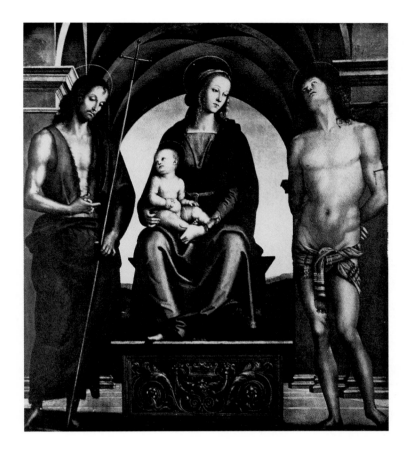

Fig. 17-A. Perugino, *Virgin and Child Enthroned with St. John the Baptist and St. Sebastian,* 1493, tempera on panel, Florence, Uffizi.

tume and head studies.[1] Perugino's figure poses were frequently taken from live models, often in everyday apparel. Only on rare occasions did he show a figure posed nude or in undergarments, so that the Cleveland sheet is extraordinary for its depiction of a completely nude figure.

As a study from nature, the Cleveland drawing represents a fourth stage in the process of composition as practiced during this time.[2] After the quick compositional sketch came reworking of details of the whole, leading to a refined composition study, followed by detail studies from nature, such as Perugino's *St. Sebastian.* The nature studies

would next be incorporated into the drafting of the final composition.

This may be the same drawing as the Perugino *St. Sebastian* that sold in Frankfurt in 1889 for 301 marks.[3] The Frankfurt sheet has been published by Louise S. Richards.[4] It is the artist's study of a workshop assistant posed as a figure of St. Sebastian for the altar panel of *Virgin and Child Enthroned with St. John the Baptist and St. Sebastian* (Fig. 17-A), now in the Uffizi but originally painted about 1493 for the Church of San Domenico in Fiesole. A study by Perugino in Windsor Castle for the head of the Virgin in this paint-

1. Mongan, 1987, 151.
2. Pagden, 1987, 77.

3. For information on the sale, see Prestel, Frankfort, December 4–5, 1889; Lugt 947.
4. Richards, 1962.

Fig. 17-B. Perugino, *Study of the Virgin,* ca. 1493, silverpoint, Windsor Castle, the Royal Collection, Her Majesty Queen Elizabeth II.

ing is also in metalpoint with white heightening on prepared pink paper (Fig. 17-B).[5] Other paintings in the Louvre and in the Villa Borghese collection in Rome depict only St. Sebastian, but in an identical pose.[6]

Perugino's earliest surviving *St. Sebastian,* a fresco fragment now in the Vatican from 1478 (Fig. 17-C), is a mirror image of the Cleveland figure in its pose. The drawing can also be related to Perugino's recently cleaned fresco *Martyrdom of St. Sebastian* in Panicale from 1505–1507 (Fig. 17-D), in which the martyr's posture is unchanged. The composition is novel for Perugino but reminiscent of Pollaiuolo's *St. Sebastian* of 1475 in the National Gallery, London, in its use of archers

seen from different angles.[7] The drawn figure lacks a halo and casts no shadow; it is nude, unlike the painted figures in the Uffizi, Louvre, and Borghese, who wear loincloths. All retain the foreshortened face, upturned eyes, and characteristic toe-dragging stance that is Perugino's personal permutation of the classical *contrapposto* pose. The loincloths differ in design and color in all three paintings, and only the Uffizi St. Sebastian casts a shadow at his feet. But one arrow pierces the Uffizi saint, whereas there are two arrows in the Louvre figure and four in the Borghese martyr; only the latter shows a rope bound about the saint's left arm.

7. Scarpellini (1984, 110–11, no. 134; 259, fig. 227) comments on what he considers to be Perugino's original interpretation of the composition in his discussion of this fresco, but he makes no reference to the Cleveland drawing.

5. Ames-Lewis and Wright, 1983, 314–17, no. 73.

6. These three paintings are reproduced in Johnson, 1980, 33–35.

Fig. 17-C. Perugino, *St. Sebastian,* 1478, fresco fragment, Rome, Vatican.

Fig. 17-D. Perugino, *Martyrdom of St. Sebastian,* 1505–1507, fresco, Panicale, San Sebastiano.

Perugino's foreshortening of his model's upturned face led to some difficulty in the addition of ears, the placement of which is not convincing; in the paintings he covered the figures' ears with hair. He corrected his description of the right elbow with a slight turn in the figure of St. Sebastian in the Uffizi painting. The three fingers of the model's right hand, which emerge faintly at the hip just below the left arm in the drawing, are clearly stated in the Uffizi, Louvre, and Borghese paintings.

The Cleveland model is identical in pose to figures, both male and female, in other paintings by Perugino. Giorgio Vasari criti-cized the artist for his laziness and lack of imagination in repeating poses,[8] but static poses and formulaic shop practices were typical of the times. Recent infrared studies of metalpoint figure drawings by Perugino show black chalk underdrawings with variations in composition.[9] Perugino's interest in serenity and in human anatomy reflects the classical spirit that would inspire his gifted follower, Raphael.

E. J. O.

8. Vasari, 1906, 3:586.
9. Pagden, 1987, 99–100, figs. 26-27.

18

Perugino (Pietro di Cristoforo Vannucci, 1445/50–1523), *Study for the Baptism of Christ,* ca. 1480–1490, 278 x 123 mm (10 15/16 x 4 13/16 in.), opaque brown watercolor heightened in gray, white, and pale ocher over stylus on prepared pink paper, Kansas City, Nelson-Atkins Museum of Art, Nelson Trust, 34-300/2.

TECHNICAL CONDITION: Examination with a binocular microscope in April 1982 confirmed that the medium included gray highlights and not discolored white pigment, as had been suggested. A full examination in autumn 1988 revealed that the drawing had undergone a great deal of restoration, especially in the form of multiple retouchings. In the course of a subsequent conservation treatment, some of these retouchings were removed and the losses in-painted; the modern, dark brown overpaint in the background was also removed. There is no visual evidence to support the frequent assertion that the drawing's media include silverpoint. (Conservation report by Mark Stevenson, former assistant conservator of works on paper, March 5, 1992).

INSCRIPTIONS: In graphite on verso, "F. Lippi."

COLLECTORS' MARKS: Unidentified (crowned initial); Emile Wauters, Brussels (Lugt 911).

WATERMARKS: Handscales, similar to Briquet, 1923, nos. 2376, 2437.

PROVENANCE: Emile Wauters (1846–1933), Brussels; Frederick Müller & Cie., Amsterdam, E. Wauters sale, June 15–16, 1926; Mrs. Dudley Blois.

EXHIBITIONS:
Detroit Institute of Arts, June 1–September 15, 1950, *Loan Exhibition of Old Master Drawings from Midwestern Museums,* no. 41 (as Perugino).

St. Louis, Washington University Gallery of Art, September 22–December 3, 1989, *Master Drawings from the Nelson-Atkins Museum of Art, Kansas City, Missouri* unnumbered (as Perugino).

Kansas City, Nelson-Atkins Museum of Art, February 17–March 25, 1990, *Master Drawings from the Permanent Collection* (as Perugino).

BIBLIOGRAPHY:
The William Rockhill Nelson Collection, 1941, 98 ill. fig. 8 (as Perugino).

The William Rockhill Nelson Collection, 1949, 123 ill. (as Perugino).

"Artists' Handwriting Makes Good Reading at the Detroit Institute," 1950, 9 ill. (as Perugino).

Handbook of the Collections in the William Rockhill Nelson Gallery of Art and Mary Atkins Museum of Fine Arts, 1959, 63 ill. (as Perugino).

Hoetink, 1962, 26, cited under no. 15 (records E. Haverkamp Begemann's verbal comparison of Nelson-Atkins drawing to two male nude studies by Benozzo Gozzoli in the Boymans–van Beuningen Museum).

Taggart and McKenna, eds., 1973, 1:177 ill. (as Perugino).

Ward and Weil, 1989, 9, 14 ill. (as Perugino).

COMMENTS:
This drawing is seldom discussed in the

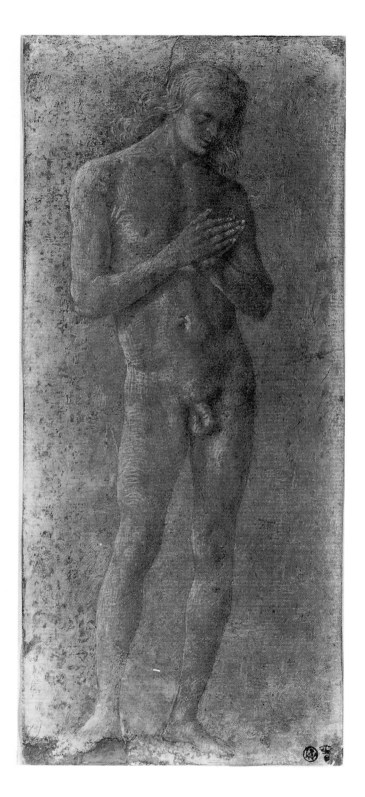

18. Perugino (Pietro di Cristoforo Vannucci, 1445/50–1523), *Study for the Baptism of Christ,* ca. 1480–1490, Kansas City, Nelson-Atkins Museum of Art, Nelson Trust, 34-300/2.

Fig. 18-A. Perugino, *Baptism of Christ,* 1481–1482, fresco, Rome, Vatican, Sistine Chapel.

literature on Perugino. Its critical status is difficult to determine given its very worn condition and the existence of multiple restorations. Still, the sinuous anatomy and white highlighting compare favorably with Perugino's autograph study in the Gallerie dell'Accademia in Venice for his painting *Apollo and Marsyas* of ca. 1490 in the Louvre.[1] The treatment of the hair and the manner of applying the white highlights also recall similar features in the autograph *Head of a Boy* in the Uffizi, which has been associated with the time of Perugino's work in the Sistine Chapel in Rome.[2] In short, the technical and stylistic

qualities of this drawing imply it is an autograph work from the 1480s.

The Kansas City sheet is undoubtedly a study for the figure of Christ in a scene depicting his baptism. Perugino and his workshop depicted this theme on at least eight occasions.[3] Although the pose in the present drawing resembles the overall position of the Christ figure in each of these works, it differs from all of them in the more horizontal placement of the hands. The figure is also less mannered than all of the painted figures of Christ, with the exception of that found in the *Baptism of Christ* fresco (executed 1481–

1. For the study, see Scarpellini, 1984, fig. 79, and Pagden, 1984, no. 54 ill. For the painting, see Scarpellini, 1984, 85, in which alternative dates are recorded. According to Scarpellini, the panel actually represents Apollo and the young shepherd Dafni.

2. Gabinetto Disegni e Stampe degli Uffizi, inv.

no. 416E, recto, brown wash, white lead, traces of metalpoint and black chalk on beige-tinted paper, 105 x 103 mm (overall size). For this work, see, most recently, Pagden, 1982, no. 8, fig. 9.

3. See Scarpellini, 1984, nos. 31, 79, 121, 142, 157, 158, 161, 170.

1482) in the Sistine Chapel (Fig. 18-A).[4]
Here the Christ (which was most likely exe-
cuted by Perugino himself) has the same

comparatively rugged body type found in the
Kansas City drawing. However, given the
drawing's condition, we can only tentatively
suggest that the latter represents a study draw-
ing for the figure in the Sistine Chapel fresco.

E. R.

4. Ibid., 78, no. 31, fig. 44. Part of the fresco's exe-
cution is due to pupils and/or colleagues of
Perugino, although the figures of Christ, the Baptist,
and attendants are usually attributed to the master.

19

Antonio Pisano, called Pisanello (before 1395–ca. 1455/56), *Studies of the Emperor John VIII Palaeologus, a Monk, and a Scabbard* (recto) and *Bowcase and Quiver of Arrows* (verso), 1438, maximum 190 x 266 mm (7 1/2 x 10 1/2 in.), pen and brown ink on ivory-laid paper, Art Institute of Chicago, Margaret Day Blake Collection, 1961.331.

BIOGRAPHICAL NOTE: Pisanello, one of the most prominent practitioners of the Italian version of the "International Style," was born in Pisa around 1395, perhaps a few years earlier. About 1404–1405 his mother, remarried after the death of her husband, moved the family back to her native city of Verona, where the boy was raised. After his early training, possibly with Stefano da Zevio (Stefano da Verona) but more assuredly with Gentile da Fabriano, the artist enjoyed a busy and successful career, working in both tempera and fresco and, with Gentile, creating some of the most important religious and historical murals (now mostly destroyed) of the early Quattrocento. In addition, Pisanello is generally recognized as the first major Renaissance (and therefore modern) artist to produce medals, of which some two dozen examples are extant. The artist was also a prolific draftsman, and many of his drawings have been preserved, including designs for his medals, cartoons for frescoes and panels, copies after the antique, drawings of wild and domestic birds and animals, and records of historical events, such as those represented in the Chicago sheet. The artist worked exten-sively in northern Italy—Verona, Mantua, Ferrara, Venice, Pavia, Milan, and perhaps Florence—but also in Rimini and Rome and as far south as Naples.[1]

TECHNICAL CONDITION: Trimmed, probably by about 1.5 cm in height and 3.5 cm in width;[2] a number of small tears, but in general in very good condition; slight tear at the bottom edge in the center (recto) that extends through the feet of the central figure and part of his cloak, and four small tears along this same edge; another tear just over the foot of the horseman on the left and a longer horizontal tear on the left edge that goes through the head of the horse and reaches the rider's face. (This was once repaired with the addition of a strip of paper on the verso, covering part of the quiver's straps. Although this tear has long since been repaired and the strip removed, the latter appears in all previously published photographs of the drawing.)

INSCRIPTIONS: On the recto above the central figure, "chalone" (or "chaloire").

COLLECTORS' MARKS: None.

WATERMARKS: Oxhead (Briquet, 1923, no. 14.811, Vicenza, 1423).

1. For more detailed biographical accounts, see G. F. Hill, "Pisanello, Antonio di Puccio Pisano," in Thieme and Becker, 1901–1956, 27:92f; Degenhart, 1972; Paccagnini, 1973, 117–64; and, most recently, Woods-Marsden, 1988, 32–38 (all with extensive bibliographies).
2. The suggestion that the sheet has been cropped is based on comparison to the drawing, now in the Louvre, usually seen as a companion folio from the same sketchbook (see Comments, below).

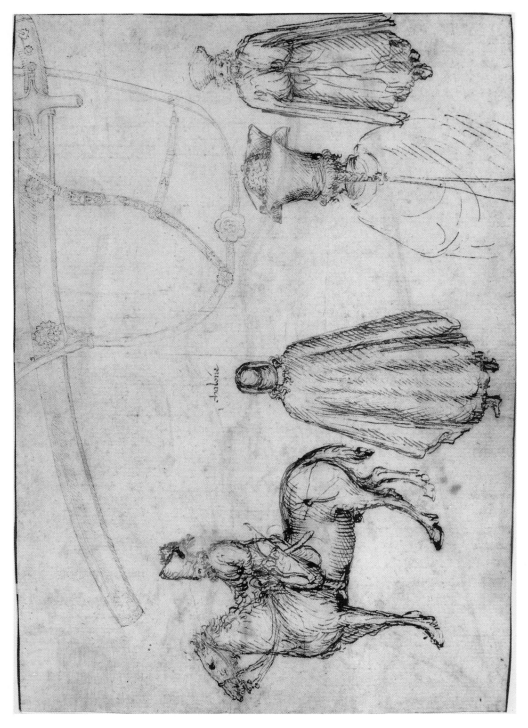

19 recto. Antonio Pisano, called Pisanello (before 1395–ca. 1455/56), *Studies of the Emperor John VIII Palaeologus, a Monk, and a Scabbard,* 1438, Art Institute of Chicago, Margaret Day Blake Collection, 1961.331.

19 verso. Antonio Pisano, called Pisanello (before 1395–ca. 1455/56), *Bowcase and Quiver of Arrows,* 1438, Art Institute of Chicago, Margaret Day Blake Collection, 1961.331.

PROVENANCE: Anonymous private collection; Wildenstein and Co., New York.

EXHIBITIONS:

New York, Wildenstein and Co., October 17–November 30, 1963, *Master Drawings from the Art Institute of Chicago,* no. 2.

Chicago, Art Institute, April 28–June 7, 1970, *A Quarter Century of Collecting: Drawings Given to the Art Institute of Chicago, 1944–1970, by Margaret Day Blake,* no. 1.

BIBLIOGRAPHY:

(Attributed to Pisanello and dated either 1438 or 1439, unless stated otherwise)

A. Venturi, 1939, 37, n. 1, pl. 32 (verso), pl. 33 (recto).

Degenhart, 1945, 44, 65, n. 26.

Degenhart, 1953, 182–85, n. 2. Several references, beginning with this review by Degenhart, note that R. Brenzoni (1952, pl. 84) mistakenly cites the recto of the Chicago sheet as belonging to the Louvre. In fact, Brenzoni's error was in reproducing the Chicago sheet in place of the related sheet in the Louvre, the drawing that he does, in fact, discuss in his text (210). The Chicago sheet is not mentioned by Brenzoni.

Art Quarterly, 1961, 304 ill.

Gazette des Beaux-Arts, 1962, 23, figs. 94, 95.

Fasanelli, 1965, 36–47, pl. 30 (verso), pl. 31 (recto).

Todorow, 1966, 30–31, 81, no. 58, pl. 69 (recto), pl. 71 (verso).

Todorow, 1970, 92, fig. 39 (verso).

Dell'acqua and Chiarelli, 1972, 105, nos. 166–67 (verso: "1438?"; recto: "1430–40?"). This seems to be a typographical error; the authors indicate that the verso and recto share the same history.

Paccagnini, 1973, 156.

Vickers, 1978, 417–24, fig. 7 (recto), fig. 8 (verso).

Joachim and McCullagh, 1979, 20–21.

Joachim, 1979, 11, no. 1A3.

COMMENTS:

The recto of the Chicago sheet contains sketches of a mounted rider facing left and three standing men. The mounted figure, wearing hunting attire, carries a bow case and bow and a curved sword; he wears a hat in the form of an inverted bell with openings at the sides and a high, fleecy dome. The farthest left of the standing figures is seen from the back and is dressed in a long cloak and "shovel" hat. Directly above him is written "chalone" or "chaloire." The next figure, also seen from the rear, is shown in half length and is wearing a cloak and a hat similar to the headgear of the mounted figure. The figure's hair seems to be thickly braided and hangs down past the shoulders. The figure at the far right, seen from the front, is similarly dressed in a gown, cloak, and elaborate hat, though the latter may be a simpler variant of that seen on the mounted and adjacent figures. At the top of the sheet, more delicately drawn than the quick sketches of these figures, is the image of a scabbard with its straps.

On the verso of the sheet, also sharply delineated but rather darker in effect than the scabbard, are a quiver with arrows and a bow case with a bow and one visible arrow. Both are in the Turkish style of such battle accoutrements, known from later examples.[3]

Several properties of the Chicago sheet are recognized by almost all authorities: first, that the drawing is indisputably by Pisanello, with no additions by other hands; second, that the sheet is intimately connected in both style and subject to a sheet in the Louvre; third, that the subjects of both works are related to the visit of Emperor John VIII Palaeologus to Ferrara in 1438–1439; and fourth, that the drawings were executed at that time and were studies from life.

3. Vickers, 1978, 421.

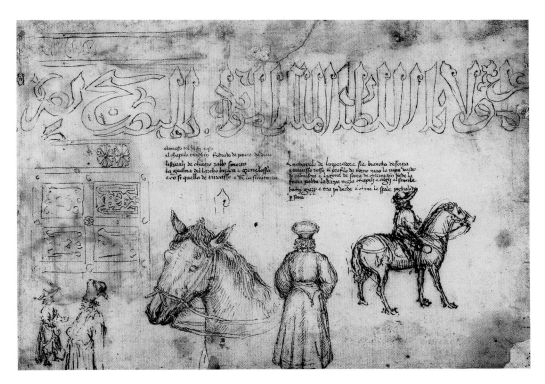

Fig. 19-A. Pisanello, *A Knight, Figures of Orientals and Decorative Arabic Script,* drawing, Paris, Musée du Louvre, Département des Arts Graphiques, MS M.I. 1062.

The drawing in the Louvre (Fig. 19-A) represents, on its recto, several standing figures attired similarly to those on the recto of the Chicago sheet, the head of a horse, a mounted figure facing right, and inscriptions in decorative Arabic and in Italian. The former is a formal inscription referring to the Sultan, El Moaid-Abuk-El Nasr, while the latter consists of color notes on the clothing and appearance of an emperor. The verso of the Louvre sheet represents four figures, a full-length figure in profile, a bust in three-quarter view, a bust in frontal view, and a barely visible head in three-quarter view. All but the last wear high, elaborate headgear; the exception wears a "shovel" hat with the brim turned up at the sides. All the figures are executed in the same sketchy style as the

figures on the recto of the Chicago sheet.[4]

Because of its inscription, the Louvre drawing is generally accepted as Pisanello's sketches of John VIII Palaeologus, emperor of Constantinople, executed during the latter's attendance at the Council of Ferrara (February 29, 1438, to January 10, 1439) preceding the Council of Florence later in 1439. Also in attendance was the patriarch of the Eastern Orthodox Church, Joseph II, whose image has been seen by some in the recto of the Chicago sheet (the mounted figure) and on the verso of the Louvre sheet (the central

4. Other drawings that have been related to the emperor's medal in question are *The Emperor John VIII Palaeologus* (Louvre MS 2478) and *A Horse Seen from Front and Back* (Louvre MS 2468). On the verso, see Vickers, 1978, fig. 6.

bust in three-quarter view).[5] The resemblance in subject and style between these two sheets has led to the general acknowledgment that they were both part of the same sketchbook.[6]

The mounted figure of the Louvre sheet is generally recognized as a preliminary drawing by Pisanello for his famous medallion of the emperor.[7] Although J. Fasanelli sees the similar figure on the left recto of the Chicago drawing as a member of the emperor's retinue,[8] M. Vickers brings strong evidence to bear that this image represents John.[9] Indeed, Vickers's argument, based on the known appearance of the emperor at the time of the council, convincingly indicates that all but one of the figures of the Chicago sheet represent him. Vickers argues that Pisanello made numerous sketches of the emperor, trying to ascertain the final design for the medal that was modeled, most probably, in 1438 (and, as the color indications of the Louvre

sheet indicate, planning a painting as well). Pisanello apparently sketched John in both formal and hunting clothing and, probably because of John's near obsession with the chase, finally elected to show him in that activity in the medallion.

The one figure of the Chicago sheet that Vickers did not identify as the emperor is the central image of a robed man wearing a so-called shovel hat. Vickers points out the resemblance between this figure's headgear and that of the lightly drawn head on the verso of the Paris sheet, the features of which bear little resemblance to those of the emperor. The inscription that accompanies this figure would seem to support the presumption that it does not represent John, since the single word, rather than giving an indication of color for the clothing (as does the extensive inscription of the Louvre sheet), seems to indicate an identification of some sort. The meaning, indeed the reading, of that word is not clear; it has been interpreted variously as "chalone" and "chaloire." The former may mean a cardinal's hat, and the hat certainly differs from those found on all the other images. The word *chaloire,* suggested as an Italian phonetic pronunciation of the Greek word *kalogeros,* meaning monk, while less

5. Fasanelli's dating of the drawings on October 8, 1438 (1965, 39f), is based in part on the fact that this is the one day on which the emperor and the patriarch both attended a session—the first—of the Council of Ferrara. This conclusion, however, assumes the identification of the bust of Joseph on the recto of the Louvre sheet, something that Vickers has shown to be unlikely. In addition, Fasanelli (1965, 43, n. 8) did not know of any portraits of Joseph, while Vickers (1978, 421) establishes his appearance from both a contemporary description and a manuscript likeness (fig. 9).

6. The slight size difference between the pages is probably due to the trimming of the Chicago sheet. Fasanelli persuasively contends that the two drawings were contiguous in the original sketchbook.

7. See Hill, 1930; Fasanelli, 1965; Weiss, 1966; Todorow, 1966, 30–32, 80–81; Hill and Pollard, 1967, 7, no. 1; Dell'Acqua and Chiarelli, 1972, 97, no. 83; Vickers, 1978.

8. Fasanelli (1965, 38) suggests that the mounted archer might be the emperor's squire and perhaps a dwarf.

9. Vickers (1978) argues that all figures whose faces are visible on both the Louvre and the Chicago sheets represent the emperor as he is known from

other sources. For Vickers, the representations of the mounted figures are logically related to Pisanello's study for the emperor's medallion: that in the Louvre clearly a study close to the final design, that in Chicago an earlier thought. In reaction to the proposal of Fasanelli (1965, 38, 43 n. 8) that the latter figure is a squire of the emperor and probably a dwarf, Vickers does not see the horseman's proportions as unusual for a subject known to be short, to have worn a beard, and to have been a lover of the hunt. Vickers similarly points out that all but one of the faces on the verso of the Louvre sheet also show John's recognizably forked beard and that the age and generally healthy appearance of these images are far closer to those of the emperor than the patriarch, known to be old and infirm in 1438.

likely an interpretation, leads essentially to the same result: that the figure represents an ecclesiastic and not the emperor.[10]

The significance of the Chicago sheet has been recognized by all students of Pisanello, not only for the light it throws on the artist's creative approach and some details of an important historic event, but also because the work seems to mark a turning point in Pisanello's drawing style. The earlier stage is represented by the rather precise renderings of the armament, the later stages by the loose, feathery touch of the figures.

R. M.

10. This suggestion is usually attributed to Ulrich Middledorf, who, in a verbal communication to Todorow, suggested that the word *chaloire* could be the vocative of the Greek *kalogeros,* pronounced in modern Greek. Two small points might be noted, however: first, a letter to Felice Stampfle from Harold Joachim (July 13, 1965; archive of the Art Institute) indicates that Middledorf received this interpretation from some Greek historians; second, P. A. Michelis, in a letter to James A. Speyer (November 9, 1965; archive of the Art Institute), states that the word cannot be *chalone* because "it does not correspond to any Greek word" nor "can it be read as 'chaloiré,' because if he intended to write the name of a monk, he would have written 'calogero', which is the Greek word, existing in Italian. The accent over n is not a point of i but a sign meaning a double n (=chalonne)." (The latter suggestion Michelis attributes to the subdirector of the Institute in Venice, Mr. Messinis.) It should also be noted that following Joachim's reading of Fasanelli's article, the latter author (in a letter to Felice Stampfle, July 20, 1965), after some lengthy analysis of the way in which Pisanello wrote the letters n and r, continued to interpret the word as *chalone.*

102

20 recto. Parri Spinelli (ca. 1387–1453), *Page from a Sketchbook: An Adaptation of Giotto's Navicella*, ca. 1415, Cleveland Museum of Art, purchase, J. H. Wade Fund, 61.38.

20 verso. Parri Spinelli (ca. 1387–1453), *Studies of ships*, ca. 1415, Cleveland Museum of Art, purchase, J. H. Wade Fund, 61.38.

20

Parri Spinelli (ca. 1387–1453), *Page from a Sketchbook: An Adaptation of Giotto's Navicella* (recto) and *Studies of Ships* (verso), ca. 1415, 271 x 371 mm (10 5/8 x 14 5/8 in.), pen and brown ink, Cleveland Museum of Art, purchase, J. H. Wade Fund, 61.38.

BIOGRAPHICAL NOTE: Parri Spinelli was a native of Arezzo and its dominant painter in the first half of the fifteenth century. He had worked with his father, Spinello Aretino, in Siena and trained in the workshop of Lorenzo Ghiberti in Florence, but he never achieved the modern recognition of either master.[1] Although Spinelli received commissions for fresco projects in Arezzo, many of them were already destroyed by the sixteenth century, and he is better known through his drawings, of which a surprisingly large number survive from this early period.[2] The sixteenth-century artist and biographer Giorgio Vasari praised the painter as a superb colorist and described him as a prolific draftsman whose drawings he himself collected.[3]

TECHNICAL CONDITION: Water stains at all four corners; vertical center crease with five repairs; losses and paper backing evident at upper left corner and both right corners; oxidized ink hole at mouth of wind god at upper left; small water stain at top center.

INSCRIPTIONS: None.

COLLECTORS' MARKS: Right lower edge of recto, marks of Sir Joshua Reynolds and Jonathan Richardson Sr.

WATERMARKS: None observed.

PROVENANCE: Jonathan Richardson Sr., London (Lugt 2183); Sir Joshua Reynolds, London (Lugt 2364); C. M. Metz, Rome and London (Lugt 598a, not stamped); W. Young Ottley, London (Lugt 2662, not stamped); Marquess of Northampton, Castle Ashby; Thomas Agnew & Sons Ltd., London.

EXHIBITIONS:

London, Burlington House, 1930, *Italian Drawings,* no. 1 (as copy from Giotto di Bondone).

London, Christie, Manson and Woods, sale of May 1, 1959, no. 14 (as Parri Spinelli).

Baltimore, Walters Art Gallery, October 23–December 30, 1962, *The International Style,* no. 32 (as Parri Spinelli?).

Cleveland Museum of Art, July 13–September 19, 1971, *Florence and the Arts: Five Centuries of Patronage,* no. 50 (as Ascribed to Parri Spinelli).

Cleveland Museum of Art, December 15, 1986–March 1, 1987, *Italian Drawings from the Permanent Collection* (as Attributed to Parri Spinelli).

Cleveland Museum of Art, November 5, 1991–January 12, 1992, *Artists' Working Books* (as Parri Spinelli).

1. For background on Parri Spinelli, see Vasari, 1906, 2:275–85. See also Salmi, 1914, and Zucker, 1973.

2. Zucker (1981, 426) reports twenty-eight sheets with forty-eight drawings now attributed to him. Many of his studies are reproduced by Zucker, 1981, pls. 9–22; Ames-Lewis, 1981b, figs. 57–59, 73, 101, 102; and Ames-Lewis and Wright, 1983, 152–53, 234–37. See also Degenhart and Schmitt, 1968, 2:pls. 223–33.

3. Vasari (1906, 2:285) wrote, "In our book there are some sheets of his [Spinelli's] very beautifully drawn with the pen" ("E nel nostro libro sono alcune carte da lui disegnate di penna molto bene").

Fig. 20-A. Parri Spinelli, *Navicella,* drawing, New York, Metropolitan Museum of Art, Hewitt Fund, 1917, 19.76.2.

Fig. 20-B. Giotto, *Navicella* (restored), mosaic, Rome, Vatican, St. Peter's.

BIBLIOGRAPHY:

Richardson and Richardson, 1722, 293 (as Giotto).

Richardson, 1728, III/2, 538 (as from Vasari's *Libro* by Giotto).

Metz, 1790, 5 ill. in reverse as etching (as Giotto).

Ottley, 1823, 9 ill. as facsimile engraving by J. Vivares (as Giotto).

Lübke, 1878, 123.

Crowe and Cavalcaselle, 1912a, 2:45 (as Giotto).

L. Venturi, 1922, 49–69, fig. 4 (as circle of Lorenzo Monaco, early fifteenth century).

Popham, 1931, no. 1, pl. I recto (as copy from Giotto di Bondone, in the style of Parri Spinelli).

Kurz, 1937, 7 (as copy of Giotto's mosaic).

Berenson, 1938, 2:254, no. 1837K (as Parri Spinelli).

Annuaire des Ventes d'Objets d'Art, 1958–1959, 418 ill., recto (as Parri Spinelli).

"The Year in Review, 1960," 1961, 251, no. 93, 239 ill. (as Parri Spinelli).

Virch, 1961, 189–93, fig. 5 (as Ottley engraving).

The International Style, 1962, 34–35, no. 32, pl. 35 (as Parri Spinelli?).

Richards, 1962, 168–69, 174 (as Parri Spinelli).

"Gothic Art 1360–1440," 1963, 182, fig. 86, 213, no. 86 (as Parri Spinelli).

Handbook of the Cleveland Museum of Art, 1966, 1969, 57 ill., recto (as Parri Spinelli).

Degenhart and Schmitt, 1968, 2:281, no. 183, 637; 3:pls. 204a, b (as circle of Lorenzo Monaco).

van Regteren Altena, 1970, 400 (as Parri Spinelli?).

Pillsbury, 1971, no. 50 (as Ascribed to Parri Spinelli).

Levenson, Oberhuber, and Sheehan, 1973, 160, fig. 7-1 (verso) (as Parri Spinelli).

Collobi, 1974, 1:28, 38, 39, 2:figs. 46, 47 (as Antonio Veneziano).

Zucker, 1981, 426–41 (as Parri Spinelli).

Handbook of the Cleveland Museum of Art, 1991, 61 (as attributed to Parri Spinelli).

Köhren-Jansen, 1993, fig. 75 (as Parri Spinelli).

COMMENTS:

This sheet is remarkable for its extraordinary provenance, bearing the marks of such prestigious English collectors of drawings as Jonathan Richardson Sr. and Sir Joshua Reynolds. Richardson and his son referred to the sheet in a book on Italian art, in which they suggested that the noted Renaissance painter and biographer Giorgio Vasari may have acquired the page for his album of drawings.[4] Bernhard Degenhart and Annegrit Schmitt have observed that Vasari could have obtained the sheet from the nephew of Spinelli's master, the sculptor Lorenzo Ghiberti.[5] This claim has been supported by Claus Virch, who interpreted lines both in the Cleveland sheet and in another in the Metropolitan Museum of Art (Fig. 20-A) as parts of missing decorative borders, such as those used by Vasari in embellishing the drawings mounted in his five-volume *Libro de' disegni.*[6]

The drawing was cited in publications in 1790 by Conrad Metz and in 1823 by William Young Ottley, each of whom owned the sheet at the time of its mention.[7] The drawing's early owners believed the recto

4. See Richardson Sr. and Jr., 1722, 293. This claim was first made in a French translation of Richardson, 1728. See Virch, 1961, 191.

5. Degenhart and Schmitt, 1968, 2:637; Collobi, 1974, 1:51, 2:25–26, figs. 46–47.

6. Virch, 1961, 191.

7. Metz, 1790, 5; Ottley, 1823, 9. Ottley repeated Richardson's claim that the drawing had once belonged to Vasari. Ottley was a painter and collector who spent ten years in Italy from 1791 and whose collection of drawings included several studies by Michelangelo for the Sistine ceiling.

Fig. 20-C. Parri Spinelli, *Christ and the Adulteress,* drawing, Chatsworth, Duke of Devonshire Collection, 703.

composition to be a study by the painter Giotto for his *Navicella* mosaic in the old basilica of St. Peter (Fig. 20-B). Bernard Berenson was the first to attribute the sheet to Spinelli.[8]

Vasari identified Spinelli's draftsmanship by the artist's predilection for elongated figures, which were often more than ten heads tall,[9] a quality readily evident in a number of his sheets in the Uffizi and other collections (Fig. 20-C). Perhaps the cautious attribution of the Cleveland drawing as "after Spinelli" is based on the more normative proportions of its apostles. Even Christ, although tall, is not distended to the extent of figures in other of

8. Berenson, 1938, 2:254, no. 1837K, 3:fig. 8. For more information on Giotto's *Navicella,* see Köhren-Jansen, 1993, and Schwarz, 1995.

9. "Parri made his figures much taller and more slender than any painter who had preceded him; and

where others made them at most ten heads high, he made his eleven and even twelve" ("Fece Parri le sue figure molte più svelte e lunghe che niun pittore che fusse stato innanzi a lui; e dove gli altri le fanno il più di diece teste, egli le fece d'undici e talvolta di dodici");Vasari, 1906, 2:276.

Fig. 20-D. Andrea da Firenze, *Navicella,* ca. 1365, fresco, Florence, Santa Maria Novella, Spanish Chapel.

Spinelli's sketches, but Mark Zucker has recently observed that more normative proportions are typical of figures in Spinelli's early drawings.[10] Degenhart and Schmitt agreed with Berenson's identification of the Cleveland folio with Spinelli, although J. Q. van Regteren Altena, in his review of their *Corpus,* preferred to leave the attribution open.[11]

Zucker argued that the sheet is an autograph Spinelli drawing.[12]

Zucker's analysis of the sketchbook page included an extensive study of its subject, the apostle Peter's attempt to emulate Christ's walking on water. The Cleveland design lacks the fisherman whom Vasari described as a striking part of Giotto's composition.[13] He appears in the less spirited drawing of the

10. Zucker, 1981, 430, 434, 437.
11. Degenhart and Schmitt, 1968, 1:2, no. 183, 277, 281, 637; van Regteren Altena, 1970.

12. Zucker, 1981, 431–37.
13. Vasari, 1906, 1:386–87.

Fig. 20-E. Lorenzo Ghiberti, *Christ in the Storm,* bronze, Florence, Duomo Baptistry, North Doors.

Navicella in the Metropolitan Museum of Art in New York, which was bound in the same album with the Cleveland page,[14] and which is a closer match to Giotto's restored mosaic. Zucker noted that the Cleveland *Navicella* seems to follow Florentine interpretations of the subject, such as Andrea da Firenze's fresco in the Spanish Chapel of Santa Maria Novella (Fig. 20-D), with its greater emphasis on the apostles and their ship, embellished at the stern with a poop deck and helmsman. In addition, the prominence of the saints in the clouds, the fisherman, and Christ and St. Peter

14. Zucker, 1981, 437.

in Giotto's mosaic refer to important elements of Roman iconography that confirm the divine protection of the church, allude to St. Peter as "a fisher of men," and recognize his calling as the first pope.

Spinelli's Christ and St. Peter are similar to their counterparts in Ghiberti's treatment of the subject on his first set of bronze doors for the Baptistry of the Cathedral of Florence (Fig. 20-E). The back of St. Peter's head, the drapery hanging from his right arm, and the posture of Christ are similar, but Spinelli departs from the compact grouping of Ghiberti's apostles. The sheet would date from Spinelli's early years in Florence, about 1415.

Spinelli has added wind gods to the upper and lower left corners of his composition to rationalize the ship's billowing sail, the pulleys and rigging of which preoccupy the frantic apostles, a detail that would later be approved of by Leon Battista Alberti[15] and that augments the treatments of Giotto and Bonaiuti.

The Cleveland page's verso is divided vertically and contains two drawings of ships. Both sides of the page show animated designs with strong accents and intersecting directional lines. A vertical crease down the center stems from the sheet's having been mounted across both pages of an album. In this regard, it is related to the similarly creased folio in the Metropolitan Museum.[16] Also part of the album was a sheet in Bayonne that is a variant on the *Navicella* of the apostles drawing in their nets.[17]

E. J. O.

15. Spencer, 1966b, 81.

16. Virch, 1961.
17. Berenson, 1968, 3:fig. 10.

French, German, and Netherlandish Artists

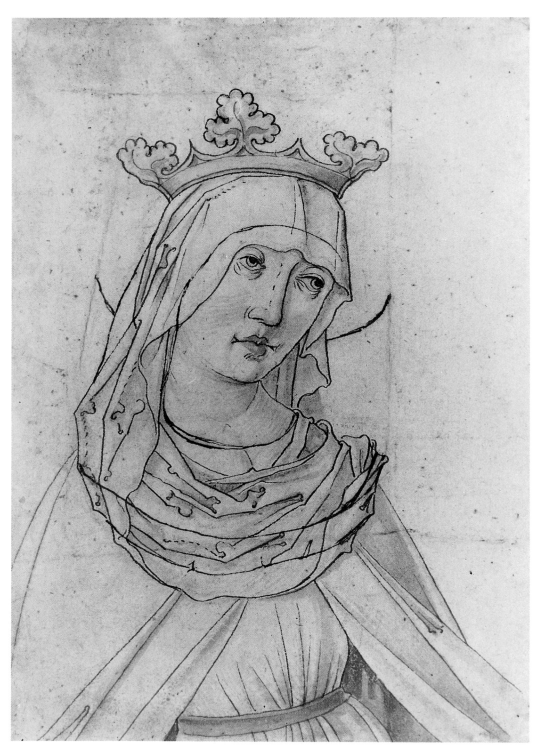

21. Anonymous German artist, School of Augsburg, *Half Figure of a Crowned Female Saint,* ca. 1500, Oberlin College, Dudley Peter Allen Memorial Art Museum, 55.30.

21

Anonymous German artist, School of Augsburg, *Half Figure of a Crowned Female Saint,* ca. 1500, 207 x 148 mm (8 1/4 x 5 13/16 in.), pen in brown and black ink with colored watercolor washes in red, blue, brown, and yellow on white laid paper. Oberlin College, Dudley Peter Allen Memorial Art Museum, 55.30.

TECHNICAL CONDITION: Numerous pricked holes across entire sheet do not appear to be related to the transfer of the drawing, for they are also found in the background areas where there are no drawn lines; parts of the drawing are strengthened with thicker, dark brown lines: the outlines of the crown (where black ink is also used), parts of the head cloth, and the two lines of the incipient halo; these thicker lines are visible from the verso of the drawing and may have been added by a later hand, judging from the darker ink and thicker lines employed.

INSCRIPTIONS: None.

COLLECTORS' MARKS: None.

WATERMARKS: Variant of Briquet, 1923, no. 15310 (oxhead). The Oberlin watermark is only a fragment of the upper part of Briquet's oxhead with star above. The horns in the Oberlin watermark are more vertically oriented and the star is four-lobed, not five-lobed as in Briquet. These differences are such that we should not accept Briquet's date for 15310 of 1525–1550 for the Oberlin drawing.

PROVENANCE: Collection Philip Hofer, Cambridge, Massachusetts; Durlacher Brothers, New York.

EXHIBITIONS:
Iowa City, State University of Iowa, summer 1951, *Six Centuries of Master Drawings,* no. 2 ill.

Charlottesville, University of Virginia Museum of Fine Arts, February 1955.

Oberlin College, Allen Memorial Art Museum, June–September, 1956, *Recent Additions.*

Kenwood, England, London County Council, Iveagh Bequest, May 30–September 30, 1962, *An American University Collection,* cat. no. 52 (as Unknown Artist, Augsburg, end of the 15th century).

BIBLIOGRAPHY:
Allen Memorial Art Museum Bulletin, 1955, 31 (as German, fifteenth century).

Allen Memorial Art Museum Bulletin, 1959a, 86, no. 54.

Allen Memorial Art Museum Bulletin, 1959b, 201 ill. (as German, Augsburg, ca. 1480).

Pantheon, 1962, 260 ill. (as German, Augsburg, ca. 1480).

Stechow, 1976, 28–29, no. 142 (as German, Augsburg, ca. 1500).

COMMENTS:

Augsburg was the most important South German artistic center after Nuremberg in the years around 1500. Both were imperial cities and metropolitan centers, large by German standards; Augsburg had a population of approximately twenty thousand. Receiving acclaim as the home of Hans Holbein the Younger in the early sixteenth century, Augsburg earlier hosted the large and prosperous studio of his father, Hans Holbein the

Fig. 21-A. Hans Holbein the Elder, *Design for a Winged Altar,* drawing, Pavia, Museo Civico, Castello Visconteo.

Elder (ca. 1460/65–1524).[1] Augsburg was geographically well situated at the mercantile crossroads of northern and southern Europe. In addition to commercial exchange, the

town received artistic influences from Italy as well as patronage from Italian and German merchants. During the last quarter of the fifteenth century, Augsburg (like Nuremberg) was still engaged in the production of art in the Late Gothic style. Augsburg's Italianism at this time consisted of humanist ideas and classical authors. Italian artistic influences took

1. Baxandall, 1980, 6, 136; Andersson and Talbot, 1983, no. 102. See Lieb, ed., 1970, 2:169–77, and Falk, 1979.

hold after the turn of the century, primarily in the hands of Hans Burgkmair and Hans Holbein the Younger, whom we think of as "Renaissance" artists. Both were active in Augsburg around 1500 when the Oberlin drawing, which reflects Augsburg's Gothic spirit, was produced there.

The drawing depicts a crowned female saint in half length who looks to the right. The cloth covering her head and her hairstyle suggest the saint could be a matron, according to the custom of the time.[2] Her dress is partially covered by a cloak.

Wolfgang Stechow's 1976 catalog entry still provides the most complete information on the drawing; prior publications only mention it briefly. Stechow linked the type of saint—crowned, with head cloth, and in half length—to comparable figures by other Augsburg artists, such as Hans Burgkmair, the Master of 1477, Thoman Burgkmair, and Hans Holbein the Elder.[3] He concluded that the drawing was probably used as a model for a painted predella panel—rather than as a model for stained glass, sculpture, or woodcut—based on drawings with similar female saints associated with altarpieces by Holbein the Elder and his circle. Specifically, he compared the Oberlin drawing to four female saints in separate arched openings of a predella from an altarpiece by Holbein the Elder now in Pavia, Civici Instituti di Arte e Storia (Fig. 21-A). The female saints represented in the predella are Barbara, Catherine of Alexandria, Dorothy, and Margaret, all of whom are shown as youthful virgins with long, unbound hair, crowns, and halos, but in slightly longer format than the Oberlin figure.

The subject of the winged altarpiece to which the predella paintings belong is the life of the Virgin with scenes of the Annunciation, Visitation, and Nativity, and Death of the Virgin (all in the center panel) and Sts. Christopher and Sebastian for the wings.

Stechow also linked the style of the Oberlin drawing to altar wings dating to about 1480 from Lake Constance or Swabia, and thus to southwest Germany, an association that is confirmed by similar drawings of female religious figures, especially sibyls, from the Upper Rhine.[4] In the last analysis, however, the Oberlin drawing bears fewer parallels to these more elegant Upper Rhenish works than to the designs by Holbein the Elder and his shop.

Contemporary paintings from Augsburg and southwest Germany help little in establishing the specific identity of the Oberlin saint. Paintings by Augsburg artists that show a related female saint (one having a similar facial type with a straight nose turned up slightly at the end and a head cloth and/or crown) are to be found, for example, in the oeuvres of Master 1477, Hans Holbein the Elder, and Hans Holbein the Younger. These parallels point to such varied identifications of the female saint as the Virgin Mary and St. Elizabeth of Thuringia.[5] Because the drawing lacks any specific attributes to identify the saint, I believe Stechow was correct in rejecting the provisional identification as St. Elizabeth of Thuringia used earlier by the Allen Museum. Stechow's "crowned female saint" will, therefore, suffice as a title at this time.[6]

2. Stewart, 1979, 94–97.
3. Stechow, 1976, 28–29, no. 142. For the Master of 1477 and Thoman Burgkmair, see Lieb, ed., 1970, 152–53 and 155–58.

4. Falk, 1979, 51, nos. 33 and 34, pl. 1.
5. For St. Elizabeth of Thuringia, see Schmoll, 1918.
6. See Stange, 1957, 8, figs. 87–89, 92–93, 110, 113, 116, 117, 125, Madonna, and 154, St. Elizabeth of Thuringia by Holbein the Younger, Munich, Alte Pinakothek.

In sum, the Oberlin drawing appears to be a product of the Late Gothic spirit of Holbein the Elder's Augsburg. Although differences in style between the Oberlin study and Holbein's drawings prohibit an attribution to him, the figure type may, in fact, have had its ultimate origins in that workshop in which the differentiation of drawings by shop and assistants from those by the master is extremely difficult. The silverpoint drawings from Holbein the Elder's circle are considered to have been used in his own individual, creative process, but his drawings in pen and wash, like the Oberlin sheet, have been directly linked to the collective workshop process of this master and his shop. One such pen-and-wash drawing, now in the Universitätsbibliothek, Würzburg, has been shown to be an inferior copy of an extant drawing given to Holbein's workshop. The original drawing is located today in the Germanisches Nationalmuseum, Nuremberg.[7] Like the Oberlin drawing, both were executed in pen and wash and both show half-length female saints in the predellas. It is possible, therefore, that the Oberlin drawing was also part of that communal process and represents a stock figure of the workshop, perhaps two or three times removed from Holbein the Elder himself. However, the stylistic evidence permits us to place the drawing no more specifically than in Augsburg at the turn of the century.

A. G. S.

7. *Hans Holbein der Ältere und die Kunst der Spätgotik,* 1965, 34, no. 106, fig. 111.

22

French School, anonymous artist, *Lady with Three Suitors,* ca. 1500, 230 x 193 mm (9 1/6 x 7 5/8 in.), pen and brown ink, brush and brown wash, traces of black chalk, on laid paper, Cleveland Museum of Art, John L. Severance Fund, 56.40.

TECHNICAL CONDITION: Horizontal crease through approximately the middle of the sheet, where it has been folded; some water spots at top.

INSCRIPTIONS: In brown ink presumably by the hand of the artist or a contemporary hand in pen and ink, "Celui mamour conquestera / qui deca ce lass passera / Sanns lempirer ne desnourer / sanns dessuss / ne dessoubz passer" (He will conquer my love who passes this [barrier] neither destroying nor loosening it, neither going above nor beneath it).[1]

COLLECTORS' MARKS: None.

WATERMARKS: Wheel, similar to Briquet, 1923, no. 13389, used between 1484 and 1525.

PROVENANCE: Antonio II Badile, Verona (d. 1507); Moscardo Collection, Verona (Lugt 2990b–h, not stamped);[2] Marquis of Calceolari, Verona (not stamped); Francis Matthiesen, London.

EXHIBITIONS:
Cleveland Museum of Art, *Treasurers from Medieval France,* 1967, no. VII (as French, ca. 1490).
Lawrence, University of Kansas Museum of Art, *The Waning of the Middle Ages,* 1969, no. 38 (as French, ca. 1500).
Ann Arbor, University of Michigan Museum of Art, 1975, *Images of Love and Death in Late Medieval and Renaissance Art,* no. 58 (as anonymous, French, ca. 1490).

BIBLIOGRAPHY:
Handbook of the Cleveland Museum of Art, 1958, ill. no. 578 (possibly of Burgundian origin).
Bulletin of the Cleveland Museum of Art, 1958, 63 ill. (as anonymous, French, ca. 1480).
"Accessions of American and Canadian Museums, April–June, 1958," 1958, 336 ill. (as French, late fifteenth century).
Handbook of the Cleveland Museum of Art, 1966, 75 (France, 1490–1500).
Wixom, 1967, 314, no. VII 11, 315 ill. (as French, ca. 1490).
Schrader, 1969, 43–44, no. 38, ill. pl. LXVIII (as French, ca. 1500).
Olds, Williams, and Levin, 1975, 97, no. 58, ill. pl. IX (as anonymous, French, ca. 1490).
Muylle, 1983, 131.

COMMENTS:

The figure style and costumes point to a French origin for this drawing. The costumes reflect the fashions of the time of Charles VIII (1483/92–1498).[3] J. L. Schrader identifies the headdress as a Breton type, a fashion popularized by Anne of Brittany (1477–1514), consort of both Charles VIII (1470–1498) and Louis XII (1462–1515). According to Wolfgang Stechow, the drapery style is very close to that

1. For help with this translation, I am greatly indebted to Michael Miller, former assistant curator of prints and drawings, Cleveland Museum of Art.

2. For a discussion of the Moscardo Collection, see above, No. 1, n. 6.

3. Wixom, 1967, 314; see also Joan Evans, 1952, 62–63.

22. French School, anonymous artist, *Lady with Three Suitors,* ca. 1500, Cleveland Museum of Art, John L. Severance Fund, 56.40. (Museum attribution: Late XV–Early XVI Century.)

of Jean Bourdichon (ca. 1457–1521) in the facial types and in the handling of the drapery.[4]

The subject is enigmatic. The words inscribed above seem to be spoken by the young lady, but it is not clear if they are addressed to her suitors as a warning or a challenge. The little wicker fence surrounding the lady may function like the traditional *hortus conclusus* (enclosed garden), symbolizing her chastity, or perhaps her unmarried state in general. Schrader has noted that the fence resembles the one enclosing the captive unicorn in a tapestry from the *Unicorn Tapestries,* woven in France around 1514; the unicorn was a traditional image of chastity.[5]

It has been suggested that this sheet was a preparatory drawing for a print. Schrader thinks it was a study for a tapestry or an embroidered pillowcase, or perhaps was copied after a textile of this sort. William Wixom suggests it was one of a series of drawings, each with verses of a comparable nature.[6]

According to Jan Muylle, the Cleveland drawing was intended as a tapestry design; he also sees many similarities in style and in the verses between this drawing and the so-called Bourbon-Emblem Book, a collection of gouaches illustrating proverbs and executed around 1510–1513 as models for tapestry weavers, workers in stained glass, and other artisans.[7]

W. S. G.

4. Schrader, 1969, 43–44, and letter of April 1966 to the Cleveland Museum of Art, preserved in the museum files. Stechow, letter of April 1966 to the Cleveland Museum of Art, preserved in the museum files.

5. Schrader, 1969, 43.

6. Olds, Williams, and Levin, 1975, 97; Schrader, 1969, 43–44; Wixom, 1967, 314.

7. Muylle, 1983, 131. I would like to thank Charles Cuttler for this reference.

23. French School, anonymous artist, *The Mocking of Elisha,* ca. 1500, Art Institute of Chicago, gift in memory of Everett D. Graff, 1965.16. Reproduced actual size.

23

French School, anonymous artist, *The Mocking of Elisha,* ca. 1500, 210 x 145 mm (8 1/4 x 5 3/4 in.), pen (or point of brush) with black ink, some brown ink, and colored washes (gray, pink, green, blue, yellow), on ivory paper, Art Institute of Chicago, gift in memory of Everett D. Graff, 1965.16.

TECHNICAL CONDITION: Some foxing; small holes at the upper and lower edges; glue spots (?) on reverse.

INSCRIPTIONS: Noted on reverse in pencil, "Lucas Jacobs dit Lucas de Leyde" and (in another hand) "Lucas de Leyde"; in pencil at the lower right, "80."

COLLECTORS' MARKS: None.

WATERMARKS: None.

PROVENANCE: Ambroise Firmin-Didot, Paris, 1790–1876 (Lugt 119); Emile Galichon, Paris, 1829–1875 (Lugt 1058–59, S1058); Louis Galichon, 1829–1893 (Lugt 1060–61); E. Rodrigues, Rotterdam, 1853–1928 (Lugt 897, S897); Muller & Cie., Amsterdam, July 12, 1921, no. 114; H. E. ten Cate Collection, Rotterdam, 1868–1955 (Lugt S533b); Boerner & Co., Düsseldorf, 1964.

EXHIBITIONS: None.

BIBLIOGRAPHY:

Vente Rodrigues, 1921, 25 and plate XLI (as French Master).

Hannema, 1955, 1:127, n. 219b, 2:pl. 88 (French School circa 1500).

Art Institute of Chicago Annual Report, 1964–1965 (French, about 1500).

Old Master Drawings, 1966, 57 (French School, about 1500).

Joachim, 1977, 6, 27–28 (Anonymous Northern France, around 1500).

Backhouse, 1987, 211–31, fig. 14 (relates to author of miniatures in the Tilliot Hours, British Library, Ms. Yates Thompson 5, Loire school, ca. 1500).

COMMENTS:

In a hilly landscape, an elderly prophet climbing up a rocky slope in the middle background turns to hear the taunts of numerous figures swarming out of a walled city at the right side of the drawing. Two figures in the foreground look toward the prophet, while two bears appear in a cave at the lower left. The figure on the left in the foreground, seen from the back, is preparing to throw an object he holds in his right hand, perhaps a stone. His companion makes a threatening gesture at the prophet. This man and four others in the crowd all wear pointed caps, the medieval symbol for Jews. The artist portrayed the scene with energetic contour lines and added shadows with parallel hatching strokes and some gray washes. Tinted washes highlight certain areas of the composition: the man in the left foreground wears a cloak and hat tinted in a pale red; pale reds and greens appear in the garments of the other mockers; landscape elements are touched up in yellow, green, and blue; while the rooftops of the buildings are either pinkish or brown.

This drawing probably illustrates an episode from the Old Testament Book of Kings (2 Kings 2:23–24; in the Vulgate, 4 Kings 2:23–24). Shortly after Elijah was taken

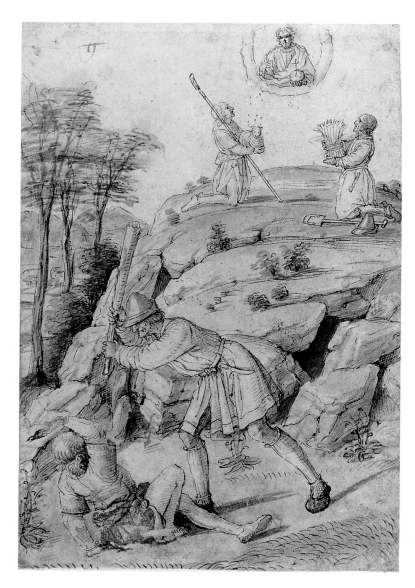

Fig. 23-A. Anonymous, *Cain and Abel,* early sixteenth century, drawing, London, British Museum, 1874-6-13-538.

into heaven, his disciple Elisha left Jericho for the city of Bethel. As he was going by the city, a group of boys came out of the city and mocked him, saying, "Go up, thou bald head (Ascende, calve)." Elisha cursed them in the name of the Lord, and two bears came out of the forest and attacked forty-two of the youths.[1]

There are enough details in the drawing to identify the theme clearly with this episode from the life of Elisha. The two central mockers, the entourage of Jews filing out of the

1. "And he went up from thence to Bethel: And as he was going up by the way, little boys came out of

the city and mocked him, saying: Go up thou bald head; go up thou bald head. And looking back, he saw them, and cursed them in the name of the Lord: and there came forth two bears out of the forest, and tore of them two and forty boys." On the mocking of Elisha as a type for the Passion, see also Neff, 1990.

Fig. 23-B. Anonymous, *The Sacrifice of Isaac,* early sixteenth century, drawing, London, British Museum, 1874-6-13-539.

walled city, and the two bears all point to the identity of the central figure in the upper middle ground as Elisha. However, some aspects of the drawing do not follow the Old Testament text. In the Chicago drawing, the mockers are clearly not "little boys," but men (one of the foreground figures is bearded). Elisha's bald head—ostensibly the reason he was mocked—is covered by part of his cloak (or possibly a turban).

This is a relatively unusual theme, rarely depicted in medieval art. When it does appear in the middle ages, it is in the context of illustrated Bibles, or in cycles on the lives of Elijah and Elisha, who were claimed as special patrons of the Carmelite order.[2] It also

2. For other versions of this theme, see Kirschbaum, 1968, cols. 613–18; Réau, 1955–1958, 2:361. Erlangen, Universitatsbiblothek, cod. 121, f. 117v (H. Swarzenski, *Salsburger Malerie,* pl. 37, fig. 122). The theme is also treated in numerous printed Bibles of the fifteenth century: see Eichenberger and Wendland, 1977, 137, figs. 119, 200. Holbein depicted it also, in the woodcuts that accompanied the Old Testament published in Lyon in 1538.

Fig. 23-C. Anonymous,
Joseph Sold into Slavery, early
sixteenth century, drawing,
Rotterdam, Boymans–van
Beuningen Museum.

appears in the Bible Moralisée, in which the mocking of Elisha is interpreted as a proto-type for the Jews mocking Christ during his Passion (with a link made between the word *Calve* and Calvary). The attack of the two bears is seen as a prefiguration of Titus and Vespasian's conquest of the Jews.[3] In the

Biblia Pauperum of the late middle ages, the scene of Elisha being mocked also prefigures the mocking of Christ.[4] As a subject for individual works of art, the story enjoyed a certain vogue in the sixteenth and seven-teenth centuries, especially in the northern Netherlands.[5]

3. In the manuscripts of the Bible Moralisée in Oxford (Bodleian, MS 270b, f. 175v) and in Vienna (Imperial Library, cod. 1179, f. 128). See Laborde, 1911–1927, 1:pl. 175 and 4:pl. 683.

4. For example, in the block book of forty leaves in Esztergom; see Soltesz, 1967, n. 23.

5. For sixteenth- and seventeenth-century depic-

In a sermon on Elisha, St. Augustine elucidated the further significance of this narrative.[6] Responding to the complaints of some commentators at the severity of the boys' punishment merely for mocking the prophet, Augustine argued that parents were ultimately responsible for the rude behavior of their children and that the bears' attack on the boys was a punishment directed at their parents. He claimed that the punishment was not revenge on Elisha's part, but "correction" supplied by the Holy Spirit to Jews who did not respect the prophets. Perhaps this interpretation of the narrative explains the age of the mockers in the Chicago drawing and the physical threat they seem to present to Elisha; following Augustine, the artist makes adults responsible for the insults and the target of the bears' attack.

The drawing is one of a series of five drawings of Old Testament subjects all done in a similar style and format. Two of these are in the British Museum; they depict *Cain and Abel* (Fig. 23-A) and *The Sacrifice of Isaac* (Fig. 23-B). Another, depicting *Joseph Sold into Slavery,* is now in the Boymans–van Beuningen Museum, Rotterdam (Fig. 23-C). The other, *Coronation of a King,* belonged to the ten Cate Collection with the *Mocking of Elisha;* its present location is unknown.[7]

As the inscription on its reverse reveals, the Chicago drawing was once attributed to Lucas van Leyden, but modern scholars have assigned it to France at the end of the fif

teenth century. Details of costume in several of the other drawings in this group suggest this dating; the ceremony of coronation in the ten Cate *Coronation of a King* suggests the French court. Recently, Janet Backhouse has associated these drawings with the miniatures in a group of manuscripts executed in Tours or Bourges toward the end of the fifteenth century; the core works in this group are the Tilliot Hours (London, British Library, Ms. Yates Thompson 5) and the Great Book of Hours of Henry VIII (New York, Morgan Library, Ms. Heinemann 8). Several other manuscripts have been grouped around these two books. Attempts have been made to associate these manuscripts with the name of Jean Poyet, who is documented as a painter to Anne of Brittany in the 1490s, but the evidence adduced for this identification is purely circumstantial.[8]

Mocking of Elisha compares well with these manuscripts, especially the Tilliot and Heinemann books. Backhouse has pointed out strong similarities between the landscape structures in the group of drawings and these two illuminated books. She draws attention, for example, to the "steep and fissured rocky slopes" supporting Elisha and to the landscape settings in the miniature *David and Goliath* in the Tilliot Hours (f. 99v) and the miniature of the penitent St. Jerome in the Heinemann Hours (f. 170). She also notes the similar willowy trees in the manuscripts and these drawings. I would also point out the similar renderings of cities: the rectilinear city walls in the Chicago drawing compare to the view of Jerusalem in the Heinemann Hours miniature of *David Dispatching Uriah* (f. 108v).[9] And the

tions of this theme see Réau, 1949, 114–15; Pigler, 1956, 1:181–82; and Roethlisberger, 1981, 64.

6. Migne, 1861, cols. 1826–27.

7. The British Museum drawings were included in the exhibit *The Art of Drawing* (London, British Museum, 1972), nos. 106 and 107; *The Coronation of a King* was sold at Sotheby's in London, July 7, 1966, lot 94, where it was identified as the "Coronation of Charles VIII."

8. Backhouse, 1987, 213–14; Plummer and Clark, 1982, 85–89; Kren, 1983, 175–80.

9. Backhouse, 1987, 227–28; *David Dispatching Uriah* is reproduced in Backhouse, 1987, fig. 2.

tree stumps in the *Mocking of Elisha* reappear in the *Massacre of the Innocents* in the Heinemann Hours (f. 69v).[10] There are also numerous parallels in the figure style. However, problems with this attribution still remain. Myra Orth has noted that the style of underdrawing in the miniatures (visible to the naked eye) "is very different from that of the drawings themselves."[11] Nonetheless, the similarities are striking and suggest a more specific origin for this drawing than had previously been proposed. As Backhouse points out, drawings from this period are rare enough, but drawings connected with surviving manuscripts are rarer still.[12]

The function of these five drawings is difficult to determine. They seem too finished to be studies for a sketchbook or model book.

Their size suggests they may have been studies for an illuminated manuscript, although Backhouse notes that the combination of subjects in the surviving drawings would be appropriate only to an illustrated Bible.[13] Alternatively, they may have been designs for prints, although the buoyant contour lines, the sketchy hatching lines, and the tonal quality provided by the colored washes would be difficult to reproduce in print methods available around 1500. The transparent washes that appear on some of the drawings, including the one in Chicago, might suggest they were designs for stained glass or tapestries, although the lack of finish and detail, especially in the landscapes, would indicate otherwise.

A. R.

10. Plummer and Clark, 1982, fig. 113.
11. Myra Orth, letter, November 15, 1989.
12. Backhouse, 1983, 47.

13. Backhouse, 1987, 226.

Hans Holbein the Elder

The leading figure of Swabian art between 1490 and 1510, Hans was born probably about 1460–1465, the son of the Augsburg tanner Michael Holbein. Active in Augsburg between 1494 and 1515, he established a large shop, assisted by his younger brother Sigmund, by Leonhard Beck, and later by his two sons, Ambrosius (born about 1494) and Hans the Younger (born about 1497–1498). He moved to Basel in 1515, but he continued his ties with Augsburg until his death in 1524. He produced numerous altarpieces, as well as many drawings in pen and ink wash as designs for woodcuts and stained glass. He also made silverpoint drawings intended for his own use, generally as models for his paintings.[1]

The comparatively large number of drawings by Hans and his immediate shop has contributed greatly to the interest in him by modern scholars, especially over the last half century.[2] The freshness of his drawings and their versatility have helped to establish the significance of his own art, always overshadowed in earlier literature by the fame of Hans the Younger. The two excellent drawings by Hans the Elder cataloged here both illustrate his facility with the silverpoint medium. The earlier study, in the Cleveland museum, fits well with a large number of free, relatively spontaneous studies, seemingly immediate sketches from life. The later sheet, in Kansas City, demonstrates a more deliberate style, similar to a series of portrait studies in Basel. The second drawing takes us well beyond the chronological limits of the fifteenth century, but it conforms totally to the late Gothic spirit of many of Hans the Elder's earlier studies.

1. Modern monographs on the artist begin with C. Glaser, 1908. Later works include Buchner, 1928; Schmid, 1941–1942; Stange, 1957, 57–76; Beutler and Thiem, 1960; Lieb and Stange, 1960; and most recently, Bushart, 1987. The documents about his life are discussed in detail by Hannelore Müller ("Zum Leben Hans Holbeins der Älteren," in *Hans Holbein der Ältere und die Kunst der Spätgotik,* 1965, 15–21).

2. Beginning with Alfred Woltmann and Eduard His in the nineteenth century, modern scholars have identified a core of nearly one hundred and fifty drawings by Hans and another one hundred or so from his shop. See Woltmann, 1876; His, 1885; Schilling, 1933; Baumeister, 1933–1952; Kodlin-Kern, 1953; Schilling, 1954 and 1955; Landolt, 1960; and Falk, 1979, 3:11–101.

24. Hans Holbein the Elder (1460–1524), *Head of a Woman,* ca. 1500?, Cleveland Museum of Art, purchase, J. H. Wade Fund, 70.14. Reproduced larger than actual size.

24

Hans Holbein the Elder (1460–1524), *Head of a Woman,* ca. 1500?, 65 x 58 mm (2 9/16 x 2 1/4 in.), silverpoint and pen and ink on white prepared ground of pigment and glue on paper, Cleveland Museum of Art, purchase, J. H. Wade Fund, 70.14.

TECHNICAL CONDITION: Two small holes in the ground close to the right side of the figure's mouth; otherwise in an excellent state of preservation.

INSCRIPTIONS: None.

COLLECTORS' MARKS: Unknown collector's mark (Lugt 178c).

WATERMARKS: None observed.

PROVENANCE: Unknown collector (Lugt 178c); Mrs. E. Zwicky, Basel-Arlesheim.

EXHIBITIONS: None.

BIBLIOGRAPHY:

(All attributed to Hans Holbein the Elder)

Lieb and Stange, 1960, 91, no. 157, fig. 234 (listed among the early drawings, before 1500).

Bulletin of the Cleveland Museum of Art, 1971, 67, no. 81, ill. 31.

Richards, 1971, 290-95.

Miller, 1987, 125 ill.

COMMENTS:

This fine, well-preserved drawing of an old woman, possibly a nun, is one of a number of portrait studies that Holbein made over a period of perhaps twenty years. They formed a repertory from which the artist selected facial types for his paintings; they also served as models to be copied by his workshop. The Cleveland sheet clearly shows Holbein's working method. While it appears to be executed entirely in silverpoint, closer inspection under magnification shows that the artist strengthened certain contours with the pen, using an ink virtually indistinguishable from the silverpoint in color; these reworked areas include two of the drapery contours that fall from the head cloth to the bottom of the drawing, and the shadow on top of the chin cloth where it disappears beneath the headdress. In the contour of the chin cloth, just to the left of the mouth, Holbein scratched away part of the silverpoint line, exposing the unmarked ground beneath. A similar use of ink to accent or strengthen details can be found in two drawings by Holbein in Copenhagen, and such alterations most likely represent finishing touches by Holbein himself rather than additions by a later hand.[1]

The style of Holbein's silverpoint portraits varies with the subject and with his manipulation of the actual line; hence they are difficult to date. Norbert Lieb and Alfred Stange, however, place the Cleveland sheet shortly before 1500.[2] Louise Richards suggests a date shortly after 1500, based on the following observations. *Head of a Woman* may be compared in style with such early drawings as *Head of a Man Looking Up* (Fig. 24-A) in Bamberg, which was then utilized in a workshop drawing dated 1508. The Bamberg sheet was also a model for the head of one of the figures in the *St. Catherine* altarpiece of

1. Richards, 1971, 291–93.
2. Lieb and Stange, 1960, 91.

129

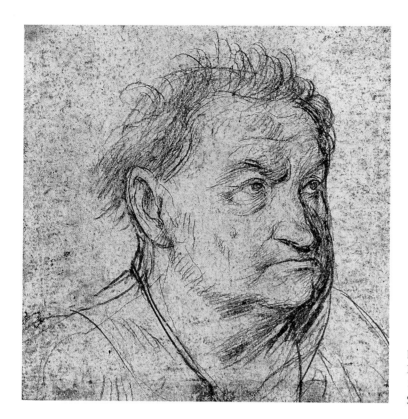

Fig. 24-A. Hans Holbein the
Elder, *Head of a Man Looking
Up,* drawing, Bamberg,
Staatliche Bibliothek.

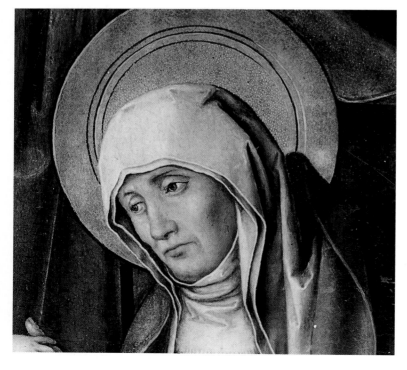

Fig. 24-B. Hans Holbein
the Elder, *St. Anna with the
Virgin and Christ Child,*
panel, detail, Augsburg,
Staatsgalerie.

1515, now dismantled. In another panel from this altarpiece, *St. Anna Selbdritt (St. Anna with the Virgin and Christ Child)* in Augsburg (Fig. 24-B),[3] the head of St. Anna bears some resemblance to the head in the Cleveland drawing. A very similar head is used for St. Anna in a picture of the same subject painted by Holbein about a decade before,[4] now lost, but surviving in a copy. The Cleveland study may have served as a model for both St. Anna figures, but as Richards emphasizes, this remains extremely conjectural, as does the date she proposes.

W. S. G.

3. Richards, 1971, 294, fig. 7; Lieb and Stange, 1960, fig. 103.

4. *Hans Holbein der Ältere und die Kunst der Spätgotik,* 1965, 87–88, no. 41, fig. 42.

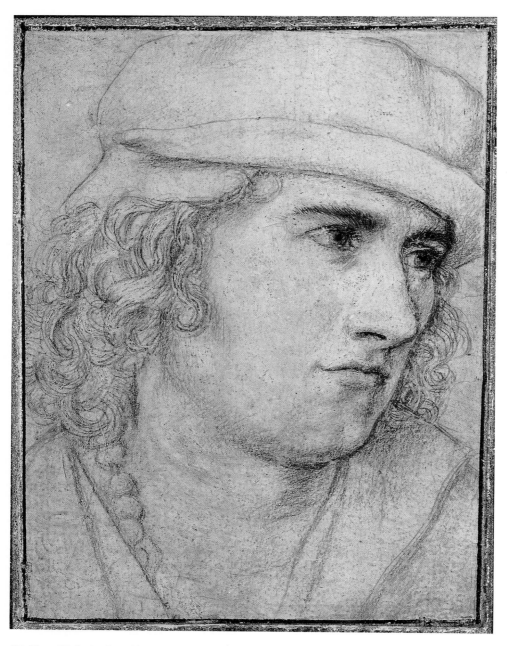

25. Hans Holbein the Elder (1460–1524), *Portrait of a Young Man,* ca. 1510–1515, Kansas City, Nelson-Atkins Museum of Art, Nelson Trust, 56-55. Reproduced larger than actual size.

25

Hans Holbein the Elder (1460–1524), *Portrait of a Young Man,* ca. 1510–1515, 118 x 88 mm (4 5/8 x 3 1/2 in.), silverpoint on cream ground paper, with red and white highlights, Kansas City, Nelson-Atkins Museum of Art, Nelson Trust, 56–55.

TECHNICAL CONDITION: Slight touches of red highlighting in the cheek areas; bister ink lines reinforcing the eyes, eyebrows, nose, and mouth, probably by a later hand; numerous abrasions and scratches in the ground, all easily visible. Examination of the drawing under ultraviolet light confirms that it has been retouched, especially on the left side of the sitter's face and in the neck area. A few preparatory lines appeared under infrared during an examination conducted by Molly Faries, but it is not possible to determine with what kind of instrument they were made (perhaps chalk).

INSCRIPTIONS: None.

COLLECTORS' MARKS: None.

WATERMARKS: None.

PROVENANCE: Philip Hardwick estate, England;[1] H. E. Schwabe, Manchester.[2]

EXHIBITIONS: None.

BIBLIOGRAPHY:

Schilling, 1954, 13, 11.

Schilling, 1955, 15 (as Hans Holbein the Elder depicting Anton Fugger, 1511–1513).

Lieb, 1958, 464 (as Hans Holbein the Elder but not of Anton Fugger).

Lieb and Stange, 1960, 113, no. 299, fig. 377 (as Hans Holbein the Elder, "late work").

COMMENTS:

The drawing is a bust-length portrayal of a young man, probably in his twenties, who looks toward the viewer's right with a slightly downward cast to his head. The deftness of Holbein's line and his ability to capture the immediacy of the sitter's personality are still apparent in this little drawing, despite certain problems of its condition. The identity of the sitter is unknown, but his soft hat and his necklace betray his favored class. The sheet was first attributed to Hans in 1954 by Edmund Schilling, who identified the sitter (with question) as Anton Fugger and dated the work about 1511–1513. In 1958, Norbert Lieb accepted Schilling's attribution, but he seriously doubted that the drawing portrays Fugger.[3] A comparison of the Kansas City drawing to Hans's portrait drawing of Antonius Fugger in Berlin (Fig. 25-A) supports Lieb in dismissing Schilling's suggestion. It shows an individual in strict profile with a less pointed nose and a more prominent chin than the sitter of the Kansas City drawing. Probably drawn when Anton was in his late teens, the Berlin sheet is logically dated about 1510. Later portraits of Anton, such as Hans Maler zu Schwarz's painting of 1525, show a more readily identifiable profile

1. This drawing is not listed in the sale of this collection in 1879 (see *Catalogue of the Valuable Library formed by C. R. Cockerell, R.A. . . . A Portion of the Architectural Library of the Late Philip Hardwick, R.A.,* 1879, 10; drawings sold at the Hardwick sale are listed on p. 33).

2. Schilling, 1954, 13.

3. Ibid., fig. 11; Schilling, 1955, 15; Lieb, 1958, 464.

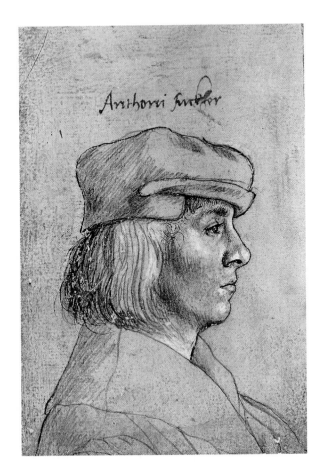

Fig. 25-A. Hans Holbein the Elder, *Portrait of Antonius Fugger,* drawing, Berlin-Dahlem, Kupferstichkabinett.

with his immediately recognizable bald pate.[4]

The Kansas City drawing is closely related to a series of silverpoint portraits of Augsburg burghers in the so-called second sketchbook by Hans the Elder in Basel. Consisting of eleven folios, now separated, the book was one of two recorded in the Amerbach collec-

tion in 1586.[5] The Kansas City head and at least eight of the portraits in the Basel sketch-book are relatively highly finished, all drawn with silverpoint on a prepared ground with occasional red and white highlights. The *Portrait of Hans Aytlehe* (Fig. 25-B) in this sketchbook provides an especially good comparison to the Kansas City head from the standpoint of handling and technique.[6]

4. For the Berlin drawing of Anton Fugger, see Schilling, 1954, 13; Lieb, 1958, 291, 463, fig. 216. Anton was born June 10, 1493, in Augsburg, the son of Georg Fugger and Regina Imhof. He received his majority on October 17, 1513, in Augsburg, visited Rome between 1517 and 1522, and died in 1560 (for his biography see Lieb, 1958, 67–75, and von Pölnitz, 1958). The later portrait of Anton by Hans Maler exists in several versions. See Lieb, 1958, 294, fig. 6; Eisler, 1977, 35–36; and Lauts, 1966, 1:177–78; 2:44.

5. Falk, 1979, 1:82–86, nos. 175–85.
6. Coincidentally, the eyes and eyebrows in both drawings have been reinforced with sharp pen lines in dark ink, probably by a later hand (cf. Falk, 1979, 1:83, 85, no. 184). The ink in the Kansas City draw-ing appears to me to be somewhat lighter and more brown than the added lines on the Basel folio.

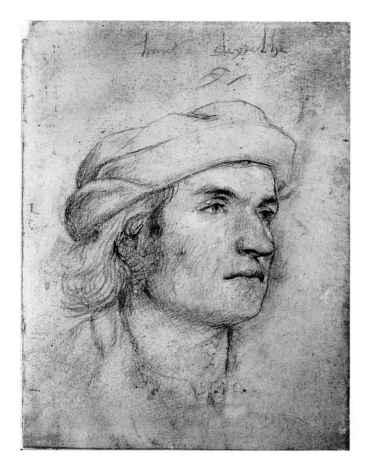

Fig. 25-B. Hans Holbein the Elder, *Portrait of Hans Aytlehe,* drawing, Basel, Kunstmuseum, 1662.199.

Fortunately, the Basel sketchbook has the date of 1513 clearly written on its *Portrait of an Eighty Year Old Monk* (no. 1662.188), and Falk uses this fact to date the entire sketchbook sometime between 1512 and 1515. Therefore, we should logically think of the Kansas City sheet as being produced by Hans at about the same time, perhaps in 1510–1515, some years earlier than the comparatively late date of 1518–1520 suggested by Lieb and Alfred Stange.[7]

B. L. D.

7. Falk, 1979, 1:83; Lieb and Stange, 1960, 113, no. 299, fig. 377.

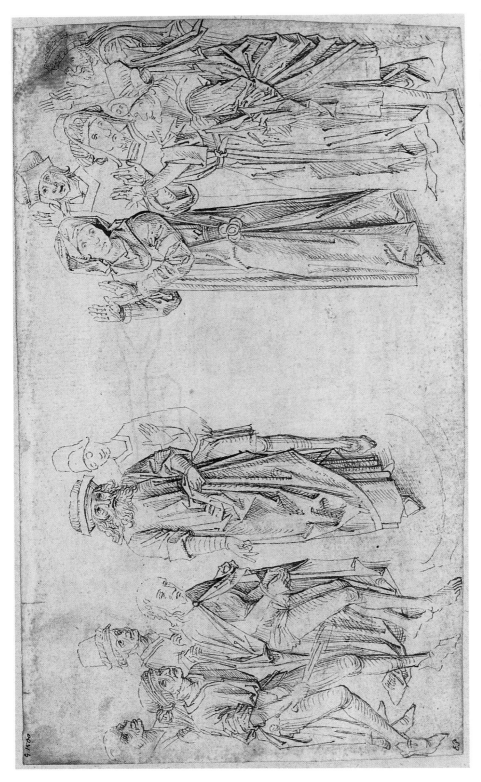

26. Master of the Drapery Studies (active ca. 1475–1500), *Ecce Homo*, ca. 1500, Houston, Texas, Museum of Fine Arts, museum purchase, 72.44.

26

Master of the Drapery Studies (active ca. 1475–1500), *Ecce Homo,* ca. 1500, 167 x 277 mm (6 5/8 x 10 7/8 in.), pen and brown ink on laid paper, Houston, Texas, Museum of Fine Arts, museum purchase, 72-44.

BIOGRAPHICAL NOTE: The artistic personality of the Master of the Drapery Studies, known also as the Master of the Coburg Roundels, was first identified by Thorlacius-Ussing, E. Buchner, L. Kaemmerer, and Friedrich Winkler. L. Fischel localized the master in Strasbourg and recognized his dependence on the Master of the Karlsruhe Passion, now identified with Hans Hirtz. In a painstaking critique of the literature, Christiane Andersson noted that the master's extant corpus comprises more than thirty panel paintings and a hundred and fifty drawings, including designs for glass and copies after Netherlandish paintings and German prints. Michael Roth has recently undertaken a separation of this material into various hands.[1]

TECHNICAL CONDITION: Generally good, with old repair at upper right corner and local restoration (in crown of hat); edges irregularly trimmed, with loss of composition; deep discoloration at upper corners from adhesive stains; edge mounted on tinted rag paper; diagonal crease in lower half visible on verso.[2]

INSCRIPTIONS: On recto, at upper left corner in dark brown ink, "G1500." On verso, at lower right in brown ink, "Israel van Meckeln 1500"; in pencil, "D31839" and "D12."

COLLECTORS' MARKS: EP (Lugt 891) stamped in lower left.

WATERMARKS: Gothic P.[3]

PROVENANCE: Edward Peart, M.D.;[4] P. and D. Colnaghi and Co. Ltd., London.

EXHIBITIONS:

London, P. and D. Colnaghi, 27 June–29 July 1972, *Exhibition of Old Master Drawings,* no. 21 (as Master of the Drapery Studies, ca. 1500).

BIBLIOGRAPHY:

"Acquisitions des Musées en 1972," 1973, 115, no. 408 ill. (as Master of the Drapery Studies).

Wisdom, 1981, 32–33, no. 60 ill. (as Master of the Drapery Studies, ca. 1500).

Andersson and Talbot, 1983, 389 (as Master of the Coburg Roundels).

Roth, 1988, 562–64, no. 171 (as unrelated to the Master of the Drapery Studies).

1. Buchner, 1927; Kaemmerer, 1927; Winkler, 1930, cites Thorlacius-Ussing in *Kunstmuseets Aarskrift* 11–12 (1926): 244 ff.; Fischel, 1934; Andersson and Talbot, 1983, 108–44, 388–93, for further bibliography. The artist's relation to glassmaking was explored by Wentzel, 1949, and Anzelewsky, 1964. Roth's dissertation, 1988, will be published as *Entwerfen, Sammeln, Verwenden. Die Zeichnungen des 'Meisters der Coburger Rundblätter' als Vorlagengut in Strassburger Glas- und Tafelmalerateliers der Spätgotik.*

2. I am grateful to Wynne Phelan and Maggie Olvey, my colleagues at the Museum of Fine Arts, Houston, for examining the drawing with me.

3. The watermark is not recorded in Briquet, 1923; however, Michael Roth (1988) compares it generally to Piccard, 1977, group 9, 432–37.

4. See sale at London, Christie's, April 12, 1822.

COMMENTS:

The composition consists of two figural groups, one at either side, with an intentional void at the center. On the left Jesus appears with his hands bound, wearing a loincloth and the mantle of derision. The mantle is drawn back by two bailiffs, the foremost holding in his right hand a switch directed toward Christ's right leg. Behind, at the left edge, a third bailiff, who raises a stick or switch, is summarily sketched in. To the right of Christ, Pilate stands on a low round dais (the only architectural element in the scene), which he shares with a youth standing behind him to the right. Pilate gestures toward Jesus, with his right hand held straight down and first two fingers pointing downward in a V; he directs his glance toward the group of richly dressed onlookers at the right. Four members of this group hold up their hands; three avert their gaze. A fifth figure in the far right foreground is differentiated by his caricatured features and smirking expression.

The drawing was attributed to the Master of the Drapery Studies by John Rowlands on the basis of similarities with a drawing of *Raising of Lazarus* in the Boymans–van Beuningen Museum in Rotterdam that displays color notes in German and is thought to be a copy of a Flemish painting. The 1972 Colnaghi catalog suggests this *Ecce Homo* was also copied from a Flemish source. Rowlands's attribution has been retained in subsequent publications, notably that of Christiane Andersson, who uses, however, the artist's alternate designation: Master of the Coburg Roundels. In his recent dissertation, Michael Roth concludes that the Houston drawing is not attributable to what he now characterizes as the Strasbourgian circle of artists previously encompassed under the names Master of the Coburg

Roundels and Master of the Drapery Studies.[5] Although offering no alternate suggestion for the authorship or date of this *Ecce Homo,* Roth has significantly established cognate examples of the composition in two pairs of grisaille paintings, originally the outer wings of triptychs, now respectively in the Museo Bandini, Fiesole, and the collection of Bob Jones University, Greenville, South Carolina (Fig. 26-A).[6]

Roth's association of *Ecce Homo* with the monochromatic shutters, which must all descend from a common prototype, is surely accurate and of considerable interest. The left panel of each pair repeats the left-hand figural group of the drawing, with the elimination of the youth behind Pilate and the bailiff at the far left. The four figures in each left shutter are grouped on a hexagonal pedestal; Pilate holds a staff in his right hand and gestures toward Christ with his left. Otherwise, the poses, costumes, and attributes of both grisaille compositions are

5. Colnaghi, 1972, credits Rowlands with the attribution and comparison; the ensuing comment that the Rotterdam drawing is after the painting of the same subject by the Haarlem painter Aelbert van Ouwater (Berlin, Dahlem) and that the *Ecce Homo* may also copy a Flemish picture is contradictory and misleading. Although the drawing is described in the older literature as coming from Haarlem and shares some compositional features with the van Ouwater work, the latter association is no longer noted by A. W. F. M. Meij (1974, 20, no. 7 ill.), who indeed postulates a Flemish prototype for the drawing. Roth, with whom I corresponded in 1985, has kindly sent me the entry cited above and a letter of July 20, 1990. I have not yet had access to his entire dissertation.

6. Friedländer, 1967–1976, 2:pl. 107, nos. 87 and 87a, respectively. Cf. also for the former Bandera, 1981, p.32, fig. 89f, p. 34, and for the latter Folie, 1960, no. 11, 87–89, ill. I am grateful to Joan C. Davis for sending me the photograph and references to the Greenville panels.

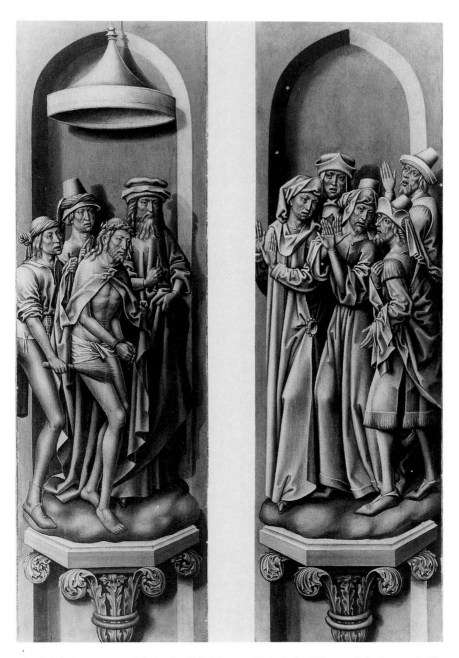

Fig. 26-A. Anonymous Netherlandish Master, *Christ before Pilate and the Jews,* grisaille panels, Greenville, South Carolina, Bob Jones University.

 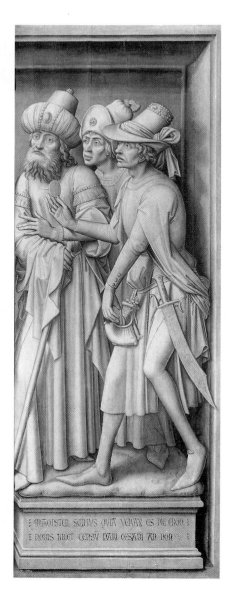

Fig. 26-B. Circle of Rogier van der Weyden, *Tribute Money,* exterior panels to the *Crucifixion,* Madrid, Museo del Prado.

analogous to the drawing well beyond the iconographic requisites of the theme. Both right-hand grisaille shutters correspond with the right half of the drawing. All five figures here are included in the two painted versions, more tightly massed, as are their counterparts in the left shutters, and grouped on a matching pedestal. The Fiesole panels are inscribed, respectively, with Pilate's words, "Exe: Omo," and the crowd's response, "Crusefige: Crusefige." The Houston drawing and Fiesole panels, as Roth notes, share details omitted in the Greenville panels (namely, the trilobate clasp worn by the leftmost witness and the medallion on the hat brim of the second man from the right) and would therefore appear to reflect the prototype more closely.

The Fiesole and Greenville panels have traditionally been assigned to the late circle of Rogier van der Weyden, on the basis of their stylistic similarity to the *Tribute Money* panels (Fig. 26-B) adorning the exterior of the *Crucifixion* triptych in the Museo del Prado in Madrid and with the understanding that they derive from a two-part *Ecce Homo* analogous to them. The work in Madrid was once identified as Rogier's documented altarpiece for Cambrai, but it is more recently thought to be the work of an imitator dating from about 1460 or later.[7] Comparing the Houston drawing as well as

the Fiesole and Greenville panels with the Madrid *Tribute Money,* it is interesting to note that the physiognomy of the Houston Pilate finds a closer parallel to the elderly bearded figure in *Tribute Money* than to that of either Pilate in the *Ecce Homo* grisailles. Moreover, the inward-turning youth behind Pilate in the drawing (a figure that does not appear in either the Fiesole or the Greenville composition) finds his analogue in the apostle standing directly behind Christ in *Tribute Money.*

The question thus emerges as to whether the drawing, with its sensitive physiognomic and emotional distinctions, might have derived from an unknown Rogierian prototype, rather than from either of the extant pair of *Ecce Homo* panels. It is also possible that all three extant examples of the composition were based on still another altarpiece (now lost) in which the two additional figures were present in a single scene with the more traditional elevation of Pilate on a well-defined porch with the jeering crowd massed below. If this were so, the wide intervals between figure groups in the drawing, the glaring empty space at the center of the sheet, and the conspicuous lack of architecture might reflect the draftsman's omission of a standard compositional element motivated by his single-minded concentration on the figures.

As for the attribution of the Houston work, it indeed shares general characteristics with many of the drawings historically given to the Master of the Drapery Studies / Master of the Coburg Roundels. These qualities include a strong, dry pen line, the intense expression of the figures, and the uneven degree of finish, most notable here in the contrast between the rigorously articulated figure of Pilate and the broadly sketched youth to his left. For these reasons,

7. Friedländer, 1967–1976, pl. 66, no. 47. Cf. especially the summaries of Folie, 1960, and commentary of Panofsky, 1953, 473 and 485. Several authors follow Hulin de Loo's suggestion of Vrancke van der Stockt as the author; Hoogewerff (1937, 228–32) tentatively attributes the Madrid wings to the shop of Dirc Bouts and associates both the Fiesole shutters as well as the Rotterdam drawing noted above also with Haarlem. For drawings ascribed to the Master of the Drapery Studies as copies after Rogier van der Weyden, see especially van Gelder, 1966.

I have retained the attribution to the Drapery Master with a date between 1480 and 1500. Any attribution to this artist, however, must be provisional, given Roth's radical disassociation of this drawing and others from the oeuvre of the Master. A full evaluation of his theories on the master must await publication of his expanded monograph based on his 1988 dissertation.[8]

C. C. W.

8. Difficulties in characterizing the anonymous master's style are analyzed by Andersson with reference to the abundance of copies taken from a variety of sources and under different conditions (Andersson and Talbot, 1983, 389–90); a separation of the attributed corpus is anticipated by Meij, 1974, 18.

27

N etherlandish or German School (Middle or Upper Rhine), *An Angel Supporting Two Escutcheons,* last quarter of fifteenth century, 173 x 212 mm (6 13/16 x 8 3/8 in.), black chalk on salmon-tinted paper, Cleveland Museum of Art, purchase, Dudley P. Allen Fund and Delia E. Holden Fund, 62.205.

TECHNICAL CONDITION: Upper corners clipped; some water spots near angel's head.

INSCRIPTIONS: None.

COLLECTORS' MARKS: Crown over "V," lower left corner (Lugt 2500).

WATERMARKS: Briquet, 1923, no. 14229 (Besançon or Champagne, ca. 1450); close to Piccard no. 100 (Oschenkopf; Frankfurt am Main 1452).

PROVENANCE: Charles Ferdinand Louis, Marquis de Valori, Paris (Lugt 2500); Hôtel Drouot, Paris, Valori Salez, November 26, 1907, no. 225 (as Schongauer); Eugène Rodrigues, Paris (Lugt 897, not stamped); Henry Oppenheimer, London (Lugt 1351); Ludwig Rosenthal; Louis V. Randall, Montreal.

EXHIBITIONS: None.

BIBLIOGRAPHY:

Catalogue d'une vente importante de dessins anciens collection R[odrigues] de Paris, 1921, no. 129 (as Netherlandish Master, ca. 1490).

Schilling, 1931–1932, 53–54, ill. pl. 48 (as Upper Rhenish).

Catalogue of the Famous Collection of Old Master Drawings Formed by the Late Henry Oppenheimer, 1936, no. 336 (as Anonymous, South German, ca. 1470–1480).

Wescher, 1938–1939, 2 (associated with Vrancke van der Stoct).

Catalogue of Important Old Master Drawings, The Property of L. V. Randall, Esq., of Montreal, First Part, 1961, no. 6 ill. (as School of the Upper Rhine, ca. 1470).

Göpel, 1961, 23 (as School of the Upper Rhine).

Bulletin of the Cleveland Museum of Art, 1962, 226, no. 127, ill. 210 (attributed to Nicolaus Gerhaert van Leyden).

Sonkes, 1973, 103, 110, 111, 121–22, cat. no. 13 (school of Vrancke van der Stoct).

COMMENTS:

The drawing shows a kneeling angel supporting two coats of arms; the crest on the left is surmounted by the head of an ass. This sheet was first published in 1931–1932 by Edmund Schilling, who noted that it was most likely a model for a sculpture;[1] this is suggested by the vaguely indicated socle on which the angel kneels. Schilling also connected the sheet with a group of drawings that Friedrich Winkler had earlier published under the name of the Master of the Drapery Studies, an anonymous artist who Winkler thought worked in the Middle Rhine area between 1490 and 1500.[2] Schilling consid-

1. Schilling, 1931–1932. Schilling also states that he discerned the word *Holtz* (wood) inscribed in the left background. A recent examination of the drawing by Michael Miller and the present author failed to reveal any inscriptions.

2. Winkler, 1930. See also Anzelewski, 1964. Neither Winkler nor Anzelewski mentions the Cleveland drawing. For this Master, see also above, No. 26.

144

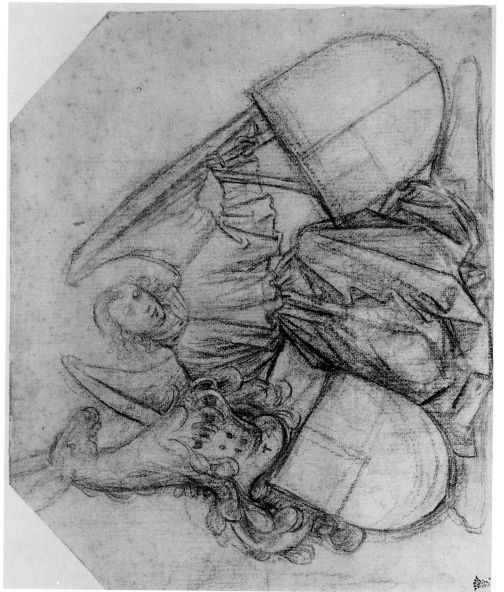

27. Netherlandish or German School, *An Angel Supporting Two Escutcheons*, last quarter of fifteenth century, Cleveland Museum of Art, purchase, Dudley P. Allen Fund and Delia E. Holden Fund, 62.205. (Museum attribution: Circle of Nicolaus Gerhaert van Leyden.) Reproduced actual size.

Fig. 27-A. Netherlandish School, *Angel,* fifteenth century, drawing, Berlin-Dahlem, Kupferstichkabinett.

anonymous draftsman display affinities with the art of Burgundy and the Netherlands. In 1967, Schilling's attribution was reaffirmed by Egbert Haverkamp-Begemann, who suggested the Cleveland sheet was done by the Master of the Drapery Studies.[4]

Paul Wescher associated the Cleveland sheet with another group of drawings, probably from a sketchbook, that he attributed to the Flemish painter Vrancke van der Stoct (or Stockt; before 1430–1495), a follower of Rogier van der Weyden who succeeded Rogier as city painter in Brussels in 1464. Especially similar, Wescher claimed, is a silverpoint drawing of four flying angels with instruments of the Passion, at that time apparently in the Städelsches Kunstinstitut, Frankfort.[5]

The Cleveland drawing was discussed at length by Micheline Sonkes in 1973. According to Sonkes, it shows the closest stylistic affinities with two paintings in the Ruiz Collection, Madrid, by Vrancke van der Stoct or his circle.[6] Depicting an adoring angel and an angel harpist, these two panels show a number of similarities to the Cleveland drawing, especially the head of the angel harpist. It is possible, however, that the paintings and the drawing were by two artists

ered one of these drawings, a sheet depicting an angel (Fig. 27-A), to be a companion to the Cleveland drawing.[3] He further discerned a stylistic resemblance between *Angel with Two Escutcheons* and the sculpture of Nicolaus Gerhaerts van Leyden and placed it in his circle, noting that both the sculptor and the

3. Schilling, 1931–1932, 53, n. 1. See also Bock, 1921, inv. no. 1978, 2:pl. 127.

4. Verbal message preserved in the museum files.

5. Wescher, 1938–1939, 2. For other drawings attributed to this master, see also Winkler, 1965. For an illustration of this drawing, Wescher cites an article by Schrey in *Stift und Feder,* 5/6 (1926), which I have been unable to consult. In any event, the drawing mentioned by Wescher is not cataloged by Schilling and Schwarzweller, 1973.

6. Sonkes, 1973. She suggests the artist might have been one of Van der Stoct's painter sons, Bernard or Michel, or one of his apprentices, of whom we know the names of three: Jenin Bughier, Hannin Hollande, and Henry Genois. Presumably the Madrid paintings are identical to two panels attributed to Vrancke van der Stoct, in a private collection, Madrid. See Friedländer, 1967–1976, 2:add. 159, pl. 143.

working after the same model. In any case, Sonkes placed the Cleveland sheet in a group of drawings that she attributed to an anonymous Brussels artist active in the second half of the fifteenth century and suggested he may have been trained in the workshop of Van der Stoct. She also suggested that the coats of arms supported by the angel are those of the Brabantine family de Berges.[7] This identification is far from certain, however, given the vagueness of the design for both shields in the Cleveland drawing.

The most recent attribution was advanced by Felix Thürlemann in 1992. Identifying its watermark as very close to Piccard no. 100, he proposed that the Cleveland drawing was done around 1450, or sometime earlier.[8] He further suggested that this sheet and all the other drawings on salmon-tinted paper in the "Vrancke van der Stoct" group were made by a pupil of Robert Campin active in Brussels or Louvain, an artist to whom Thürlemann also assigned *Madonna Enthroned in Heaven with Sts. Peter and Augustine and a Donor* (Aix-en-Provence, Musée Granet), traditionally attributed to Campin himself.[9]

Most of these attributions proposed for the Cleveland drawing are not without problems. Schilling's connection of the drawing with the circle of Nicolaus Gerhaerts van Leyden is inconclusive. First recorded in Trier in 1462, Gerhaerts worked also in Strasbourg and Vienna before his death in 1473.[10] A number of wood and stone sculptures have survived from his hand, but he does not seem to have left any drawings, and the Cleveland sheet has little in common with his extant sculpture. The attempts to associate the Cleveland sheet with the Master of the Drapery Studies and with Vrancke van der Stoct are complicated by the fact that the drawings attributed to these two artists seem to have been produced in each case by several hands, none of which can be definitively connected with the drawing in Cleveland. This is true even of the Berlin drawing cited by Schilling. Most attractive, perhaps, is Sonke's proposal that the Cleveland drawing was by an artist trained by Van der Stoct, but this proposal is difficult to reconcile with Thürlemann's dating of the sheet to 1450 or earlier. As for Thürlemann's attribution, it will require further study in order to determine its validity. In view of the conflicting claims concerning the date and attribution of *Angel with Two Escutcheons,* it can be said at most that the drawing is Flemish in character, as is particularly evident in the handling of the drapery folds, and could have been done either by a Netherlandish artist or by a German artist under Flemish influence, sometime during the fifteenth century, possibly from the circle of Rogier van der Weyden.

W. S. G.

7. Sonkes, 1973, 110.

8. Letters of Felix Thürlemann to the Cleveland Museum of Art, April 1 and July 1, 1992. In the second letter, he observes that the watermark is very similar to Piccard no. 100, but also notes that the paper does not exactly correspond to the paper types mentioned by Piccard. He concludes, however, that the paper of the Cleveland sheet was produced by the same paper mill as those described by Piccard under group 9, nos. 99 and 100.

9. Friedländer, 1967–1976, 2:no. 66, pl. 94.

10. For Nicolaus Gerhaerts, see Otto Schmitt, "Nikolaus Gerhaerts von Leyden," in Thieme and Becker, 1901–1956, 25:453–55, with earlier literature; Fischel, 1944; and T. Müller, 1966, 79–87.

Netherlandish School, anonymous artist, *Three Studies of a Woman Wearing an Elaborate Headdress,* ca. 1500, retouched by Peter Paul Rubens (1577–1640), 127 x 128 mm (5 x 5 1/2 in.), pen and brown ink on paper, reworked with pen and brown ink, and brush with gray wash and white pigment, Cleveland Museum of Art, 87.31.

TECHNICAL CONDITION: Excellent; slight foxing.

INSCRIPTIONS: On the verso, inscribed in pencil in the center, with an additional illegible line beneath, "Van Eyck"; in ink at the lower right corner, "R. P. R."

COLLECTORS' MARKS: None.

WATERMARKS: None.

PROVENANCE: Sir Anthony Westcombe; Robert Prioleau Roupell; George Salting; A. W. M. Mensing; Mrs. Leo van Bergh, Wassenaar; Alexander Converse; Baskett and Day, London.

EXHIBITIONS:

London, Baskett and Day, 1986, *An Exhibition of Old Master Drawings of the French School, 1480 to 1880,* no. 1.

Wellesley College, Davis Museum and Cultural Center, 1993, *Flemish Drawings from the Age of Rubens,* no. 36 (as Northern Netherlands [?], retouched by Rubens).

BIBLIOGRAPHY:

Valuable Collection of Drawings by Old Masters, 1887, no. 89 (as by van Eyck).

Dessins anciens, collection de feu M.-Ant. W. M. Mensing, 1937, 614, with ill. (as Peter Paul Rubens).

Belkin, 1980, 119, under cat. no. 21 (as an

original drawing by Hans Suess von Kulmbach, retouched by Rubens).

Fine Dutch and Flemish Drawings, 1985, no. 4, pl. 1 (as Flemish School early sixteenth century; possibly retouched by Rubens).

An Exhibition of Old Master Drawings of the French School, 1480 to 1880, 1986, no. 1 ill. in color (Burgundian School, retouched by Rubens).

Logan, 1987, 71, under nos. 66, and 72, fig. 4 (as possibly North Netherlandish School, retouched by Rubens).

Logan, 1993, 175, no. 36 with col. ill. (as Northern Netherlands [?], retouched by Rubens).

COMMENTS:

Although Edmund Schilling believed the Cleveland drawing was originally executed by the German artist Hans Suess von Kulmbach (ca. 1480–1522),[1] most scholars attribute it to the Netherlandish School. It has been compared to drawings by Hugo van der Goes (ca. 1437–1482) and his followers. It has been considered as possibly by the same artist who did a sheet now in the British Museum with drapery studies on both sides, which, incidentally, has been retouched in the same manner, presumably by Rubens himself (Fig. 28-A).[2] The London drawing has been associated

1. Schilling, oral communication to Ludwig Burchard; see Belkin, 1980, pt. 24:119. Belkin accepts Schilling's attribution, although she notes she had not seen the drawing. Both Schilling and Belkin considered the retouches to be by Rubens.

2. These comments are taken from a description of the Cleveland drawing in the museum files. For

28. Netherlandish School, anonymous artist, *Three Studies of a Woman Wearing an Elaborate Headdress,* ca. 1500, Cleveland Museum of Art, 87.31. Reproduced larger than actual size.

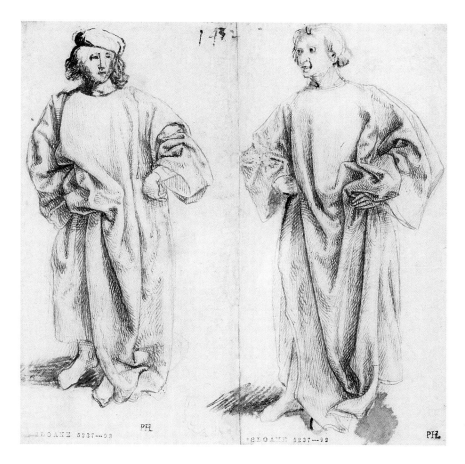

Fig. 28-A. Philippe de Mazerolles, *Drapery Studies,* drawing, London, British Museum, 5237-92-93.

with Philippe de Mazerolles, a Burgundian artist who was active in Bruges, and with Lieven van Latham, who worked in Ghent and Antwerp, but neither attribution is conclusive. Most recently Anne-Marie Logan assigned the Cleveland sheet tentatively to the North Netherlandish school.[3] In any case, the Cleveland drawing would seem to be a study after life; the headdress is a type that was commonly worn in eastern France, Flanders, and Germany between 1450 and 1500. Logan notes that the original artist seems to have been unfamiliar with the construction of the headdress.[4]

Kristen Belkin observed that Rubens introduced similar headdresses into his *Conversion of St. Bavo* (National Gallery, London, no. 57) and suggests that it was this interest in old costumes that inspired Rubens to retouch the drawings of earlier artists. When Rubens reworked old master drawings in his possession, he either adapted his tech-

the London drawing (BM 5237-92-93), now divided into two sheets, see Popham, 1932, 5, 63, no. 7, and ill. pl. 21. Popham seems to have been the first to suggest the retouching was by Rubens.

3. British Museum files. For Philippe de Mazerolles and Lieven van Latham, see Dogaer, 1987, 121–24 and 133–36 respectively, with further literature. Logan, 1987.

4. Museum files; for the costume, see also *An Exhibition of Old Master Drawings of the French School, 1480 to 1880,* 1986, no. 1.

nique to the style of the drawing or trans-
formed the drawing to conform to his own
taste.[5] The Cleveland sheet appears to be an
example of the former process, and the
quality of the original drawing is still evident.

Rubens's intervention in the Cleveland
sheet is easily distinguished by his bold use of
the pen, with strokes darker and broader than
those of the original drawing, and by his
brushwork in gray wash and white pigment.
In the figure at the top, he strengthened the
shadows on the left side of the headdress,
lowered the forehead, and reinforced the
pupils of the eyes, as well as the division

between the lips. He also brushed some
white pigment onto the right jaw and the
portion of the neck immediately below. In
the figure at the lower right, he thickened
the neck by strengthening its right contour
and extended the sleeve and skirt with
brushstrokes of gray wash. In the left-hand
figure, he lowered the hairline, retouched the
nose and chin and part of the throat with
white pigment, and reworked the left
shoulder and sleeve of the gown.[6]

W. S. G.

5. Belkin, 1980, 119. The literature on Rubens is
enormous; an extensive bibliography can be found in
C. White, 1987, 302–6. For his drawings, see Held,
1986, esp. 47–49, for a discussion of Rubens's
reworking of older drawings; Burchard and d'Hulst,
1963. For drawings retouched by Rubens, see also
Jaffé, 1964–1966.

6. I would like to thank Michael Miller, former
assistant curator of prints and drawings at the
Cleveland Museum of Art, for his assistance in deter-
mining the areas and extent of Rubens's reworking.
For a similar treatment by Rubens of another
Flemish drawing, a *Crucifixion of St. Andrew* from the
circle of Hugo van der Goes (Uffizi, Florence), see
Jaffé, 1965.

Martin Schongauer

The Alsatian painter-engraver Martin Schongauer (ca. 1450–1491) was the most influential printmaker before Albrecht Dürer, who had wished to be his journeyman but was prevented from doing so by Schongauer's untimely death. Schongauer was the first northern printmaker whose works achieved wide distribution in southern Europe as well as in the Netherlands and Germany. The first major engraver trained primarily as a painter, rather than as a goldsmith, he was also the first whose proper name and places of professional activity are documented.[1]

Schongauer's father, Caspar, was a goldsmith who around 1440 left the family home in Augsburg to settle in Colmar, on the left bank of the Rhine in what is now southeastern France.[2] Because Martin seems never to have applied for citizenship in Colmar, it is assumed he must have been born in that city; the fact that the principal church in Colmar is dedicated to St. Martin lends credence to this theory. In 1465 he matriculated at the University of Leipzig, where he remained for no more than one year. He was living in Colmar again by the early 1470s and continued to maintain a workshop there until his death in 1491, even though he had taken citizenship in 1489 in Breisach, where he was engaged in painting the colossal *Last Judgment* fresco on three walls of the church of St. Stephen.

Schongauer's widely dispersed print sales may have been in part due to the fact that three of his brothers were prominent craftsmen in important commercial centers. Ludwig, also a painter and printmaker, was active for a time in Ulm—in the center of an area where Schongauer's influence is particularly noticeable.[3] His goldsmith brothers Jörg, in Basel and Strasbourg, and Paul, in Leipzig, could have been counted upon either to display his work themselves or to find trustworthy sales agents for his prints. In addition, several of his major imitators, Wenzel von Olmütz, Israhel van Meckenem, and Masters AG and LCz, were strategically placed themselves:[4] Wenzel popularized

1. The documents concerning the Schongauer family were most recently published in Châtelet, ed., 1991, 37–53. The documents themselves are to be found in Colmar's Archives Municipales, Archives Départementales, Bibliothèque Municipale; the Office of the Registrar of the University of Leipzig; and in the municipal archives of Basel. The standard literature on the artist includes Lehrs, 1925; Baum, 1948; Flechsig, 1951; and Minott, 1971.

2. The family is presumed to have come originally from the town of Schongau, a short distance south of Augsburg on the river Lech; however, it already belonged to the Augsburg patriciate by the thirteenth century. The artist's presumed grandfather, Hans Schongauer, became a member of the Augsburg city council in 1444.

3. On Schongauer's brothers, see Châtelet, ed., 1991: Paul, 47–48; Ludwig, 49–50; Jörg, 50–53. An altar cross and a monstrance made by Jörg Schongauer are preserved in the parish church of Sts. Pierre and Germaine in Porrentruy, in the Swiss canton of Jura (see Barth, 1989, 2, nos. 8–9).

4. On Wenzel von Olmütz, Master A G, and Master LCz see Hutchison, ed., 1991; Shestack, 1971; and Lehrs, 1927. On Israhel van Meckenem's relationship to Schongauer see Bröker, ed., 1972, especially the essay by Robels, 1972.

Schongauer's designs in eastern Germany and Bohemia, while Israhel's workshop was in the lower Rhine Valley at Bocholt. Master A G was employed by the Bishop of Würzburg, and Master LCz, who is probably to be identified with the painter Lorenz Katzheimer, seems to have lived in Bamberg. All this helps to explain the distribution network of Schongauer's prints north of the Alps. However, it was the power and beauty of his draftsmanship and the extraordinarily high quality of his burin technique and his printing that were the real secret of his success: according to Vasari, even the young Michelangelo made a copy of one of his prints.

The two drawings cataloged here are excellent examples of the influence of Schongauer's prints on his contemporaries. Both drawings are copies of his engravings by artists whose identities we will probably never know. Like so many others, these artists were drawn to Schongauer's art by the clarity of his line, the originality of his figure compositions, and the obvious accessibility of the print medium itself.

J. C. H.

29

Anonymous German artist, copy after Martin Schongauer (ca. 1450–1491), *Virgin and Child*, 187 x 124 mm (7 3/8 x 4 7/8 in.), pen and ink reinforced with charcoal and ink on laid paper, Grand Rapids, Michigan, Museum of Art, 62.3.1: W.C.A. 529.

TECHNICAL CONDITION: Original pen and gray ink reworked by a later artist, probably also from the fifteenth century, with brush, charcoal, and black carbon ink; cropped on both sides.

INSCRIPTIONS: None.

COLLECTORS' MARKS: "J. P. H." inscribed in an oval (verso), in black (Lugt 1507).

WATERMARKS: Partial watermark, not identifiable.

PROVENANCE: John Postle Heseltine, London, 1843–1929; Knoedler and Company, New York.

EXHIBITIONS: None.

BIBLIOGRAPHY: None.

COMMENTS:

The Grand Rapids Museum purchased *Virgin and Child,* attributed to an anonymous follower of Martin Schongauer, from Knoedler's, New York, in 1962. It bears the collector's mark of John Postle Heseltine (b. 1843), whom Frits Lugt called "one of the most astute collectors of prints and drawings in modern times." A wealthy London stockbroker, Heseltine was one of the trustees of the National Gallery, beginning in 1893. When a portion of his collection numbering some six hundred pieces was sold to Colnaghi's in 1912, his forty Claude drawings were bought *en bloc* by the Louvre, while the British Museum bought numerous other works. The collection included seventy Rembrandts, three Holbein portraits, excellent Dürers, as well as works by Rubens, Van Dyck, Watteau, Boucher, Raphael, Michelangelo, and many seventeenth-century Dutch artists.[1]

In the Heseltine collection, the *Virgin and Child* drawing was attributed to "Franz von Bocholt," who is mentioned by the late sixteenth-century engraver, geographer, and historian Matthias Quadt von Kinkelbach (b. 1557) in his chauvinistic *Teutscher Nation Heiliqkeit* (Cologne, 1609) as the earliest known German engraver. This artist was traditionally identified with the monogrammist FVB (active circa 1480–1500), a Schongauer follower.[2] Six of FVB's plates were taken over and reprinted by Israhel van Meckenem, whose workshop was in Bocholt on the lower Rhine, but the existence of Franz von Bocholt, unfortunately, cannot be verified, since the city's archives for the years of his presumed activity have been destroyed. The name Franz von Bocholt was further cast into doubt as the identity of the monogrammist in 1930, when Max Lehrs pointed out that Master FVB must have been active in Bruges. At that time, Lehrs put forward the invented

1. Lugt 1507; Lugt supp. 1597. Heseltine's obituary by Campbell Dodgson (*Burlington Magazine* 54 [1929]: 213) gives an overview of the collection and of Heseltine's standing as one of the last great collectors who made his own purchases, without relying on professional advice.

2. On Master FVB, see Hutchison, 1993, 20–21; Shestack, 1967, 126–33; Lehrs, 1930, 102–64.

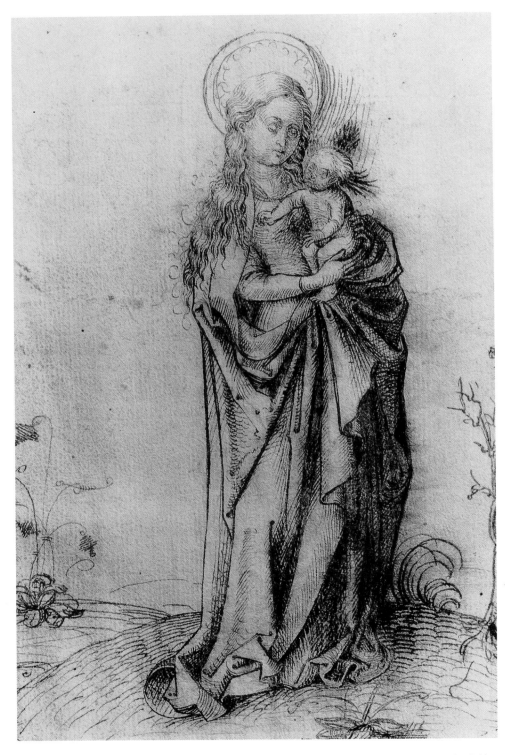

29. Anonymous German artist, copy after Martin Schongauer (ca. 1450–1491), *Virgin and Child*, Grand Rapids, Michigan, Museum of Art, 62.3.1: W.C.A. 529. Reproduced larger than actual size.

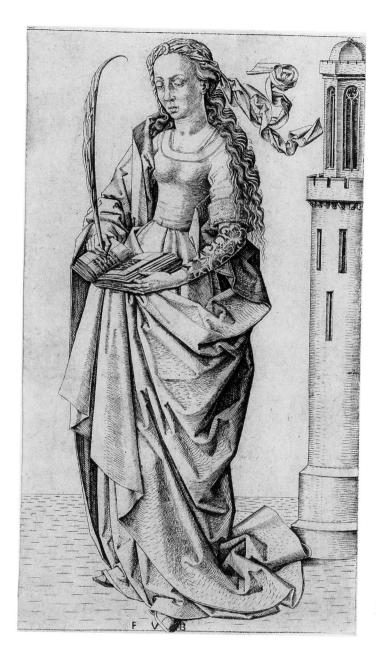

Fig. 29-A. Master FVB, *St. Barbara,* engraving, New York, Metropolitan Museum of Art, the Elisha Whittelsey Fund, 1955, 55.530 (Lehrs 4S).

name "Frans van Brugge" (Frans of Bruges) as an alternative explanation for the initials FVB. However, no engraver or goldsmith by that name is listed in the Bruges archives, and the artist is known today simply by the initials of his monogram.

Master FVB's Madonnas are frequently based on prototypes from engravings by Schongauer; they wear their long hair rolled back in a manner similar to that in the Grand Rapids drawing and are daintily proportioned and delineated in lighter-weight lines than

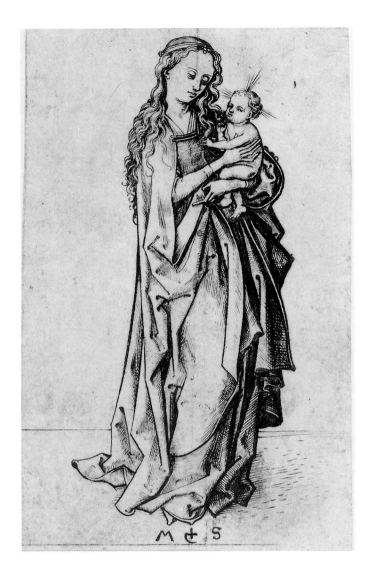

Fig. 29-B. Martin Schongauer, *Virgin and Child,* engraving, Chicago, Art Institute, Mr. and Mr. Potter Palmer Collection, 1956.867 (Lehrs 35).

Schongauer's own (Fig. 29-A).

The fact that this most interesting late-fifteenth-century drawing remained so long on the market, rather than finding an immediate and permanent home in a major collection, is surely due in part to the controversy over the existence of "Franz von Bocholt" and his relationship, if any, to the monogrammist FVB. More important, however, the drawing has been extensively reworked by a bolder hand and thus does not present a unified and pol-

ished appearance. The original drawing, a free copy after Martin Schongauer's small standing *Virgin and Child* (Fig. 29-B), was carried out in a delicate, grayish ink with an extremely fine quill. Its fine quality can still be seen best in the face, halo, and upper body of the Madonna and on the stem of the calligraphic plant at the left. The plant at right was drawn with a fine brush, using the same grayish ink mixture. At a later time, but probably still within the fifteenth century, the applied shad-

ow on the Virgin's drapery was reinforced with charcoal and the outlines of her drapery were retouched by a heavier hand, using a brush dipped in heavy black ink and a more mechanical shading system. Traces of pigment on the verso, taken together with four neatly spaced pinholes across the top of the drawing, reinforce the impression that it was used as a pattern by someone other than the original artist.

The prototype for the Virgin, Schongauer's small standing *Virgin and Child,* is one of his most popular engravings and was a particular favorite with painters of miniatures. The scalloped ornament of the Madonna's halo, the traces of pigment on the reverse side, and the reinforcement of the main outlines of drapery all suggest the drawing was kept and used in the workshop of a manuscript illuminator over a period of some years.

J. C. H.

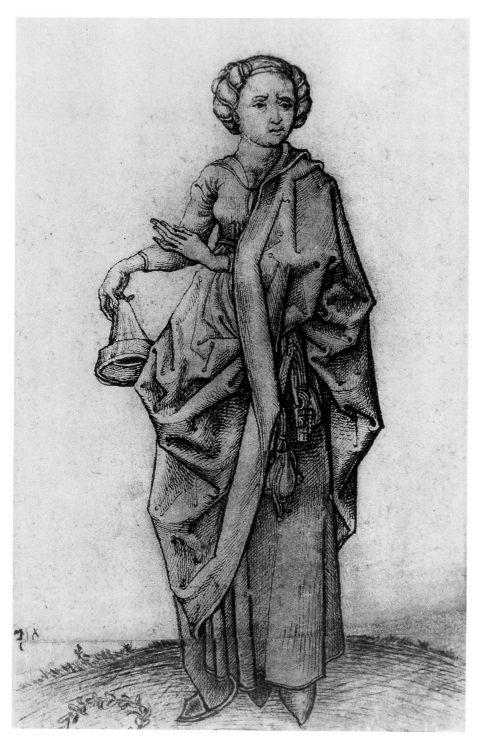

30. Anonymous German artist, copy after Martin Schongauer (ca. 1450–1491), *The Fourth Foolish Virgin,* ca. 1485–1490, Kansas City, Nelson-Atkins Museum of Art, gift of Mr. and Mrs. Milton McGreevy through the Westport Fund, F58.73. Reproduced larger than actual size.

30

Anonymous German artist, copy after Martin Schongauer (ca. 1450–1491), *The Fourth Foolish Virgin,* ca. 1485–1490, 125 x 79 mm (4 7/8 x 3 3/32 in.), brown and black ink on cream laid paper, Kansas City, Nelson-Atkins Museum of Art, gift of Mr. and Mrs. Milton McGreevy through the Westport Fund, F58-73.

TECHNICAL CONDITION: Bottom one-sixth cut away and replaced with a modern section, spliced to the original with rice paper on the reverse; the hem of the figure's garment, her feet, her myrtle wreath, and the grassy mound on which she stands are all additions by a modern restorer.

INSCRIPTIONS: In the lower left corner by a modern hand, "758." On the verso in pencil, "Auction Dr. M. Waldeck Amsler and Ruthardt, Berlin 14, February 1887."

COLLECTORS' MARKS: A blue mark, identifiable with Lugt 2773, Baron S. von Lanna, Prague, is repeated twice on the verso.

WATERMARKS: None.

PROVENANCE: Franz Graf von Sternberg-Manderscheid, 1845; Dr. M. Waldeck, 1887; S. von Lanna Collection, Prague, 1910; Joseph Brummer, New York, 1949; Durlacher Brothers, New York; Mr. and Mrs. Milton McGreevy, Kansas City, Missouri.

EXHIBITIONS: None.

BIBLIOGRAPHY:

Lehrs, 1925, 319 ("a weak drawing after the print").

The Estate of the Late Joseph Brummer. Part II, 1949, 168, no. 665 ill. (as Martin Schongauer).

COMMENTS:

The drawing is clearly copied from Schongauer's engraving *Fourth Foolish Virgin* (Fig. 30-A) in his series of ten prints of the *Wise and Foolish Virgins.*[1] The narrative is taken from Matthew 25:1–13 in which the successful trimming of the bridegroom's lamps by the wise virgins and the neglect of them by their opposites illustrate that the door to heaven is open only to those who are constantly prepared for the coming of Christ.[2] In both the print and the Kansas City drawing, the woeful figure laments her plight by gesturing toward the empty, funnel-shaped lamp, held upside down to demonstrate its lack of oil.

She stands on a grassy turf with her festive myrtle wreath discarded on the ground. Despite the slightly wider dimensions of Schongauer's print (125 x 87 mm), the figure in the drawing is almost exactly the same size as the printed image. Moreover, the details of

1. Lehrs, 1925, nos. 76–85.
2. The ten standing virgins lent themselves perfectly to jamb sculptures in Gothic portals, and they occur as a common motif in medieval church architecture throughout Germany. Moreover, the moralizing warning they communicate corresponded well to the frequent theme of the Last Judgment in tympana above them. The Virgins appear, for example, in sculptural programs at Rostock, Nuremberg, and Magdeburg. One of the earliest representations of the theme in medieval church architecture appears in the lintel of the north portal of Basel, Münster, dating from the end of the twelfth century. Another series, near Colmar, can be found at Freiburg im Breisgau, dating from the fourteenth century (see Braunfels, 1981, 4:184, 205, figs. 168, 187).

Fig. 30-A. Martin Schongauer,
Fourth Foolish Virgin, engraving,
Chicago, Art Institute, Mr. and
Mrs. Potter Palmer Collection,
1956.907 (Lehrs 84).

the drawing, including the conventions of the drapery (with small closed loops on the ends of the folds), are literal duplicates of the print. In the copyist's eagerness to record accurately the details of Schongauer's original print, he lost the overall sense of unified form, the flowing rhythm of the figure's gesture and her drapery, and the elegance of her pose. Thus the drawing is pinched and tight with even a certain flatness, details never found in Schongauer's own studies.

There are three complete engraved copies after Schongauer's series of the Virgins by the Master AB (Bartsch 18–27), Israhel von Meckenem (Bartsch 156–67), and the Master IE (also known as the Master of St. Catherine's Wheel; Bartsch 77–86).[3] There are several other drawings of single figures related to Schongauer's prints of the Virgins, but they all vary in one way or another from the

3. Lehrs, 1925, 307–8.

Kansas City sheet. Copies are located in Berlin, Sigmaringen, Basel, and Montreal. Two other drawings in Oxford and Leipzig depicting standing young maidens are likely by Schongauer himself, probably intended for a second series of the Virgins.[4]

As for the identity of the artist of the Kansas City drawing, we should certainly look to a contemporary of Schongauer, but

one probably never directly associated with Schongauer's shop. The print itself must have been published before 1483, the year in which Grunenberg used five prints from the series as models for illustrations in a *Wappenbuch*.[5] The Kansas City drawing was likely copied about the same time, probably around 1485–1490.

B. L. D.

4. See Lehrs, 1914, 5:12; Lehrs, 1925, 307–10, 318–20, 322; Rosenberg, 1923, nos. 41 and 26; and Winzinger, 1962, nos. 38–39, 81, and 89–96.

5. Lehrs, 1925, 319.

Bibliography

"Accessions of American and Canadian Museums, April–June, 1957." 1957. *Art Quarterly* 20 (autumn): 317.

"Accessions of American and Canadian Museums, April–June 1958." 1958. *Art Quarterly* 21 (autumn): 336.

"Acquisti di Musei Americani." 1959. *Sele Arte* 40 (March–April): 58.

"Acquisitions des Musées en 1972." 1973. *Gazette des Beaux-Arts* 81 (February): 115.

Agnew's: 1817–1967. 1967. London: Bradbury Agnew Press.

Ainsworth, Maryan W. 1989. "Northern Renaissance Drawings and Underdrawings: A Proposed Method of Study." *Master Drawings* 27, no. 1:5–38.

———. 1992. "Implications of Revised Attributions in Netherlandish Painting." *Metropolitan Museum Journal* 27:59–76.

Ainsworth, Maryan W., and Molly Faries. 1986. "Northern Renaissance Paintings: The Discovery of Invention." *St. Louis Art Museum Bulletin* 18 (summer): 1–47.

Allen Memorial Art Museum Bulletin. 1955. Vol. 13, no. 1 (1955): 31.

———. 1959a. Vol. 16, no. 2 (winter): 86, 88–89.

———. 1959b. Vol. 16, no. 3 (spring): 201, 203.

Ames-Lewis, Francis. 1981a. "Drapery 'Pattern'—Drawings in Ghirlandaio's Workshop and Early Apprenticeship." *Art Bulletin* 63:49–61.

———. 1981b. *Drawing in Early Renaissance Italy.* New Haven: Yale University Press.

———. 1987. "Modelbook Drawings and the Florentine Quattrocento Artist." *Art History* 10 (March): 1–11.

Ames-Lewis, Francis, and J. Wright. 1983. *Drawing in the Italian Renaissance Workshop.* London: Victoria and Albert Museum.

Andersson, Christiane, and Charles Talbot. 1983. *From a Mighty Fortress: Prints, Drawings, and Books in the Age of Luther, 1483–1546.* Detroit: Detroit Institute of Arts.

Angelini, Alessandro; Florence, Galleria degli Uffizi, Gabinetto Disegni e Stampe. 1986. *Disegni italiani del tempo di Donatello.* Florence: L. S. Olschki.

Annuaire des Ventes d'Objets d'Art. 1958–1959. Vol. 14:418.

Anzelewsky, Fedja. 1964. "Peter Hemmel und der Meister der Gewandstudien." *Zeitschrift des deutschen Vereins für Kunstwissenschaft* 18 1/2:43–53.

Art Institute of Chicago Annual Report. 1964–1965. Vol. 60.

Art Institute of Chicago Quarterly. 1957. Vol. 51, no. 3:75.

"Artists' Handwriting Makes Good Reading at the Detroit Institute." 1950. *Art Digest* 24 (June 1).

Art Quarterly. 1955. Vol. 18:195.

———. 1956. Vol. 19 (winter): 422.

———. 1959. Vol. 22 (winter): 396.

———. 1961. Vol. 24 (autumn): 304.

Asperen de Boer, J. van. 1984. "A Note on the Relation between Underdrawing and Sinopia in Two Works by Andrea del

Castagno." *De Arte et Libris: Festschrift Erasmus, 1934–1984.* Amsterdam: Erasmus Antiquariaat en Boekhandel.

Aymar, Brandt. 1970. *The Young Male Figure.* New York: Crown Publishers.

Backhouse, Janet. 1983. "A Book of Hours by a Contemporary of Jean Bourdichon: A Preliminary Note on British Library, Yate Thompson Ms. 5." In *Manuscripts in the Fifty Years after the Invention of Printing,* edited by J. B. Trapp. London: Warburg Institute, University of London.

———. 1987. "The Tilliot Hours: Comparisons and Relationships." *British Library Journal* 13:211–31.

Balniel, Lord, and K. Clark. 1931. *A Commemorative Catalogue of the Exhibition of Italian Art Held in the Galleries of the Royal Academy, Burlington House, London, January–March, 1930.* London: Oxford University Press.

Bandera, M. C. 1981. *Fiesole: Museo Bandini.* Musei d'Italia Meraviglie d'Italia, vol. 17. Bologna: Calderini.

Barth, Ulrich. 1989. *Schätze der Baseler Goldschmiedekunst 1400–1989.* Exhibition catalog. Basel: Historisches Museum.

Baum, Julius. 1948. *Martin Schongauer.* Vienna: A. Schroll.

Baumeister, E. 1933–1952. "Unbekannte Bildniszeichnungen Hans Holbeins der Älteren." *Wallraf-Richartz-Jahrbuch* n.s. 2–3:257.

Baxandall, Michael. 1980. *The Limewood Sculptors of Renaissance Germany.* New Haven and London: Yale University Press.

Belkin, Kristen Lohse. 1980. *The Costume Book: Corpus Rubenianum Ludwig Burchard Part XXIV.* Brussels: Arcade.

Berenson, Bernard. 1938. *The Drawings of the Florentine Painters.* 3 vols. Chicago:

University of Chicago Press.

———. 1961. *I disegni dei pittori fiorentini.* 3 vols. Milan: Electa.

———. 1968. *Italian Painters of the Renaissance, Central and North Italian Schools.* 3 vols. London: Phaidon.

Berti, L., and U. Baldini. 1991. *Filippino Lippi.* Florence: Arnaud.

Beutler, Christian, and Gunther Thiem. 1960. *Hans Holbein d. Ä., Die spätgotische Altar- und Glasmalerei.* Augsburg: H. Rösler.

Bober, Phyllis Pray, and Ruth Rubinstein. 1986. *Renaissance Artists and Antique Sculpture: A Handbook of Sources.* London: Oxford University Press.

Bock, Elfried. 1921. *Die deutschen Meister, Staatlichen Museen zu Berlin.* 2 vols. Die Zeichnungen Alter Meister im Kupferstich Kabinett, edited by Max J. Friedländer. Berlin: Propylaen Verlag.

Boerner, C. G. 1930. *Handzeichnungen des XV bis XVIII Jahrhunderts.* Leipzig: C. G. Boerner.

Bongiorno, L. 1976. "The Fruits of Idealism." *Apollo* 103 (February): 91–92.

Borowitz, H. 1978. "Making the Rounds at the Cleveland Museum of Art." *Bulletin of the Cleveland Medical Library* 24 (July): 58.

Borsook, E. 1975. "Fra Filippo Lippi and the Murals for Prato Cathedral." *Mitteilungen des Kunsthistorisches Institut in Florenz* 19:23–24.

———. 1980. *The Mural Painters of Tuscany from Cimabue to Andrea del Sarto.* Oxford: Clarendon Press.

Borsook, E., and J. Offerhaus. 1981. *Francesco Sassetti and Ghirlandaio at Santa Trinità, Florence: History and Legend in a Renaissance Chapel.* Holland: Davaco Publishers.

Braunfels, Wolfgang. 1981. *Die Kunst im Heiligen Römischen Reich Deutscher Nation.*

Vol. 4. Munich: C. H. Beck.

Brenzoni, R. 1952. *Pisanello pittore.* Florence:
L. S. Olschiki.

Briquet, Charles M. 1923. *Les filigranes.*
Dictionnaire historique des marques du papier
des leur apparation vers 1282 jusqu'en 1600.
2d ed. 4 vols. Leipzig: Hiersemann.

Bröker, Elizabeth, ed. 1972. *Israhel van*
Meckenem und der deutsch Kupferstich des 15.
Jahrhunderts–750 Jahre Stadt Bocholt
1222–1972. Bocholt: published as vol-
umes 3 and 4 of the periodical *Unser*
Bocholt.

Bruder, Harold. 1992. "Romanized and
Romanticized: Mantegna's Great Judith."
Drawing 14, no. 3 (September–October):
56–58.

Brugerolles, Emmanuelle. 1984. *Les dessins de*
la collection Armand-Valton: Une donation
d'un grand collectionneur de XIXe siècle à
l'Ecole des Beaux-Arts: Inventaire general.
Paris: Ecole des Beaux-Arts.

Buchner, Ernst. 1927. "Studien zur mittel-
rheinischen Malerei und Graphik der
Spätgotik und Renaissance, III: Der
Meister der Caburger Rundblatter."
Münchner Jahrbuch der bildenden Kunst n.s.
4, 3:284–300.

———. 1928. "Zum Werk Hans Holbein der
Ältere." *Beiträge zur Geschichte der Deutschen*
Kunst 2:133–58.

Bulletin of the Cleveland Museum of Art. 1958.
Vol. 45 (March): 62, 63, 66, 67, 71.

———. 1962. Vol. 49:226.

———. 1971. Vol. 58:67.

Burchard, Ludwig, and R. A. d'Hulst. 1963.
Rubens' Drawings. 2 vols. Brussels: Arcade
Press.

Bushart, Bruno. ca. 1977. "Der
Lebensbrunnen von Hans Holbein d. Ä."
In *Festschrift Wolfgang Braunfels,* 45–70.

Tübingen: E. Wasmuth.

———. 1987. *Hans Holbein der Ältere.*
Augsburg: Verlag Hofmann-Druck.

Cadogan, Jean. 1978. "Drawings by
Domenico Ghirlandaio." Ph.D. diss.,
Harvard University.

———. 1980. *Maestri toscani del quattrocento,*
Biblioteca di Disegni. Florence: Instituto
Alinari.

———. 1983. "Reconsidering Some Aspects
of Ghirlandaio's Drawings." *Art Bulletin*
65:274–90.

———. 1984. "Observations on
Ghirlandaio's Method of Composition."
Master Drawings 22:167–68.

———. 1987. "Drawings for Frescoes:
Ghirlandaio's Technique." In *Drawings*
Defined, edited by W. Strauss and T. Felker,
63–75. New York: Abaris.

Cartari, Vincenzo. 1647. *Imagini delli dei de*
gl'antichi. Reprint. Graz: Akademische
Druck u. Verlagsanstalt, 1963.

Catalogue d'une vente importante de dessins
anciens collection R[odrigues] de Paris. 1921.
Exhibition catalog. Amsterdam: Frederik
Muller & Cie., July 12–13.

Catalogue of Drawings by the Old Masters
Formed by the Late Professor August Grahl of
Dresden. 1885. London: Sotheby,
Wilkinson, and Hodge, April 27–28.

Catalogue of Important Old Master Drawings.
1963. London: Sotheby and Co., October
21.

Catalogue of Important Old Master Drawings,
The Property of L. V. Randall, Esq., of
Montreal, First Part. 1961. London: Sotheby
and Co., May 10.

Catalogue of the Carl O. Schniewind Memorial
Exhibition of Prints and Drawings. 1958.
Chicago: Art Institute.

Catalogue of the Famous Collection of Old

Master Drawings Formed by the Late Henry Oppenheimer. 1936. London: Christie's, July 10–14.

Catalogue of the Valuable Library Formed by C. R. Cockerell, R. A., A Portion of the Architectural Library of the Late Philip Hardwick, R. A. 1879. London: Christie, Manson and Woods, June 10.

Châtelet, Albert, ed. 1991. *Le beau Martin.* Colmar: Musée d'Unterlinden.

Chiarini, Marco. 1962. "Una citazione della 'Sagra' di Masaccio nel Ghirlandaio." *Paragone* 149:55.

Ciammitti, L. 1925. *Ercole Roberti: La Capella Garganelli in San Pietro.* Exhibition catalog. Bologna: Museo Civico.

———. 1985. "Ercole Roberti: La Cappella Garganelli im San Pietro." In *Tre Artisti nella Bologna dei Bentiuoglio.* Exhibition catalog. Bologna.

Clark, Kenneth. 1930. "Italian Drawings at Burlington House." *Burlington Magazine* 56 (April): 175.

College Art Journal. 1951. Vol. 11 (fall): frontispiece.

Collobi, L. Ragghianti. 1971. "Il 'Libro de' disegni' de Giorgio Vasari." *Critica d'arte* 18 (March–April): 18.

———. 1974. *Il libro de' disegni del Vasari.* 2 vols. Florence: Vallecchi.

Colnaghi's, 1760–1960. 1960. London: Colnaghi's.

Cook, H. 1903–1904. "Some Notes on the Early Milanese Painters Butinone and Zenale." *Burlington Magazine* 3–4 (October–March): 84–94, 179–85.

Crowe, J. A., and G. B. Cavalcaselle. 1912a. *A History of Painting in Italy.* 6 vols. New York: Charles Scribner's Sons.

———. 1912b. *A History of Painting in North Italy.* 3 vols. New York: Charles Scribner's Sons.

Davis, F. 1953. "Drawings by the Great and Near-Great." *Illustrated London News* (June 13): 992.

Degenhart, Bernhard. 1945. *Pisanello.* Turin: Chiantore.

———. 1953. "Di una publicazione su Pisanello e di altri fatti (I)." *Arte Veneta* 7:182–85.

———. 1955. "Dante, Leonardo and Sangallo." *Römisches Jahrbuch für Kunstgeschichte* 7:218, 251, n. 307.

———. 1972. "Pisanello." In *Encyclopedia of World Art,* 11:370–75. New York, Toronto, London: McGraw-Hill.

Degenhart, Bernhard, and Annegrit Schmitt. 1966. *Italienische Zeichnungen der Frührenzissance.* Munich.

———. 1967. *Italienische Zeichnungen 15.–18. Jahrhunderts.* Munich: H. Holzinger.

———. 1968. *Corpus der italienischen Zeichnungen, 1300–1450, I. Süd- und Mittelitalien.* 4 vols. Berlin: Mann Verlag.

———. 1984. *Jacopo Bellini: L'album dei disegni del Louvre.* Milan: Jaca.

———. 1990. *Corpus der italienischen Zeichungen, 1300–1450, II. Venedig, Jacopo Bellini.* 4 vols. Berlin: Mann Verlag.

Dell'acqua, G. A., and R. Chiarelli. 1972. *L'Opera completa del Pisanello.* Milan: Rizzoli.

Descriptive Catalogue of the Drawings . . . in the Possession of the Hon. A. E. Gathorne-Hardy. 1902. London: Ballantyne Press.

Dessins anciens, collection de feu M.-Ant. W. M. Mensing. 1937. Amsterdam: Frederik Muller, April 27–29.

de Vos, Dirk. 1986. "De Constructie van Memlings Van Nieuwenhoveportret: een probleem van interpretatie van de voorbereidende tekening." *Oud Holland* 100,

no. 3–4:165–70.

"Disegni di grandi maestri di sei secoli alla Galleria Knoedler." 1959. *Emporium* 130 (December): 282.

Dogaer, Georges. 1987. *Flemish Miniature Painting in the 15th and 16th Centuries.* Amsterdam: B. M. Israel.

Dogson, Campbell. 1929. "Obituary of Mr. Heseltine." *Burlington Magazine* 54:213.

"Drawing." 1968. *Art Quarterly* 31 (winter): 434.

"Drawings of Seven Centuries at Knoedler's, New York." 1959. *Burlington Magazine* 101 (September–October): 351.

Eichenberger, W., and H. Wendland. 1977. *Deutsche Bibeln vor Luther.* Hamburg: Evangelische Haupt-Bibelgesellschaft.

Eisler, Colin. 1977. *Paintings from the Samuel H. Kress Collection: European Schools Excluding Italian.* Oxford: Phaidon Press.

———. 1989. *The Genius of Jacopo Bellini: The Complete Paintings and Drawings.* New York: Abrams.

The Estate of the Late Joseph Brummer. Part II. 1949. New York: Parke-Bernet Galleries, May 11–14.

Evans, Joan. 1952. *Dress in Medieval France.* Oxford: Oxford University Press.

Evans, M. W. 1969. *Medieval Drawings.* London: Hamlyn Publishers.

Even, Yael. 1992. "Mantegna's Uffizi Judith: The Masculinization of the Female Hero." *Konsthistorisk Tidskrift* 61:8–20.

An Exhibition of Old Master Drawings of the French School, 1480 to 1880. 1986. London: Baskett and Day.

Falk, Tilman. 1979. *Katalog der Zeichnungen 15. und 16. Jahrhunderts im Kupferstichkabinet Basel. Das 15. Jahrhundert, Hans Holbein der Ältere und Jörg Schweiger, die Basler Goldschmiederisse* (*Kupferstichkabinet der Öffentlichen Kunstsammlung Basel [Kunstmuseum Basel]). Beschreibender Katalog der Zeichnungen. Die Zeichnungen des 15. und 16. Jahrhunderts.* 3 vols. Basel and Stuttgart: Schwabe.

Fasanelli, J. 1965. "Some Notes on Pisanello and the Council of Florence." *Master Drawings* 3 (spring): 36–47.

Ferguson, George. 1959. *Signs and Symbols in Christian Art.* Oxford: Oxford University Press.

Fine Dutch and Flemish Drawings. 1985. Amsterdam: Christie's, November 18.

Fischel, L. 1934. "Die Heimat des Meisters der Koburger Rundblätter." *Oberrheinische Kunst* 6:27–40.

———. 1944. *Nicholaus Gerhaert und die Bildhauer der Deutschen Spätgotik.* Munich: F. Bruckmann.

Flechsig, Eduard. 1951. *Martin Schongauer.* Strasbourg: P. H. Heitz.

Folie, J. 1960. *Flanders in the Fifteenth Century: Art and Civilization.* Catalog of the exhibition "Masterpieces of Flemish Art: Van Eyck to Bosch." Detroit: Detroit Institute of Arts and the City of Bruges.

Forlani Tempesti, Anna. 1991. *The Robert Lehman Collection, V: Italian Fifteenth to Seventeenth-Century Drawings.* New York: Princeton University Press for the Metropolitan Museum of Art.

Fortini, Patricia. 1992. "The Antiquarianism of Jacopo Bellini." *Artibus et Historiae* 13, no. 26:65–84.

Francis, H. 1936. *Catalogue of the Twentieth Anniversary Exhibition of the Cleveland Museum of Art, the Official Art Exhibit of the Great Lakes Exposition.* Cleveland: Cleveland Museum of Art.

———. 1937a. "A Fifteenth Century Drawing Close to the Style of Benozzo

Gozzoli." *Bulletin of the Cleveland Museum of Art* 24 (October): 123–25.

———. 1937b. "Gozzoli Drawings in Cleveland." *Art News* 36, no. 4 (October 23): 12, 21.

———. 1948. "A Fifteenth Century Drawing." *Bulletin of the Cleveland Museum of Art* 35:16–17.

———. 1958a. "Accessions of American and Canadian Museums, April–June 1958." *Art Quarterly* 21 (autumn): 336.

———. 1958b. "A Design for a Candelabrum by Bernardo Parentino." *Bulletin of the Cleveland Museum of Art* 45 (October): 199–200.

———. 1958c. "Rare Italian Drawings: A Madonna and Child Related to Stefano da Zevio." *Bulletin of the Cleveland Museum of Art* 45 (October): 200–202.

———. 1958d. "Rare Italian Drawings: Crucifixion Close to Altichiero." *Bulletin of the Cleveland Museum of Art* 45 (October): 195–98, 200–202.

Frankfurter, A. 1958. "Cleveland: Model Museum for a Modern Cosmopolis." *Art News* 57 (March): 31.

———. 1963. "'Il bon disegno' from Chicago." *Art News* 62 (November): 29, 56.

Friedländer, Max J. 1967–1976. *Early Netherlandish Painting.* Translated by Heinz Norden, with comments and notes by Nicole Veronée-Verhaegen, Henri Pauwels, et al. 14 vols. in 16. Leyden, Brussels, New York: Praeger.

Fusco, L. 1982. "The Use of Sculptural Models by Painters in Fifteenth Century Italy." *Art Bulletin* 64:175–94.

Gamba, F. 1958. *Filippino Lippi nella storia della critica.* Florence: Edizioni Arnaud.

Gardner, Edmund G. 1911. *The Painters of the School of Ferrara.* London: Duckworth and Co., 1911.

Garzelli, Annarosa. 1985. "Problemi del Ghirlandaio nella Cappella di Santa Fina: il ciclo figurativo nella cupola e i probabili disegni." *Antichità viva* 24, no. 4 (July–August): 11–25.

Gazette des Beaux-Arts. 1962. Supplement: *La Chronique des Arts.* Vol. 59 (March): 23.

Gealt, A. 1983. *Italian Portrait Drawings, 1400–1800, from North American Collections.* Bloomington; Indiana University Art Museum.

Geiger, Gail L. 1986. *Filippino Lippi's Carafa Chapel: Renaissance Art in Rome.* Kirksville, Mo.: Sixteenth Century Essays and Studies.

Gilbert, C. 1969. "The Drawings Now Associated with Masaccio's Sagra." *Storia dell'arte* 3:268.

Glaser, Curt. 1908. *Hans Holbein der Ältere.* Leipzig: Hierseman.

G[laser], M. T. 1959. *Great Master Drawings of Seven Centuries.* New York: Columbia University.

Goldner, George R. 1988 and 1992. *European Drawings: Catalogue of the Collections.* 2 vols. Malibu: J. Paul Getty Museum.

Golubew, V. 1908–1912. *Die Skizzenbucher Jacopo Bellinis.* 2 vols. Brussels: G. Van Oest & Co.

Gombrich, E. H. 1970. *Aby Warburg, an Intellectual Biography.* London: Warburg Institute.

Göpel, Erhard. 1961. "Die Sammelleidenschaft für alte Handzeichnungen wächt 330 000 Mark für eine Zeichnung von Hugo van der Goes auf der Versteigerung Randall in London." *Weltkunst* 31, no. 11 (June): 23.

"Gothic Art 1360–1440." 1963. *Bulletin of the*

Cleveland Museum of Art 50 (September): 182, 191–213.

Grigaut, P. 1959. *Decorative Arts of the Italian Renaissance, 1400–1600.* Detroit: Detroit Institute of Arts.

Griswold, William. 1987. "A Drawing by Cosimo Rosselli." *Burlington Magazine* 129 (August): 514–16.

Gronau, G. 1921. "Ercole (di Giulio Cesare) Grandi." In *Allgemeines Lexikon der bildenden Künstler von der Antike bis zur Gegenwart* by Ulrich Thieme and Felix Becker, 14:507. Leipzig: E. A. Seemann Verlag.

Guasti. C., ed. 1862. *Il Passio, o Vangelo di Nicodemo.* Bologna: Romagnoli.

Guzzo, E. M. 1992. "Giovanni Badile." In *Saur Allgemeines Künstlerlexikon,* 6:216–18. Munich-Leipzig: K. G. Saur.

Handbook of the Cleveland Museum of Art. 1958, 1966, 1969, 1978, 1991. Cleveland: Cleveland Museum of Art.

Handbook of the Collections in the William Rockhill Nelson Gallery of Art and Mary Atkins Museum of Fine Arts. 1959. Kansas City: University Trustees, W. R. Nelson Trust.

Hannema, D. 1955. *Catalogue of the H. E. Ten Cate Collection.* Vols. 1–2. Rotterdam: A Donker.

Hans Holbein der Ältere und die Kunst der Spätgotik. 1965. Exhibition catalog. Augsburg: Rathaus, August 21–November 7.

Held, Julius S. 1986. *Rubens, Selected Drawings.* 2d ed. Oxford: Oxford University Press.

Hill, G. F. 1930. *A Corpus of Italian Medals of the Renaissance before Cellini.* Vol. 1, no. 19. London: British Museum.

Hill, G. F., and G. Pollard. 1967. *Complete Catalogue of the Samuel H. Kress Collections:*

Renaissance Medals. London: Phaidon Press.

Hind, A. 1910. *Catalogue of Early Italian Engravings Preserved in the Department of Prints in the British Museum.* London: British Museum.

———. 1938–1948. *Early Italian Engraving.* 7 vols. London: B. Quaritch.

His, Eduard. 1885. *Hans Holbeins der Älteren Feder- und Silberstift-Zeichnungen in den Kunstsammlungen zu Basel.* Nuremberg.

Hoetink, H. R. 1962. *Italiaanse tekeningen in Nederlands bezit.* 2 vols. Exhibition catalog. Rotterdam: Boymans–van Beuningen Museum.

Hoogewerff, G. J. 1937. *De Noord-Nederlandsche Schilderkunst.* The Hague: M. Nijhoff.

Hutchison, Jane C., ed. 1991. *The Illustrated Bartsch.* Commentary, vol. 9. *Early German Artists: Wenzel von Olmütz and Monogrammists.* New York: Abaris Books.

———. 1993. "Master FVB." In *Six Centuries of Master Prints: Treasures from the Herbert Greer French Collection,* 120–21. Exhibition catalog. Cincinnati: Museum of Art.

Illinois Arts Quarterly. 1956. Vol. 19 (winter).

The International Style. 1962. Exhibition catalog. Baltimore: Walters Art Gallery.

"In the Auction Rooms: The Oppenheimer Collections." 1936. *Connoisseur* 98:180.

"In the Auction Rooms: The Oppenheimer Collections, the Drawings." 1917. *Burlington Magazine* 30:244.

Italian Drawings. 1930. Exhibition catalog. London: Burlington House, 1930.

Italian Drawings in the Department of Prints and Drawings in the British Museum. 1950. 2 vols. London: British Museum.

The Italian Renaissance. 1968. Poughkeepsie, N.Y.: Vassar College.

Die italienischen und französischen

Handzeichnungen im Kupferstichkabinett der Landesgalerie. 1987. Hannover: Niedersächisisches Landesmuseum, Kupferstichkabinett.

Jaffé, Michael. 1963. "Cleveland Museum of Art: The Figurative Arts of the West c. 1400–1800." *Apollo* 78 (December): 466.

———. 1964–1966. "Rubens as a Collector of Drawings." *Master Drawings* 2:383–97; 3:21–35; 4:127–48.

Jenni, Ulrike. 1987. "The Phenomena of Change in the Modelbook Tradition around 1400." In *Drawings Defined,* edited by W. Strauss and T. Felker, 35–47. New York: Abaris Books.

Joachim, Harold. 1970. *A Quarter Century of Collecting: Drawings Given to the Art Institute of Chicago, 1944–1970, by Margaret Day Blake.* Chicago: University of Chicago Press.

———. 1977. *French Drawings of the Sixteenth and Seventeenth Centuries.* Compiled by Sandra Haller Olsen. Chicago: University of Chicago Press.

———. 1979. *The Art Institute of Chicago: Italian Drawings from the 15th, 16th, and 17th Centuries.* Compiled by S. F. McCullagh and S. H. Olsen. Chicago and London: University of Chicago Press.

Joachim, Harold, and S. F. McCullagh. 1979. *Italian Drawings in the Art Institute of Chicago.* Chicago and London: University of Chicago Press.

Johnson, M. 1980. *Idea to Image: Preparatory Studies from the Renaissance to Impressionism.* Cleveland: Cleveland Museum of Art.

Kaemmerer, L. 1927. "Fünf Federzeichnungen aus der Passionsgeschichte im Kupferstichkabinett der Veste Coburg." *Münchner Jahrbuch der bildenden Kunst.* n.s. 4, no. 4:347–55.

Kanter, Laurence B. 1992. "Some Documents, a Drawing, and an Altarpiece by Luca Signorelli." *Master Drawings* 30, no. 4 (winter): 415–19.

Katalog der kostbaren und altberühmten Kupferstich-Sammlung des Marchese Jacopo Durazzo in Genoa. 1872. Stuttgart: Vereins-Buchdruckerei.

Kempers, B. 1987. *Painting, Power and Patronage.* London: Allen Lane, Penguin Press.

Kirschbaum, Englebert, S. J., ed. 1968. *Lexikon der Christlichen Iconographie* 1.

Kleine Museumsreise durch Amerika. 1969. Berlin: Mann Verlag.

Kodlin-Kern, Elizabeth. 1953. *Die Bilderzeichnungen Hans Holbein d. Ä.* Lörrach: Basel Universität.

Köhren-Jansen, H. 1993. *Giottos Navicella.* Worms am Rhein: Wernersche Verlagsgesellschaft.

Korte, W. 1938. "Giotto's Navicella." In *Festschrift, Wilhelm Pinder,* 223–63. Leipzig: E. A. Seemann.

Kren, Thomas. 1983. *Renaissance Painting in Manuscripts.* New York: Hudson Hills.

Kristof, J. 1989. "Michelangelo as Nicodemus: 'The Florence Pietà.'" *Sixteenth Century Journal* 20 (summer): 163–82.

Kruft, H. W. 1966. "Altichiero und Avanzo: Untersuchungen zur Oberitalienischen Malerie des ausgehenden Trecento." Ph.D. diss., Bonn University.

Kurz, O. 1937. "Giorgio Vasari's 'Libro de' Disegni.'" *Old Master Drawings* 12 (June): 7.

Laborde, A. de. 1911–1927. *La Bible Moralisée Illustrée.* Paris.

Ladis, A. 1993. *The Brancacci Chapel, Florence.* New York: George Braziller.

Landau, D., and P. Parshall. 1994. *The Renaissance Print, 1470–1550.* New Haven: Yale University Press.

Landolt, Hanspeter. 1960. *Das Skizzenbuch Hans Holbeins des Älteren im Kupferstichkabinett Basel.* Olten, Lausanne, and Feiburg: Urs Graf.

Lauts, Jan. 1966. *Karlsruhe, Staatliche Kunsthalle, Katalog Alte Meister Bis 1800.* 2 vols. Karlsruhe: Vereinigung der Freunde der Staatlichen Kunsthalle.

Lehrs, Max. 1914. "Schongauer-Zeichnungen in Dresden." *Mitteilungen aus den sächsischen Kunstammlungen* 5:12.

———. 1925. *Martin Schongauer und seine Schule-Erste Abteilung.* Geschichte und kritischer Katalog des deutschen, niederländischen und französischen Kupferstichs im XV. Jahrhundert, vol. 5. Vienna: Gesellschaft für vervielfaltigende Kunst.

———. 1927. *Martin Schongauer und seine Schule-Zweite Abteilung.* Geschichte und kritischer Katalog des deutschen, niederländischen und französischen Kupferstichs im XV. Jahrhundert, vol. 6. Vienna: Gesellschaft für vervielfaltigende Kunst.

———. 1930. *Israhel van Meckenem.* Geschichte und kritischer Katalog des deutschen, niederländischen und französischen Kupferstichs im XV. Jahrhundert, vol. 7. Vienna: Gesellschaft für vervielfaltigende Kunst.

Levenson, J., K. Oberhuber, and J. Sheehan. 1973. *Early Italian Engravings from the National Gallery of Art.* Washington, D.C.: National Gallery of Art.

Lieb, Norbert. 1958. *Die Fugger und die Kunst im Zeitalter der hohen Renaissance.* Munich: Schnell and Steiner.

———, ed. 1970. *Kritisches Verzeichnis. Alfred Stange: Die deutschen Tafelbilder vor Dürer.* 2 vols. Munich.

Lieb, Norbert, and Alfred Stange. 1960. *Hans Holbein der Ältere.* Munich: Deutscher Kunstverlag.

Lightbown, Ronald W. 1986. *Mantegna: With a Complete Catalogue of Paintings, Drawings, and Prints.* Berkeley: University of California Press.

———. 1989. *Sandro Botticelli, Life and Work.* New York: Abbeville Press Publishers.

Lippincott, K. 1991. "A Masterpiece of Renaissance Drawing: A Sacrificial Scene by Gian Francesco de' Maineri." *Art Institute of Chicago Museum Studies* 17:6–21.

Logan, Anne-Marie S. 1987. "Review of *Rubens: Selected Drawings* by Julius S. Held." *Master Drawings* 25:71.

———. 1988. *The Collections of the Detroit Institute of Arts: Dutch and Flemish Drawings and Watercolors.* New York: Hudson Hills Press.

———. 1993. *Flemish Drawings from the Age of Rubens.* Exhibition catalog. Wellesley, Mass.: Wellesley College, Davis Museum and Cultural Center.

Longhi, R. 1934. *Officina Ferrarese.* Florence. Reprinted in *Opera completa,* 5. Florence: Sansoni, 1956.

Lübke, W. 1878. *Geschichte der italianische Malerei.* 2 vols. Stuttgart: Paul Neff.

Lugt, Frits. 1921. *Les marques de collections de dessins et d'estampes.* 2 vols. Amsterdam: Martinus Nijhoff.

———. 1956. *Les marques de collections de dessins et d'estampes: Supplément.* The Hague: M. Nijhoff.

Luijten, G., and A. Meij. 1990. *From Pisanello to Cézanne.* Exhibition catalog. Rotterdam: Museum Boymans–van Beuningen.

Manca, Joseph. 1987. "Two Copies after a Massacre of the Innocents by Ercole de' Roberti." *Master Drawings* 25, no. 2:143–46.

Mandowsky, Erna, and Charles Mitchell. 1963. *Pirro Ligorio's Roman Antiquities.* London: Warburg Institute.

Marchini, G. 1975. *Filippo Lippi.* Milan: Electa.

Marqués, Manuela Mena. 1985. "Les collections de dessins italiens en Espagne." *Revue de l'art* 70:83–90.

Martindale, A., and N. Garavaglia. 1967. *The Complete Paintings of Mantegna.* New York: Abrams.

Martineau, Jane, ed. 1992. *Andrea Mantegna.* Exhibition catalog. London: Thames and Hudson.

Master Drawings from the Art Institute of Chicago. 1963. New York: Wildenstein.

Master Drawings of the Italian Renaissance. 1960. Exhibition catalog. Detroit: Detroit Institute of Arts.

Meder, J. 1978. *The Mastery of Drawing.* 2 vols. Translated by W. Ames. New York: Abaris Book.

Meij, A. W. F. M. 1974. *Duitse Tekeningen: 1400–1700, Catalogus van de verzameling in het Museum Boymans–van Beuningen.* Rotterdam.

Meiss, M. 1951. *Painting in Florence and Siena after the Black Death.* Princeton: Princeton University Press.

———. 1957. *Andrea Mantegna as Illuminator.* Hamburg: J. J. Augustin.

———. 1976. "Scholarship and Penitence in the Early Renaissance: The Image of St. Jerome." In *The Painter's Choice,* 189–202. New York: Harper & Row.

Metz, C. M. 1790. *Imitations of Ancient and Modern Drawings.* London: C. M. Metz.

Meyer zur Cappellen, Jurg. 1985. *Gentile Belini.* Stuttgart: Steiner Verlag Wiesbaden.

Mia N. Weiner Presents an Exhibition of Old Master Drawings. 1985. New York: Piero Corsini, November 5–23.

Migne, J. P. 1861. *Patrologiae Cursus Completus, Serie Latinae.* Vol. 39. Paris.

Miller, Michael. 1987. "Drawings in the Cleveland Museum of Art." *Drawing* 8:125.

———. 1990. "A Michelangelo Drawing." *Bulletin of the Cleveland Museum of Art* 77 (May): 158, 173–74.

Minott, Charles I. 1971. *Martin Schongauer.* New York: Collectors Editions.

Mongan, A. 1987. "On Silverpoint Drawings and the Subject of Left-Handedness." In *Drawings Defined,* 151–64. New York: Abaris Books.

Moskowitz, I., ed. 1962. *Great Drawings of All Time.* 4 vols. New York: Shorewood Publishers.

"Mostre, musei, galerie: Museo di Cleveland." 1958. *Sele Arte* 6, no. 35 (March–April): 2.

Müller, Theodor. 1966. *Sculpture in the Netherlands, Germany, France, and Spain, 1400 to 1500.* Baltimore: Penguin.

"Muséographie." 1938. *Gazette des Beaux-Arts* 19 (January): 62.

Muylle, Jan. 1983. "*Big Fishes Eat the Little Fishes* by Pieter Bruegel after Hieronymus Bosch (?): A Question of Interpretation." In *Le dessin sous-jacent dans la peinture, Colloque V. Dessin sous-jacent et autres techniques graphiques,* edited by Roger Van Schoute and Dominique Hollanders-Favart. Louvain-la-Neuve: Université Catholique.

Neff, Amy. 1990. "Wicked Children on Calvary and the Baldness of Saint Francis." *Mitteillungen des Kunsthistorischen Institutes*

in Florenz 24, no. 3:215–44.

Neilson, K. 1938. *Filippino Lippi.* Cambridge: Harvard University Press.

Offerhaus, J. 1981. *Francesco Sassetti and Ghirlandaio at Santa Trinitá, Florence; History and Legend in a Renaissance Chapel.* Doornspijic, Holland: Dadaco Publishers.

Old Master Drawings. 1960. Exhibition catalog. Newark: Newark Museum.

Old Master Drawings. 1963. London: Matthiesen.

Old Master Drawings. 1966. London: Sotheby's, July 7.

Old Master Drawings: Exhibition. 1978. London: Yvonne Tan Bunzl and Sommerville and Simpson, November 19–December 15.

Old Master Drawings from the Woodner Collection. 1991. London: Christie's, July 2.

Olds, Clifton C., Ralph G. Williams, and William R. Levin. 1975. *Images of Love and Death in Late Medieval and Renaissance Art.* Ann Arbor: University of Michigan Museum of Art.

Olszewski, E. 1977. *Giovanni Battista Armenini: On the True Precepts of the Art of Painting.* New York: Burt Franklin Publishers.

———. 1981. *The Draftsman's Eye: Late Italian Renaissance Schools and Styles.* Bloomington: Indiana University Press.

Ortolani, S. 1941. *Cosme Tura, Francesco del Cossa, Ercole de' Roberti.* Milan: U. Hoepli.

Ottley, W. Y. 1823. *The Italian School of Design.* London.

Oude tekeningen van het Prentenkabinet der Rijksuniversiteit te Leiden. Dessins anciens du Cabinet des Dessins de l'Université de Leyde. 1985. Amsterdam and The Hague: Rijksuniversiteit te Leiden, Prentenkabinet.

Paccagnini, G. 1973. *Pisanello.* London: Phaidon Press.

Pagden, S. Ferino. 1979. "A Master Painter and His Pupils: Pietro Perugino and His Umbrian Workshop." *Oxford Art Journal* 3:9–14.

———. 1982. *Disegni umbri del rinascimento da Perugino a Raffello.* Florence: Gabinetto Disegni e Stampe degli Uffizi.

———. 1984. *Disegni umbri, Galleria dell'Accademia di Venezia.* Milan: Electa.

———. 1987. "Perugino's Use of Drawing: Convention and Invention." In *Drawings Defined,* edited by W. Strauss and T. Felker, 77–102. New York: Abaris Books.

Panofsky, E. 1953. *Early Netherlandish Painting.* 2 vols. Cambridge: Harvard.

Pantheon. 1960. Vol. 18, no. 1:54.

———. 1962. Vol. 20, no. 4:260.

Parks, N. Randolph. 1979. "On the Meaning of Pinturicchio's Sala dei Santi." *Art History* 2:291–317.

Périer-d'Ieteren, Catheline. 1982–1983. "Dessin au poncif et dessin perforé: leur utilisation dans les anciens Pays-Bas au XVe siècle." *Bulletin de l'Institut Royal du Patrimoine Artistique* 19:74–94.

———. 1987. "Précisions sur le dessin sous-jacent et la technique d'exécution de la *Nativité* de Gérard David du Musée de Budapest." *Annales d'histoire de l'art et d'archéologie* 9:95–106.

Peters-Schildgen, Susanne. 1989. *Die Bedeutung Filippino Lippis für den Manierismus.* Essen: Blaue Eule.

Petrioli Tofani, Annamaria, ed. 1991. *Inventario, disegni di figura.* Vol. 1. Florence: L. S. Olschki.

———. 1992. *Il disegno fiorentino del temp di Lorenzo il Magnifico.* Milan: Silvana.

Piccard, Gerhard. 1977. *Wasserzeichen*

Buchstabe. 3 vols. Stuttgart: Hauptstaatarchiv.

Pigler, A. 1956. *Barockthemen.* Budapest: Verlag der Ungarischen Akademie der Wissenschaften.

Pignatti, T. 1974. *Venetian Drawings from American Collections.* Washington, D.C.: International Exhibitions Foundation.

Pilliod, E. 1988. "Alexander Allori's 'The Penitent St. Jerome.'" *Record of the Art Museum, Princeton University* 47:2–26.

Pillsbury, E. 1971. *Florence and the Arts: Five Centuries of Patronage.* Cleveland: Cleveland Museum of Art.

Plummer, J., and G. Clark. 1982. *The Last Flowering: French Painting in Manuscripts, 1420–1530.* New York: Pierpont Morgan Library.

Pope-Hennessy, John, assisted by Anthony F. Radcliffe. 1970. *The Frick Collection: An Illustrated Catalogue.* Vol. 3, *Sculpture, Italian.* New York: Frick Collection.

Popham, A. E. 1930. "A Book of Drawings of the School of Benozzo Gozzoli." *Old Master Drawings* 4 (March): 53–58.

———. 1932. *Dutch and Flemish Drawings of the XV and XVI Centuries.* Catalog of the Drawings by Dutch and Flemish Artists Preserved in the Department of Prints and Drawings in the British Museum, vol. 63. London: British Museum.

———. 1931. *Italian Drawings Exhibited at the Royal Academy, Burlington House, London, 1930.* London: Oxford University Press.

Popham, A. E., and P. Pouncey. 1950. *Italian Drawings in the Department of Prints and Drawings in the British Museum.* 2 vols. London: Trustees of the British Museum.

Pouncey, P. 1937. "Ercole Grandi's Masterpiece." *Burlington Magazine* 1:161–68.

———. 1964. "Reviews." *Master Drawings* 2:286–87.

Ragghianti, Carlo, and Gigetta Dalle Regole. 1975. *Firenze 1470–1480: Disegni dal modello.* Pisa: Universita de Pisa.

Réau, Louis. 1949. "Deux peintures inédites de romanistes des Pays-Bas dans des collections françaises." *Miscellanea Leo Van Puyvelde,* edited by Georges Theunis. Brussels: Editions de la connaissance.

———. 1955–1958. *Iconographie de l'art chrétien* 3 vols. Paris: Presses universitaires de France.

The Renaissance Image of Man and the World. 1961. Exhibition catalog. Columbus: Columbus Gallery of Fine Arts.

Revely, H. 1820. *Notices Illustrative of the Drawings and Sketches of Some of the Most Distinguished Masters in All the Principal Schools of Design.* London.

Rice, E., Jr. 1985. *St. Jerome in the Renaissance.* Baltimore: Johns Hopkins University Press.

Richards, Louise. 1962. "Three Early Italian Drawings." *Bulletin of the Cleveland Museum of Art* 49 (September): 170–72.

———. 1971. "A Silverpoint Drawing by Hans Holbein the Elder." *Bulletin of the Cleveland Museum of Art* 58:290–95.

Richardson, J. 1728. *Traité de la Peinture.* Amsterdam.

Richardson, J. Sr., and J. Richardson Jr. 1722. *An Account of Some of the Statues, Bas-reliefs, Drawings and Pictures in Italy.* London: J. Knapton.

Ridderbos, B. 1984. *Saint and Symbol, Images of St. Jerome in Early Italian Art.* Groningen: Bouma's Boekhaus.

Robels, Hella. 1972. "Israhel van Meckenem und Martin Schongauer." In *Israhel van Meckenem und der deutsche Kupferstich des*

15. Jahrhunderts–750 Jahre Stadt Bocholt 1222–1972, edited by Elizabeth Bröker, 31–50. Bocholt.

———. 1983. *Cologne, Wallraf-Richartz-Museum and Museum Ludwig, Niederländische Zeichnungen vom 15. bis 19. Jahrhundert.* Cologne: Wallraf-Richartz-Museum.

Roberts, Ann M. 1984. "Silverpoints by the Master of the Legend of Saint Lucy." *Oud Holland* 97, no. 4:273–345.

Roberts, Keith. 1978. "Current and Forthcoming Exhibitions." *Burlington Magazine* 120, no. 909 (December): 863.

Roethlissberger, M. 1981. *Bartolomeus Breenburgh, the Paintings.* Berlin and New York: De Gruyter.

Rosenberg, Jakob. 1923. *Martin Schongauers Handzeichnungen.* Munich: R. Piper.

Rossi, U. 1893. "Il Museo Nazionale di Firenze nel triennio 1889–91." *Archivio storico dell'arte* 6:18–20.

Roth, M. 1988. "Die Zeichnungen des Meisters der Coburger Rundblätter." Ph.D. diss., Freie Universität Berlin.

Röttgen, Herwarth. 1987. "Konrad Witz, der Farbkünstler und der Zeichner." *Zeitschrift für Schweizerische Archäologie und Kunstgeschichte* 44, no. 2:89–104.

Rubinstein, A. 1938. "Muséographie." *Gazette des Beaux-Arts* 19 (January): 62.

Ruda, Jeffrey. 1982. *Filippo Lippi Studies: Naturalism, Style and Iconography in Early Renaissance Art.* New York: Garland Dissertation Reprint.

———. 1993. *Fra Filippo Lippi: His Life and Work with a Complete Catalogue.* London: Phaidon.

Ruhmer, E. 1962. "Ergänzendes zur Zeichenkunst des Ercole de' Roberti." *Pantheon* 20:246.

———. 1963. "Ercole de' Roberti." In *Encyclopedia of Universal Art,* 11:col. 621. New York: McGraw-Hill.

Salmazo, Alberta de Nicolò. 1989. *Bernardo da Parenzo: un pittore "antiquario" di fine quattrocento.* Padua: Antenore.

Salmi, M. 1914. *Vita di Parri Spinelli.* Florence: R. Bemporad.

———. 1930. "Un libro di disegni fiorentino del sec. XV." *Rivista d'arte* 2:87–95.

———. 1960. *Ercole de' Roberti.* Milan: Silvana.

Saxl, F. 1938–1939. "Pagan Sacrifice in the Italian Renaissance." *Journal of the Warburg Institute* 2:352.

Scarpellini, P. 1984. *Perugino.* Milan: Electa.

Scharf, Alfred. 1935. *Filippino Lippi.* Vienna: Verlag von Anton Schroll & Co.

———. 1950. *Filippino Lippi.* Vienna: Verlag von Anton Schroll & Co.

Scheller, R. W. 1963. "Benozzo Gozzoli." In *A Survey of Medieval Model Books,* 207–11. Haarlem: De Erven F. Bohn N.V.

Schilling, Edmund. 1931–1932. "School of the Upper Rhine (ca. 1470–80)." *Old Master Drawings* 6:53–54.

———. 1933. "Zur Zeichenkunst der Älteren Holbein." *Pantheon* 12:315–22.

———. 1954. *Zeichnungen der Kunstler Familie Holbein.* Basel: Holbein-Verlag.

———. 1955. *Drawings by the Holbein Family.* Translated by E. Winkworth. New York: Macmillan.

Schilling, Edmund, and Kurt Schwarzweller. 1973. *Staedelsches Kunstinstitut, Frankfurt am Main, Katalog der deutschen Zeichnungen.* 3 vols. Munich: Prestel.

Schmid, H. A. 1941–1942. "Holbein Studien, I: Hans Holbein der Ältere." *Zeitschrift für Kunstgeschichte* 10:1–39.

Schmoll, F. 1918. *Die Heilige Elisabeth in der*

Bildenden Kunst des 13. bis 16. Jahrhunderts. Marburg: N. G. Elwert.

Scholz, J. 1967. "Italian Drawings in the Art Museum of Princeton University." *Burlington Magazine* 109 (May): 293.

Schönbrunner, J., and J. Meder. 1896–1908. *Handzeichnungen alter Meister aus der Albertina und anderen Sammlungen.* 12 vols. Vienna.

Schrader, J. L. 1969. *The Waning of the Middle Ages.* Lawrence: University of Kansas Museum of Art.

Schulz, J. 1962. "Pinturicchio and the Revival of Antiquity." *Journal of the Warburg and Courtauld Institutes* 25:35–55.

Schwarz, M. 1995. "Giottos Navicella zwischen *Renovatio* und *Trecento:* Ein Genealogischer Versuch." *Wiener Jahrbuch für Kunstgeschichte* 48:129–63.

Selected Works from the Cleveland Museum of Art. 1966. Cleveland: Press of Case Western University.

Seznec, Jean. 1953. *The Survival of the Pagan Gods.* New York: Pantheon Books.

Shapley, F. 1961. *The Samuel H. Kress Collection, El Paso Museum of Art.* El Paso: Museum of Art.

———. 1966–1973. *Paintings from the Samuel H. Kress Collection.* 3 vols. London: Phaidon.

Shaw, James Byam. 1934–1935. "A Lost Portrait of Mantegna and a Group of Paduan Drawings." *Old Master Drawings* 9:1–8.

———. 1983. *The Italian Drawings of the Frits Lugt Collection.* 3 vols. Paris: Institut Néerlandais.

Shestack, Alan. 1967. *Fifteenth Century Engravings of Northern Europe from the National Gallery of Art.* Washington, D.C.: National Gallery.

———. 1971. *Master LCZ and Master WB.* New York: Collectors Editions.

Shoemaker, Innis H. 1975. "Filippino Lippi as a Draughtsman." Ph.D. diss., Columbia University.

———. 1978. "Drawings after the Antique by Filippino Lippi." *Master Drawings* 16, no. 1:35–39.

Shrimplin-Evangelidis, V. 1989. "Michelangelo and Nicodemism: The Florentine 'Pietà.'" *Art Bulletin* 71 (March): 58–66.

Shulman, K. 1991. *Anatomy of a Restoration: The Brancacci Chapel.* New York: Walker.

Sizer, T. 1924. "An Exhibition of Drawings." *Bulletin of the Cleveland Museum of Art* 11 (July): 141.

'sLevens Felheid: de Meester van het Amsterdamse Kabinet of de Hausbuch Meester, ca. 1470–1500. 1985. Exhibition catalog. Amsterdam: Rijksmuseum, Rijksprentenkabinet, March 14–June 9.

Soltesz, E. 1967. *Biblia Pauperum.* Hanau/Main: W. Dausien.

Sonkes, Micheline. 1969. *Dessins du XVe siècle: Groupe van der Weyden.* Brussels: Centre National Recherches "Primitifs flamands."

———. 1973. "Les dessins du Maître de la Rédemption du Prado, le présumé Vranck van der Stockt." *Revue des archéologues et historiens d'art de Louvain* 6:110–11.

Spencer, J. 1966a. "*The Lament at the Tomb* by Filippino Lippi." *Allen Memorial Art Museum Bulletin* 24 (fall): 23–24.

———. 1966b. "On Painting." *Leon Batista Alberti.* New Haven: Yale University Press, 1966

Spiro, Stephen B., and Robert Randolf Coleman. 1987. *Master Drawings: The Wisdom Reilly Collection.* Notre Dame: University of Notre Dame and Snite

Museum of Art.

Stample, Felice. 1991. *Netherlandish Drawings of the Fifteenth and Sixteenth Centuries and Flemish Drawings of the Seventeenth and Eighteenth Centuries in the Pierpont Morgan Library.* New York: Pierpont Morgan Library.

Stange, Alfred. 1957. *Deutsche Malerei der Gotik. Schwaben in der Zeit von 1450 bis 1500.* Vol. 8. Berlin: Deutscher Kunstverlag.

Stechow, Wolfgang. 1964. "Joseph of Arimathea or Nicodemus?" In *Studien zur Toskanischen Kunst, Festschrift für Ludwig Heydenreich,* 289–302. Munich: Prestel-Verlag.

———. 1976. *Catalogue of Drawings and Watercolors in the Allen Memorial Museum, Oberlin College.* Oberlin, Ohio: Oberlin College.

Steinbrucker, Charlotte, and Hans von Erffa. 1954. "Cybele." *Reallexikon zur deutschen Kunstgeschichte* 3:895–99.

Stewart, Alison G. 1979. *Unequal Lovers: A Study of Unequal Couples in Northern Art.* New York: Abaris Books.

Stock, Julien, and David Scrase. 1985. *The Achievement of a Connoisseur, Philip Pouncey: Italian Old Master Drawings.* Exhibition catalog. Cambridge University, Fitzwilliam Museum, October 15–December 15.

Stoichita, V. I. 1978. "Deux oeuvres ferraraises au Musée d'Art de la Republique Socialiste de Roumanie." *Revue roumaine d'histoire d'art* 15:41.

Strong, S. A. 1900. *Drawings of the Old Masters in the Collection of the Earl of Pembroke and Montgomery at Wilton House.* London.

Strozzi, B. 1993. "*L'Adorazione del Bambino* della bottega di Filippo Lippi." In *Benozzo Gozzoli: La cappella dei Magi,* edited by D.

Luchinot, 29–32. Milan: Electa.

Suida, W. 1951. *Paintings and Sculpture from the Kress Collection.* Washington, D.C.: National Gallery of Art.

Taggart, Ross E., and George L. McKenna, eds. 1973. *Handbook of the Collections in the William Rockhill Nelson Gallery of Art and Mary Atkins Museum of Fine Arts.* 2 vols. Kansas City: University Trustees, W. R. Nelson Trust.

Talley, M. Kirby. 1990. "Lost Treasures." *Art News* 89, no. 2 (February): 138–47.

Thieme, Ulrich, and Felix Becker. 1901–1956. *Allgemeines Lexikon der bildenden Künstler von der Antike bis zur Gegenwart.* 37 vols., plus 6 vols. supplement. Berlin and Leipzig: Seeman.

Tietze-Conrat, E. 1924. "Von Mantegna über den Pseudo-Dürer zu Tizian." *Die Graphischen Künste, Mitteilungen der Gesellschaft für Vervielfaltigende Kunst* 47:66–67.

Todorow, M. Fossi. 1966. *I Desegni del Pisanello e della sua cerchia.* Florence: Leo S. Olschki.

———. 1970. *L'Italia dalle origini a Pisanello, I Disegni dei maestri 3.* Milan: Fabbri.

Tofani, Annamaria P. 1992. *Il disegno fiorentino del tempo di Lorenzo il Magnificio.* Milan: Silvana.

Vaccaro, M. G. 1976. *Maestri Emiliani del Quattro e Cinquecento.* Biblioteca di Disegni, 11. Florence: Instituto Alinari.

Valuable Collection of Drawings by Old Masters. 1887. London: Christie's, July 12.

van der Marck, J. 1984. *In Quest of Excellence: Civic Pride, Patronage, Connoisseurship.* Miami, Fla.: Center for the Fine Arts.

van Gelder, J. G. 1966. "Enige Kanttekeningen bij de Gerechtigheidstafeleren van Rogier van

Der Weyden." In *International Colloquium, Rogier Van Der Weyden En Zijntijd,* 119–60. Brussels.

van Marle, Raimond. 1923–1938. *The Development of the Italian Schools of Painting.* 19 vols. The Hague: Martinus Nijhoff.

———. 1929. "Some Unknown Works of Stefano da Verona." *International Studio* 93 (August): 39–43, 78, 80.

van Os, H. 1990. *Sienese Altarpieces, 1215–1460.* 2 vols. Groningen: Bouma's Boekhuis.

van Regteren Altena, J. Q. 1970. "Review of Degenhart and Schmit, *Corpus.*" *Master Drawings* 8:400.

van Schaack, E. 1959. *Great Master Drawings of Seven Centuries.* New York: Columbia University.

van Schoute, Roger. 1991. *Colloque pour l'étude du dessin sous-jacent la peinture. Dessin sous-jacent et copies.* Louvain-la-Neuve: Université catholique de Louvain.

van Schoute, Roger, and Dominique Hollanders-Favart, eds. 1983. *Dessin sous-jacent dans la peinture: Colloque IV; le probleme de l'auteur de l'oeuvre: contribution de l'étude du dessin sous-jacent à la question des attributions.* Louvain-la-Neuve: College Erasme.

Vasari, Giorgio. 1906. *Le vite de' piu eccellenti pittori, scultori ed architettori.* Edited by Gaetano Milanesi. 9 vols. Florence: G. C. Sansoni Editore.

Vente Rodrigues. 1921. Amsterdam: Frederik Muller & Cie.

Venturi, A. 1915. *Storia dell'arte italiana.* Vol. 7. Milan: Ulrico Hoepli.

———. 1926. "Scelta di rari disegni nei musei d'Europa." *L'Arte* 7:7.

———. 1939. *Pisanello.* Rome: Fratelli Palombi.

Venturi, L. 1922. "La Navicella di Giotto." *L'Arte* 25:49–69.

Vergani, G. 1985. "Nuove considerazioni sul ciclo di affreschi attribuito a Bernardino Butinone nella chiesa di S. Maria Maddalena a Camuzzago." *Arte Lombarda* 73–75:33.

Vickers, M. 1978. "Some Preparatory Drawings for Pisanello's Medallion of John VIII Palaeologus." *Art Bulletin* 60 (September): 417–24.

Virch, C. 1961. "A Page from Vasari's Book of Drawings." *Metropolitan Museum of Art Bulletin* 19 (March): 189–93.

von Pölnitz, Götz Freiherrn. 1958. *Anton Fugger.* Vol. 1. Tübingen.

von Seidlitz, W. 1903. "Zenale e Butinone." *L'Arte* 6:31–36, 398.

Ward, Roger, and Mark S. Weil. 1989. *Master Drawings from the Nelson-Atkins Museum of Art.* Exhibition catalog. St. Louis: Washington University Gallery of Art, September 22–December 3.

Wazbinski, Zygmunt. 1963a. "A propos de quelques dessins de Parentino pour le Couvent de Santa Giustina." *Arte Veneta* 17:21–26.

———. 1963b. *Bernardo da Parenzo: un peintre vagabond; étude sur la fin du quattrocento à Padoue.* Venice: Istituto Veneto.

Weiner, Mia N. 1985. *Mia N. Weiner Presents an Exhibition of Old Master Drawings, November 5–23, 1985.* New York: Piero Corsini.

Weiss, R. 1966. *Pisanello's Medallion of the Emperor John VIII Palaeologus.* London: British Museum.

Welliver, W. 1969. "Alterations in Ghirlandaio's S. Trinità Frescoes." *Art Quarterly* 32:269–81.

Wentzel, H. 1949. "Glasmaler und Maler im

Mittelatter." *Zeitschmitt für Kunstwissenshaft* 3, no. 3/4:53–62.

Wescher, Paul. 1938–1939. "Drawings of Vrancke van der Stoct." *Old Master Drawings* 8:2.

White, Christopher. 1987. *Peter Paul Rubens: Man and Artist.* New Haven: Yale University Press.

White, J. 1957. *The Birth and Rebirth of Pictorial Space.* Boston: Boston Book and Art Shop.

The William Rockhill Nelson Collection. 1941. 2d ed. Kansas City: William Rockhill Nelson Collection and Mary Atkins Museum.

———. 1949. 3d ed. Kansas City: William Rockhill Nelson Collection and Mary Atkins Museum.

Winkler, F. 1930. "Skizzenbücher eines unbekannten rheinischen Meisters um 1500." *Wallraf-Richartz-Jahrbuch,* n.s. 1:123–52.

———. 1965. "The Drawings of Vrancke Van Der Stockt." *Master Drawings* 3:155–58.

Winzinger, Franz. 1962. *Die Zeichnungen Martin Schongauers.* Berlin: Deutscher Verein für Kunstwissenschaft.

Wisdom, J. M. 1981. *In the Museum of Fine Arts, Houston: A Guide to the Collection.* Houston: Houston Museum of Fine Arts.

Wixom, William D. 1967. *Treasurers from Medieval France.* Cleveland: Cleveland Museum of Art.

Woltmann, Alfred. 1876. *Hans Holbeins der Älteren Silberstift-Zeichnungen im Königlichen Museum zu Berlin.* Nuremberg, Leipzig: K. W. Hiersmann.

Woods-Marsden, Joanna. 1985–1986. "The Sinopia as a Preparatory Drawing: The Evolution of Pisanello's Tournament Scene." *Master Drawings* 23–24:175–92.

———. 1987. "Preparatory Drawings for Frescoes in the Early Quattrocento." In *Drawings Defined,* edited by W. Strauss and T. Felker, 49–62. New York: Abaris, 1987.

———. 1988. *The Gonzaga of Mantua and Pisanello's Arthurian Frescoes.* Princeton: Princeton University Press.

Wright, J. 1983. *Drawing in the Italian Renaissance Workshop.* London: Victoria and Albert Museum.

Wunderlich, S. 1937. "Fifteenth Century Florentine Drawing." *Print Collector's Quarterly* 24 (October): 318–21.

"The Year in Review, 1959." 1959. *Bulletin of the Cleveland Museum of Art* 46 (December): 231.

"The Year in Review, 1960." 1961. *Bulletin of the Cleveland Museum of Art* 48 (November): 239.

"The Year in Review, 1968." 1969. *Bulletin of the Cleveland Museum of Art* 56 (January).

Zamboni, S. 1975. *Pittori di Ercole I d'Este: Giovan Francesco Maineri, Lazzaro Grimaldi, Domenico Panetti, Michele Coltellini.* Milan: Silvana.

Zucker, Mark. 1973. "Parri Spinelli: Aretine Painter of the Fifteenth Century." Ph.D. diss. New York: Columbia University.

———. 1981. "Parri Spinelli Drawings Reconsidered." *Master Drawings* 19 (winter): 426–41.

Index

Numbers in italics indicate illustrations.